Landscapes of the Japanese Heart　Waterfalls in Japan

日本の原風景

滝

【写真】森田敏隆　MORITA Toshitaka
宮本孝廣　MIYAMOTO Takahiro

目 次

CONTENTS

日本の滝100選リスト ———————————————————————— 7

凡例 ———————————————————————————————— 8

北海道 Hokkaido ———————————————————————————— 9

北海道 **カムイワッカの滝** 北海道斜里町 ——— 9
Kamuiwakka-no-taki　Hokkaido Pref.

湯の華の滝 北海道斜里町 ——— 10
Yunohana-no-taki　Hokkaido Pref.

フレペの滝 北海道斜里町 ——— 12
Furepe-no-taki　Hokkaido Pref.

オシンコシンの滝 北海道斜里町 ——— 14
Oshinkoshin-no-taki　Hokkaido Pref.

羽衣の滝 北海道東川町 ——— 16
Hagoromo-no-taki　Hokkaido Pref.

敷島の滝 北海道東川町 ——— 17
Shikishima-no-taki　Hokkaido Pref.

銀河・流星の滝 北海道上川町 ——— 18
Ginga-no-taki & Ryusei-no-taki　Hokkaido Pref.

白金不動の滝 北海道美瑛町 ——— 19
Shirogane-fudo-no-taki　Hokkaido Pref.

白ひげの滝 北海道美瑛町 ——— 20
Shirahige-no-taki　Hokkaido Pref.

千鳥ヶ滝 北海道夕張市 ——— 22
Chidori-ga-taki　Hokkaido Pref.

アシリベツの滝 北海道札幌市 ——— 23
Ashiribetsu-no-taki　Hokkaido Pref.

インクラの滝 北海道白老町 ——— 24
Inkura-no-taki　Hokkaido Pref.

三階滝 北海道伊達市 ——— 25
Sangai-taki　Hokkaido Pref.

賀老の滝 北海道島牧村 ——— 26
Garo-no-taki　Hokkaido Pref.

東北 Tohoku (Northern Honshu) ————————————————————— 27

青森 **くろくまの滝** 青森県鰺ヶ沢町 ——— 27
Kurokuma-no-taki　Aomori Pref.

七ツ滝 青森県中泊町 ——— 28
Nanatsu-daki　Aomori Pref.

暗門の滝 青森県西目屋村 ——— 29
Anmon-no-taki　Aomori Pref.

銚子大滝 青森県十和田市 ——— 30
Choshi-otaki　Aomori Pref.

松見の滝 青森県十和田市 ——— 32
Matsumi-no-taki　Aomori Pref.

雲井の滝 青森県十和田市 ——— 33
Kumoi-no-taki　Aomori Pref.

みろくの滝 青森県田子町 ——— 34
Miroku-no-taki　Aomori Pref.

岩手 **不動の滝** 岩手県八幡平市 ——— 35
Fudo-no-taki　Iwate Pref.

鳥越の滝 岩手県雫石町 ——— 36
Torigoe-no-taki　Iwate Pref.

秋田 **幸兵衛滝** 秋田県北秋田市 ——— 37
Kobe-taki　Akita Pref.

七滝 秋田県小坂町 ——— 38
Nana-taki　Akita Pref.

曽利滝 秋田県鹿角市 ——— 39
Sori-taki　Akita Pref.

三階滝 秋田県北秋田市 ——— 40
Sangai-daki　Akita Pref.

桃洞滝 秋田県北秋田市 ——— 41
Todo-no-taki　Akita Pref.

安の滝 秋田県北秋田市 ——— 42
Yasu-no-taki　Akita Pref.

回顧の滝 秋田県仙北市 ——— 44
Mikaeri-no-taki　Akita Pref.

法体の滝 秋田県由利本荘市 ——— 46
Hottai-no-taki　Akita Pref.

元滝伏流水 秋田県にかほ市 ——— 48
Moto-taki Fukuryusui　Akita Pref.

奈曽の白滝 秋田県にかほ市 ——— 50
Naso-no-shirataki　Akita Pref.

山形 **十二滝** 山形県酒田市 ——— 51
Juni-taki　Yamagata Pref.

白糸の滝 山形県戸沢村 ——— 52
Shiraito-no-taki　Yamagata Pref.

白銀の滝 山形県尾花沢市 ——— 54
Shirogane-no-taki　Yamagata Pref.

七ッ滝 山形県鶴岡市 ——— 56
Nanatsu-daki　Yamagata Pref.

米の粉の滝 山形県鶴岡市 ——— 57
Komenoko-no-taki　Yamagata Pref.

	滑川大滝　山形県米沢市 —— 58		福島	白糸の滝　福島県猪苗代町 —— 68	
	Namegawa-otaki　Yamagata Pref.			Shiraito-no-taki　Fukushima Pref.	
	芳沢不動滝　山形県米沢市 —— 59			小野川不動滝　福島県北塩原村 —— 69	
	Yoshizawa-fudo-taki　Yamagata Pref.			Onogawa-fudo-daki　Fukushima Pref.	
	赤滝と黒滝　山形県米沢市 —— 60			八幡滝　福島県二本松市 —— 70	
	Aka-taki & Kuro-taki　Yamagata Pref.			Hachiman-taki　Fukushima Pref.	
宮城	不動の滝　宮城県栗原市 —— 62			銚子ヶ滝　福島県郡山市 —— 71	
	Fudo-no-taki　Miyagi Pref.			Choshi-ga-taki　Fukushima Pref.	

滑川大滝　山形県米沢市 ——— 58
Namegawa-otaki　Yamagata Pref.

芳沢不動滝　山形県米沢市 ——— 59
Yoshizawa-fudo-taki　Yamagata Pref.

赤滝と黒滝　山形県米沢市 ——— 60
Aka-taki & Kuro-taki　Yamagata Pref.

宮城

不動の滝　宮城県栗原市 ——— 62
Fudo-no-taki　Miyagi Pref.

鳳鳴四十八滝　宮城県仙台市 ——— 64
Homei-shijuhachi-taki　Miyagi Pref.

秋保大滝　宮城県仙台市 ——— 65
Akiu-otaki　Miyagi Pref.

不動滝　宮城県蔵王町 ——— 66
Fudo-taki　Miyagi Pref.

三階滝　宮城県蔵王町 ——— 67
Sankai-taki　Miyagi Pref.

福島

白糸の滝　福島県猪苗代町 ——— 68
Shiraito-no-taki　Fukushima Pref.

小野川不動滝　福島県北塩原村 ——— 69
Onogawa-fudo-daki　Fukushima Pref.

八幡滝　福島県二本松市 ——— 70
Hachiman-taki　Fukushima Pref.

銚子ヶ滝　福島県郡山市 ——— 71
Choshi-ga-taki　Fukushima Pref.

つむじ倉滝　福島県柳津町 ——— 72
Tsumujikura-taki　Fukushima Pref.

乙字ヶ滝　福島県玉川村 ——— 73
Otsuji-ga-taki　Fukushima Pref.

三条ノ滝　福島県檜枝岐村 ——— 74
Sanjo-no-taki　Fukushima Pref.

関東　Kanto (Around Tokyo) ——— 75

栃木

華厳の滝　栃木県日光市 ——— 75
Kegon-no-taki　Tochigi Pref.

湯滝　栃木県日光市 ——— 79
Yu-daki　Tochigi Pref.

竜頭の滝　栃木県日光市 ——— 80
Ryuzu-no-taki　Tochigi Pref.

蛇王の滝　栃木県日光市 ——— 83
Jao-no-taki　Tochigi Pref.

マックラ滝　栃木県日光市 ——— 84
Makkura-taki　Tochigi Pref.

丁字の滝　栃木県日光市 ——— 85
Choji-no-taki　Tochigi Pref.

裏見の滝　栃木県日光市 ——— 86
Urami-no-taki　Tochigi Pref.

霧降の滝　栃木県日光市 ——— 88
Kirifuri-no-taki　Tochigi Pref.

白滝　栃木県日光市 ——— 89
Shira-taki　Tochigi Pref.

虹見の滝　栃木県日光市 ——— 90
Nijimi-no-taki　Tochigi Pref.

茨城

袋田の滝　茨城県大子町 ——— 92
Fukuroda-no-taki　Ibaraki Pref.

七ツ滝　茨城県北茨城市 ——— 94
Nanatsu-taki　Ibaraki Pref.

群馬

裏見の滝　群馬県みなかみ町 ——— 95
Urami-no-taki　Gunma Pref.

強清水の滝　群馬県沼田市 ——— 96
Kowashimizu-no-taki　Gunma Pref.

小泉の滝　群馬県中之条町 ——— 97
Koizumi-no-taki　Gunma Pref.

吹割の滝　群馬県沼田市 ——— 98
Fukiware-no-taki　Gunma Pref.

大仙の滝　群馬県中之条町 ——— 100
Ozen-no-taki　Gunma Pref.

東京

払沢の滝　東京都檜原村 ——— 101
Hossawa-no-taki　Tokyo Pref.

名古の滝　東京都八丈町 ——— 102
Nago-no-taki　Tokyo Pref.

埼玉

黒山三滝　埼玉県越生町 ——— 103
Kuroyama-san-taki　Saitama Pref.

神奈川

千条の滝　神奈川県箱根町 ——— 104
Chisuji-no-taki　Kanagawa Pref.

洒水の滝　神奈川県山北町 ——— 106
Shasui-no-taki　Kanagawa Pref.

甲信越　Koshinetsu Region (Yamanashi, Nagano & Niigata) ——— 107

山梨

三重の滝　山梨県山梨市 ——— 107
Mie-no-taki　Yamanashi Pref.

七ツ釜五段の滝　山梨県山梨市 ——— 108
Nanatsugama-godan-no-taki　Yamanashi Pref.

大滝　山梨県甲府市 ——— 112
O-taki　Yamanashi Pref.

仙娥滝　山梨県甲府市 ——— 113
Senga-taki　Yamanashi Pref.

精進ヶ滝　山梨県北杜市 ——— 114
Shoji-ga-taki　Yamanashi Pref.

神蛇滝　山梨県北杜市 ——— 115
Jinja-daki　Yamanashi Pref.

	千ヶ滝　山梨県北杜市 ——— 116 Senga-taki　Yamanashi Pref.	千ヶ滝　長野県軽井沢町 ——— 133 Senga-taki　Nagano Pref.
	吐竜の滝　山梨県北杜市 ——— 117 Doryu-no-taki　Yamanashi Pref.	白糸の滝　長野県軽井沢町 ——— 134 Shiraito-no-taki　Nagano Pref.
長野	おしどり隠しの滝　長野県茅野市 ——— 120 Oshidorikakushi-no-taki　Nagano Pref.	米子大瀑布　長野県須坂市 ——— 136 Yonako-dai-bakufu　Nagano Pref.
	王滝　長野県茅野市 ——— 122 O-taki　Nagano Pref.	唐沢の滝　長野県上田市 ——— 138 Karasawa-no-taki　Nagano Pref.
	乙女滝　長野県茅野市 ——— 124 Otome-daki　Nagano Pref.	八滝　長野県高山村 ——— 139 Ya-taki　Nagano Pref.
	乙見滝　長野県茅野市 ——— 125 Otomi-daki　Nagano Pref.	雷滝　長野県高山村 ——— 140 Kaminari-daki　Nagano Pref.
	三本滝　長野県松本市 ——— 126 Sanbon-daki　Nagano Pref.	澗満滝　長野県山ノ内町 ——— 142 Kanman-daki　Nagano Pref.
	善五郎の滝　長野県松本市 ——— 128 Zengoro-no-taki　Nagano Pref.	新潟　苗名滝　新潟県妙高市 ——— 144 Naena-taki　Niigata Pref.
	唐沢の滝　長野県木曽町 ——— 130 Karasawa-no-taki　Nagano Pref.	惣滝　新潟県妙高市 ——— 146 Sou-taki　Niigata Pref.
	こもれびの滝　長野県木曽町 ——— 131 Komorebi-no-taki　Nagano Pref.	蛇淵の滝　新潟県津南町 ——— 148 Jabuchi-no-taki　Niigata Pref.
	不易の滝　長野県木曽町 ——— 132 Fueki-no-taki　Nagano Pref.	

北陸・東海　Hokuriku & Tokai (Central Honshu) ——— 149

富山	称名滝　富山県立山町 ——— 149 Shomyo-daki　Toyama Pref.	白水の滝　岐阜県白川村 ——— 165 Shiramizu-no-taki　Gifu Pref.
	常虹の滝　富山県富山市 ——— 152 Tokoniji-no-taki　Toyama Pref.	宇津江四十八滝　岐阜県高山市 ——— 166 Utsue-shijuhachi-taki　Gifu Pref.
	夫婦滝　富山県南砺市 ——— 154 Meoto-daki　Toyama Pref.	阿弥陀ケ滝　岐阜県郡上市 ——— 168 Amida-ga-taki　Gifu Pref.
	宮島峡一の滝・二の滝　富山県小矢部市 — 155 Miyajimakyo Ichi-no-taki & Ni-no-taki　Toyama Pref.	女男滝　岐阜県高山市 ——— 169 Meoto-daki　Gifu Pref.
石川	垂水の滝　石川県輪島市 ——— 156 Tarumi-no-taki　Ishikawa Pref.	根尾の滝　岐阜県下呂市 ——— 170 Neo-no-taki　Gifu Pref.
	かもしか滝　石川県白山市 ——— 157 Kamoshika-taki　Ishikawa Pref.	五宝滝　岐阜県八百津町 ——— 171 Goho-daki　Gifu Pref.
	姥ヶ滝　石川県白山市 ——— 158 Uba-ga-taki　Ishikawa Pref.	養老の滝　岐阜県養老町 ——— 172 Yoro-no-taki　Gifu Pref.
	ふくべの大滝　石川県白山市 ——— 159 Fukube-no-otaki　Ishikawa Pref.	静岡　浄蓮の滝　静岡県伊豆市 ——— 173 Joren-no-taki　Shizuoka Pref.
福井	一乗滝　福井県福井市 ——— 160 Ichijo-daki　Fukui Pref.	二階滝　静岡県河津町 ——— 174 Nikai-daru　Shizuoka Pref.
	龍双ヶ滝　福井県池田町 ——— 161 Ryuso-ga-taki　Fukui Pref.	河津七滝　静岡県河津町 ——— 175 Kawazu-nana-daru　Shizuoka Pref.
岐阜	平湯大滝　岐阜県高山市 ——— 162 Hirayu-otaki　Gifu Pref.	対島の滝　静岡県伊東市 ——— 177 Tajima-no-taki　Shizuoka Pref.
	百間滝　岐阜県高山市 ——— 164 Hyakken-daki　Gifu Pref.	白糸の滝　静岡県富士宮市 ——— 178 Shiraito-no-taki　Shizuoka Pref.

	陣馬の滝　静岡県富士宮市 ——— 180		七ツ釜滝　三重県大台町 ——— 187
	Jinba-no-taki　Shizuoka Pref.		Nanatsugama-daki　Mie Pref.
	音止の滝　静岡県富士宮市 ——— 182		光滝　三重県大台町 ——— 188
	Otodome-no-taki　Shizuoka Pref.		Hikari-daki　Mie Pref.
愛知	阿寺の七滝　愛知県新城市 ——— 183		荒滝　三重県熊野市 ——— 189
	Atera-no-nanataki　Aichi Pref.		Ara-taki　Mie Pref.
三重	赤目四十八滝　三重県名張市 ——— 184		布引の滝　三重県熊野市 ——— 190
	Akame-shijuhachi-taki　Mie Pref.		Nunobiki-no-taki　Mie Pref.

近畿　Kinki (Around Osaka) ——— 191

	那智の滝　和歌山県那智勝浦町 ——— 191		御船の滝　奈良県川上村 ——— 207
和歌山	Nachi-no-taki　Wakayama Pref.		Mifune-no-taki　Nara Pref.
	滝の拝　和歌山県古座川町 ——— 195		みたらいの滝　奈良県天川村 ——— 208
	Taki-no-hai　Wakayama Pref.		Mitarai-no-taki　Nara Pref.
	雫の滝　和歌山県すさみ町 ——— 196	滋賀	八ツ淵の滝　滋賀県高島市 ——— 209
	Shizuku-no-taki　Wakayama Pref.		Yatsubuchi-no-taki　Shiga Pref.
	八草の滝　和歌山県白浜町 ——— 197	大阪	箕面大滝　大阪府箕面市 ——— 210
	Haso-no-taki　Wakayama Pref.		Mino-otaki　Osaka Pref.
	桑ノ木の滝　和歌山県新宮市 ——— 198	京都	金引の滝　京都府宮津市 ——— 212
	Kuwanoki-no-taki　Wakayama Pref.		Kanabiki-no-taki　Kyoto Pref.
	鼻白の滝　和歌山県新宮市 ——— 200	兵庫	布引の滝　兵庫県神戸市 ——— 213
	Hanajiro-no-taki　Wakayama Pref.		Nunobiki-no-taki　Hyogo Pref.
	高野大滝　和歌山県高野町 ——— 201		天滝　兵庫県養父市 ——— 214
	Koya-otaki　Wakayama Pref.		Ten-daki　Hyogo Pref.
奈良	十二滝　奈良県十津川村 ——— 202		猿尾滝　兵庫県香美町 ——— 216
	Juni-taki　Nara Pref.		Saruo-daki　Hyogo Pref.
	笹の滝　奈良県十津川村 ——— 204		二段滝　兵庫県豊岡市 ——— 217
	Sasa-no-taki　Nara Pref.		Nidan-taki　Hyogo Pref.
	中ノ滝　奈良県上北山村 ——— 205		原不動滝　兵庫県宍粟市 ——— 218
	Naka-no-taki　Nara Pref.		Hara-fudo-taki　Hyogo Pref.
	不動七重の滝　奈良県下北山村 ——— 206		
	Fudonanae-no-taki　Nara Pref.		

中国・四国　Chugoku (Western Honshu) & Shikoku ——— 219

	神庭の滝　岡山県真庭市 ——— 219		壇鏡の滝　島根県隠岐の島町 ——— 232
岡山	Kanba-no-taki　Okayama Pref.		Dangyo-no-taki　Shimane Pref.
	絹掛の滝　岡山県新見市 ——— 221	山口	犬戻の滝　山口県岩国市 ——— 233
	Kinukake-no-taki　Okayama Pref.		Inumodoshi-no-taki　Yamaguchi Pref.
鳥取	雨滝　鳥取県鳥取市 ——— 222		鼓の滝　山口県山口市 ——— 234
	Ame-daki　Tottori Pref.		Tsuzumi-no-taki　Yamaguchi Pref.
広島	三段滝　広島県安芸太田町 ——— 223	徳島	雨乞の滝　徳島県神山町 ——— 236
	Sandan-daki　Hiroshima Pref.		Amagoi-no-taki　Tokushima Pref.
	常清滝　広島県三次市 ——— 226		大釜の滝　徳島県那賀町 ——— 237
	Josei-daki　Hiroshima Pref.		Ogama-no-taki　Tokushima Pref.
島根	八重滝　島根県雲南市 ——— 229		轟九十九滝　徳島県海陽町 ——— 238
	Yae-daki　Shimane Pref.		Todoroki-kujuku-taki　Tokushima Pref.
	龍頭が滝　島根県雲南市 ——— 230		大轟の滝　徳島県那賀町 ——— 240
	Ryuzu-ga-taki　Shimane Pref.		Otodoro-no-taki　Tokushima Pref.

| 高知 | 龍王の滝　高知県大豊町 ——— 241
Ryuo-no-taki　Kochi Pref. | 愛媛 | 御来光の滝　愛媛県久万高原町 ——— 243
Goraiko-no-taki　Ehime Pref. |
| | 大樽の滝　高知県越知町 ——— 242
Odaru-no-taki　Kochi Pref. | | 雪輪の滝　愛媛県宇和島市 ——— 244
Yukiwa-no-taki　Ehime Pref. |

九州・沖縄　Kyushu & Okinawa ——————————— 245

佐賀	見帰りの滝　佐賀県唐津市 ——— 245 Mikaeri-no-taki　Saga Pref.		鵜の子滝　熊本県山都町 ——— 271 Unoko-daki　Kumamoto Pref.
	轟の滝　佐賀県嬉野市 ——— 247 Todoroki-no-taki　Saga Pref.	宮崎	真名井の滝　宮崎県高千穂町 ——— 272 Manai-no-taki　Miyazaki Pref.
	観音の滝　佐賀県唐津市 ——— 248 Kannon-no-taki　Saga Pref.		白滝　宮崎県五ヶ瀬町 ——— 274 Shira-taki　Miyazaki Pref.
長崎	鮎帰りの滝　長崎県南島原市 ——— 250 Ayugaeri-no-taki　Nagasaki Pref.		矢研の滝　宮崎県都農町 ——— 275 Yatogi-no-taki　Miyazaki Pref.
大分	東椎屋の滝　大分県宇佐市 ——— 251 Higashishiiya-no-taki　Oita Pref.		白滝　宮崎県都農町 ——— 276 Shira-taki　Miyazaki Pref.
	西椎屋の滝　大分県玖珠町 ——— 252 Nishishiiya-no-taki　Oita Pref.		関之尾滝　宮崎県都城市 ——— 277 Sekinoo-no-taki　Miyazaki Pref.
	慈恩の滝　大分県玖珠町 ——— 253 Jion-no-taki　Oita Pref.		五重の滝　宮崎県日南市 ——— 278 Goju-no-taki　Miyazaki Pref.
	七折れの滝　大分県九重町 ——— 254 Nanaore-no-taki　Oita Pref.	鹿児島	曽木の滝　鹿児島県伊佐市 ——— 279 Sogi-no-taki　Kagoshima Pref.
	震動の滝　大分県九重町 ——— 255 Shindo-no-taki　Oita Pref.		湯之尾滝　鹿児島県伊佐市 ——— 280 Yunoo-daki　Kagoshima Pref.
	原尻の滝　大分県豊後大野市 ——— 256 Harajiri-no-taki　Oita Pref.		丸尾滝　鹿児島県霧島市 ——— 282 Maruo-no-taki　Kagoshima Pref.
	名水の滝　大分県由布市 ——— 258 Meisui-no-taki　Oita Pref.		龍門滝　鹿児島県姶良市 ——— 283 Ryumon-daki　Kagoshima Pref.
熊本	鍋ヶ滝　熊本県小国町 ——— 259 Nabe-ga-taki　Kumamoto Pref.		大川の滝　鹿児島県屋久島町 ——— 284 Oko-no-taki　Kagoshima Pref.
	夫婦滝　熊本県南小国町 ——— 262 Meoto-daki　Kumamoto Pref.		千尋の滝　鹿児島県屋久島町 ——— 286 Senpiro-no-taki　Kagoshima Pref.
	四十三万滝　熊本県菊池市 ——— 264 Yonjusanman-taki　Kumamoto Pref.	沖縄	比地大滝　沖縄県国頭村 ——— 288 Hiji-otaki　Okinawa Pref.
	鹿目の滝　熊本県人吉市 ——— 265 Kaname-no-taki　Kumamoto Pref.		マリユドゥの滝　沖縄県竹富町 ——— 289 Mariyudu-no-taki　Okinawa Pref.
	古閑の滝　熊本県阿蘇市 ——— 266 Koga-no-taki　Kumamoto Pref.		カンピレーの滝　沖縄県竹富町 ——— 292 Kanpire-no-taki　Okinawa Pref.
	数鹿流ヶ滝　熊本県南阿蘇村 ——— 268 Sugaru-ga-taki　Kumamoto Pref.		ピナイサーラの滝　沖縄県竹富町 ——— 293 Pinaisara-no-taki　Okinawa Pref.
	五老ヶ滝　熊本県山都町 ——— 270 Goro-ga-taki　Kumamoto Pref.		

滝の形態 ————————————————————————————— 296

あとがき ————————————————————————————— 297

MAP ————————————————————————————— 298

日本の滝 100 選リスト　※数字は掲載頁

オシンコシンの滝／北海道斜里町　Oshinkoshin-no-taki	14	
羽衣の滝／北海道東川町　Hagoromo-no-taki	16	
銀河・流星の滝／北海道上川町　Ginga-no-taki & Ryusei-no-taki	18	
アシリベツの滝／北海道札幌市　Ashiribetsu-no-taki	23	
インクラの滝／北海道白老町　Inkura-no-taki	24	
賀老の滝／北海道島牧村　Garo-no-taki	26	
くろくまの滝／青森県鰺ヶ沢町　Kurokuma-no-taki	27	
松見の滝／青森県十和田市　Matsumi-no-taki	32	
不動の滝／岩手県八幡平市　Fudo-no-taki	35	
七滝／秋田県小坂町　Nana-taki	38	
茶釜の滝／秋田県鹿角市　Chagama-no-taki		
安の滝／秋田県北秋田市　Yasu-no-taki	42	
法体の滝／秋田県由利本荘市　Hottai-no-taki	46	
白糸の滝／山形県戸沢村　Shiraito-no-taki	52	
七ツ滝／山形県鶴岡市　Nanatsu-daki	56	
滑川大滝／山形県米沢市　Namegawa-otaki	58	
秋保大滝／宮城県仙台市　Akiu-otaki	65	
三階滝／宮城県蔵王町　Sankai-taki	67	
銚子ヶ滝／福島県郡山市　Choshi-ga-taki	71	
乙字ヶ滝／福島県玉川村　Otsuji-ga-taki	73	
三条ノ滝／福島県檜枝岐村　Sanjo-no-taki	74	
華厳の滝／栃木県日光市　Kegon-no-taki	75	
霧降の滝／栃木県日光市　Kirifuri-no-taki	88	
袋田の滝／茨城県大子町　Fukuroda-no-taki	92	
吹割の滝／群馬県沼田市　Fukiware-no-taki	98	
棚下不動滝／群馬県渋川市　Tanashitafudo-no-taki		
常布の滝／群馬県草津町　Jofu-no-taki		
払沢の滝／東京都檜原村　Hossawa-no-taki	101	
丸神の滝／埼玉県小鹿野町　Marugami-no-taki		
洒水の滝／神奈川県山北町　Shasui-no-taki	106	
早戸大滝／神奈川県相模原市　Hayato-otaki		
七ツ釜五段の滝／山梨県山梨市　Nanatsugama-godan-no-taki	108	
仙娥滝／山梨県甲府市　Senga-taki	113	
精進ヶ滝／山梨県北杜市　Shoji-ga-taki	114	
三本滝／長野県松本市　Sanbon-daki	126	
田立の滝／長野県南木曽町　Tadachi-no-taki		
米子大瀑布／長野県須坂市　Yonako-dai-bakufu	136	
苗名滝／新潟県妙高市　Naena-taki	144	
惣滝／新潟県妙高市　Sou-taki	146	
鈴ヶ滝／新潟県村上市　Suzu-ga-taki		
称名滝／富山県立山町　Shomyo-daki	149	
姥ヶ滝／石川県白山市　Uba-ga-taki	158	
龍双ヶ滝／福井県池田町　Ryuso-ga-taki	161	
平湯大滝／岐阜県高山市　Hirayu-otaki	162	
阿弥陀ヶ滝／岐阜県郡上市　Amida-ga-taki	168	
根尾の滝／岐阜県下呂市　Neo-no-taki	170	
養老の滝／岐阜県養老町　Yoro-no-taki	172	
浄蓮の滝／静岡県伊豆市　Joren-no-taki	173	
白糸の滝／静岡県富士宮市　Shiraito-no-taki	178	
音止の滝／静岡県富士宮市　Otodome-no-taki	182	
安倍の大滝／静岡県静岡市　Abe-no-otaki		

阿寺の七滝／愛知県新城市　Atera-no-nanataki	183	
赤目四十八滝／三重県名張市　Akame-shijuhachi-taki	184	
七ツ釜滝／三重県大台町　Nanatsugama-daki	187	
布引の滝／三重県熊野市　Nunobiki-no-taki	190	
那智の滝／和歌山県那智勝浦町　Nachi-no-taki	191	
八草の滝／和歌山県白浜町　Haso-no-taki	197	
桑ノ木の滝／和歌山県新宮市　Kuwanoki-no-taki	198	
笹の滝／奈良県十津川村　Sasa-no-taki	204	
中ノ滝／奈良県上北山村　Naka-no-taki	205	
不動七重の滝／奈良県下北山村　Fudonanae-no-taki	206	
双門の滝／奈良県天川村　Somon-no-taki		
八ツ淵の滝／滋賀県高島市　Yatsubuchi-no-taki	209	
箕面大滝／大阪府箕面市　Mino-otaki	210	
金引の滝／京都府宮津市　Kanabiki-no-taki	212	
布引の滝／兵庫県神戸市　Nunobiki-no-taki	213	
天滝／兵庫県養父市　Ten-daki	214	
猿尾滝／兵庫県香美町　Saruo-daki	216	
原不動滝／兵庫県宍粟市　Hara-fudo-taki	218	
神庭の滝／岡山県真庭市　Kanba-no-taki	219	
雨滝／鳥取県鳥取市　Ame-daki	222	
大山滝／鳥取県琴浦町　Daisen-daki		
常清滝／広島県三次市　Josei-daki	226	
八重滝／島根県雲南市　Yae-daki	229	
龍頭が滝／島根県雲南市　Ryuzu-ga-taki	230	
壇鏡の滝／島根県隠岐の島町　Dangyo-no-taki	232	
寂地峡五竜の滝／山口県岩国市　Jakuchikyogoryu-no-taki		
雨乞の滝／徳島県神山町　Amagoi-no-taki	236	
大釜の滝／徳島県那賀町　Ogama-no-taki	237	
轟九十九滝／徳島県海陽町　Todoroki-kujuku-taki	238	
龍王の滝／高知県大豊町　Ryuo-no-taki	241	
大樽の滝／高知県越知町　Odaru-no-taki	242	
轟の滝／高知県香美市　Todoro-no-taki		
御来光の滝／愛媛県久万高原町　Goraiko-no-taki	243	
雪輪の滝／愛媛県宇和島市　Yukiwa-no-taki	244	
見帰りの滝／佐賀県唐津市　Mikaeri-no-taki	245	
観音の滝／佐賀県唐津市　Kannon-no-taki	248	
東椎屋の滝／大分県宇佐市　Higashishiiya-no-taki	251	
西椎屋の滝／大分県玖珠町　Nishishiiya-no-taki	252	
震動の滝／大分県九重町　Shindo-no-taki	255	
原尻の滝／大分県豊後大野市　Harajiri-no-taki	256	
四十三万滝／熊本県菊池市　Yonjusanman-taki	264	
鹿目の滝／熊本県人吉市　Kaname-no-taki	265	
数鹿流ヶ滝／熊本県南阿蘇村　Sugaru-ga-taki	268	
栴檀轟の滝／熊本県矢代市　Sendantodoro-no-taki		
真名井の滝／宮崎県高千穂町　Manai-no-taki	272	
矢研の滝／宮崎県都農町　Yatogi-no-taki	275	
関之尾滝／宮崎県都城市　Sekinoo-no-taki	277	
むかばきの滝／宮崎県延岡市　Mukabaki-no-taki		
龍門滝／鹿児島県姶良市　Ryumon-daki	283	
大川の滝／鹿児島県屋久島町　Oko-no-taki	284	
マリユドゥの滝／沖縄県竹富町　Mariyudu-no-taki	289	

・日本の滝 100 選は 1991 年に日本の滝選考会（緑の文明学会・グリーンネッサンス・緑の地球防衛基金）が環境庁、林野庁の後援
　のもと選定したものである。
・リストの滝名に関しては、本書掲載の滝は本文で掲載した滝名を記載し、それ以外の滝は選定名に準じた。

Landscapes of the Japanese Heart
Waterfalls in Japan

First Edition July 2018
by Mitsumura Suiko Shoin Publishing Co., Ltd.
217-2 Hashiura-cho Horikawa Sanjo Nakagyo-ku,
Kyoto 604-8257 Japan

Author: MORITA Toshitaka
　　　　MIYAMOTO Takahiro

Designer: INAMOTO Masatoshi
Printing director: TODA Shigeo
Printing program director: KAWAKAMI Koji
Translator: EMI Ikuko
Editor: OHNISHI Ritsuko & TAKAHASHI Azusa
Publisher: GODA Yusaku

All rights reserved. No part of this publication may be reproduced or used in any form or by any means, graphic, electronic, or mechanical, including photocopying, recording, taping, or information storage and retrieval systems, without written permission of the publisher.

© 2018 MORITA Toshitaka, MO Photos　Printed in Japan
ISBN978-4-8381-0577-9 C0026

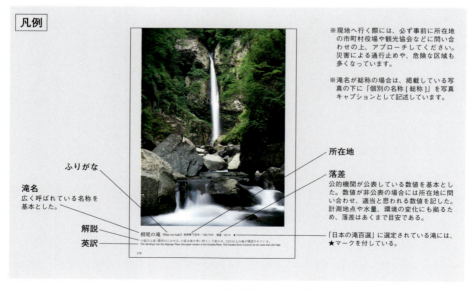

※写真撮影当時と現状が異なる場合もあります。ご了承ください。

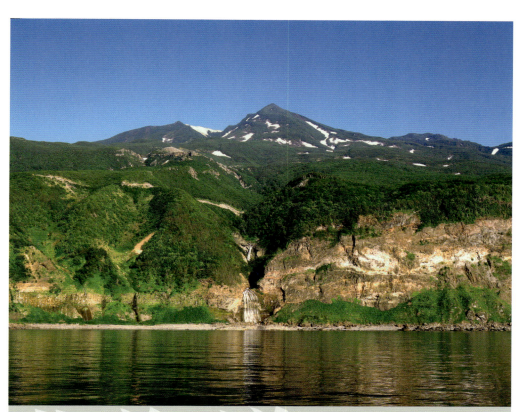

北海道 Hokkaido

カムイワッカの滝〈Kamuiwakka-no-taki〉北海道斜里町／Hokkaido Pref.　落差：32m

カムイワッカ川がオホーツク海へと流れる滝。陸上からはアクセスできないが、観光船に乗り海上から見ることができる。
This fall is situated at the mouth of the Kamuiwakka River facing the Okhotsk Sea. It is inaccessible by land; however, tourists can enjoy the view from sightseeing boats.

湯の華の滝 〈Yunohana-no-taki〉 北海道斜里町／Hokkaido Pref.　落差：推定 50m

知床半島にあり、断崖から沁みだした地下水がオホーツク海へと注ぐ滝。陸路はヒグマの生息地のため、観光船で海から見るのがおすすめ。

This fall is located in the Shiretoko Peninsula. It is a kind of spring waterfall that emerges from the cliffs and flows into the Okhotsk Sea. Since the area provides a habitat for brown bears, it is recommended to see it from sightseeing boats.

フレペの滝 〈Furepe-no-taki〉 北海道斜里町／Hokkaido Pref.　落差：80 m

別名「乙女の涙」。知床半島の断崖から沁みだした水がオホーツク海へと注ぐ。知床自然センターから徒歩20分。
Also known as "Otome-no-namida" (Maiden's tears). Like Kamuiwakka-no-taki, this fall also flows directly into the Okhotsk Sea from the sea-battered cliffs of the Shiretoko Peninsula. It is 20 minutes' walk from Shiretoko Natural Park Nature Center.

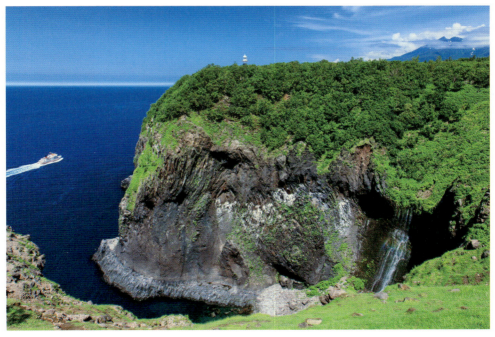

オシンコシンの滝 〈Oshinkoshin-no-taki〉 北海道斜里町／Hokkaido Pref.　落差：30 m　★
二手に広がって流れることから「双美の滝」とも呼ばれる。チャラッセナイ川にかかる。

This waterfall splits into two in midstream and drops into the Charassenai River. Also called "Sobi-no-taki"(Two wings of beauty).

羽衣の滝 〈Hagoromo-no-taki〉 北海道東川町／Hokkaido Pref. 落差：270 m ★

アイシホップ沢川と双見沢川が合流し、流れ落ちる。滝名は詩人で随筆家の大町桂月により、名付けられた。
The Aishihoppusawa River and the Futamisawa River join together and dynamically fall down a cliff. Named "Hagoromo-no-taki" by the poet and essayist, OMACHI Keigetsu, in the Taisho-era (1912-1926).

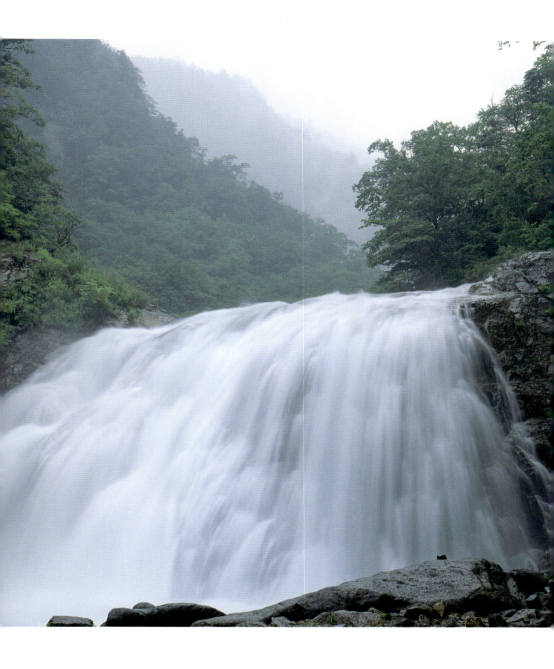

敷島の滝 〈Shikishima-no-taki〉 北海道東川町／Hokkaido Pref. 落差：20m
忠別川が川幅いっぱいにわたり流れ落ちる。「北海道のナイアガラ」とも呼ばれる。
This fall drops over the width of the Chubetsu River. Also known as "Niagara falls in Hokkaido".

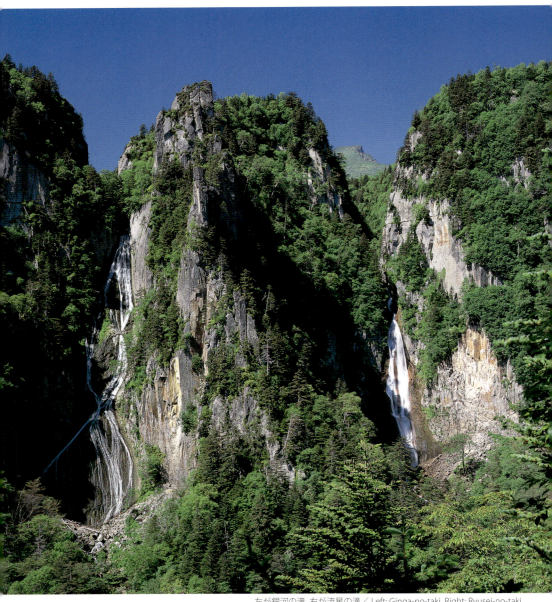

左が銀河の滝、右が流星の滝／ Left: Ginga-no-taki, Right: Ryusei-no-taki

銀河・流星の滝 〈Ginga-no-taki & Ryusei-no-taki〉 北海道上川町／ Hokkaido Pref.
落差：銀河の滝 118 m　流星の滝 74 m　★

石狩川上流にかかる。絶壁・不動岩をはさんで流れる二つの滝は、別名「女滝・男滝」とも呼ばれ、層雲峡の滝を代表する景観を生み出している。
Two falls are located on the upper stream of the Ishikari River. The "Fudo-iwa" cliff stands between the falls and they are also known as "Me-daki & O-daki" (Woman fall & Man fall). This view is the hallmark of the Soun Valley waterfall scenery.

白金不動の滝 〈Shirogane-fudo-no-taki〉　北海道美瑛町／Hokkaido Pref.　落差：25 m

白金温泉の近くにある。美瑛川支流にかかる滝。階段状に降りる滝で、あたりの渓流美もすばらしい。
This fall is situated near Shirogane-onsen hot springs. It is a stepped cascade dropping into a branch of the Biei River. The mountain stream view around the fall is also spectacular.

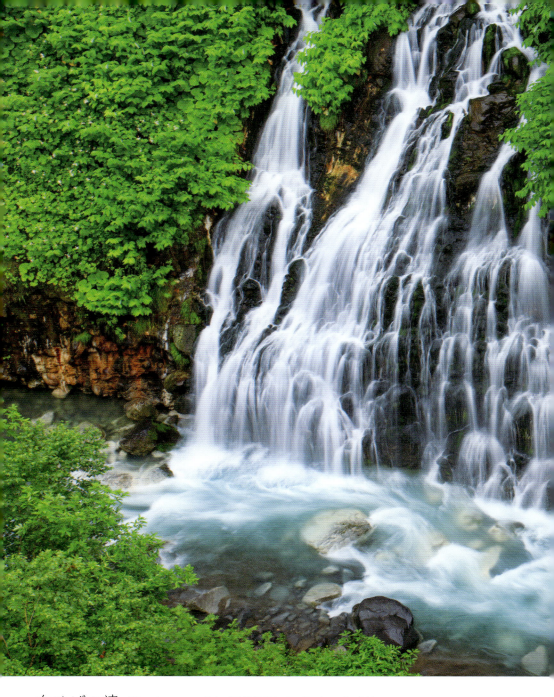

白ひげの滝 〈Shirahige-no-taki〉 北海道美瑛町／Hokkaido Pref. 落差：30 m
美瑛川上流、白金温泉街にある滝。岩の間から沁みでた地下水が美瑛川に注ぐ。美瑛川の鮮やかなブルーは温泉成分によるもの。

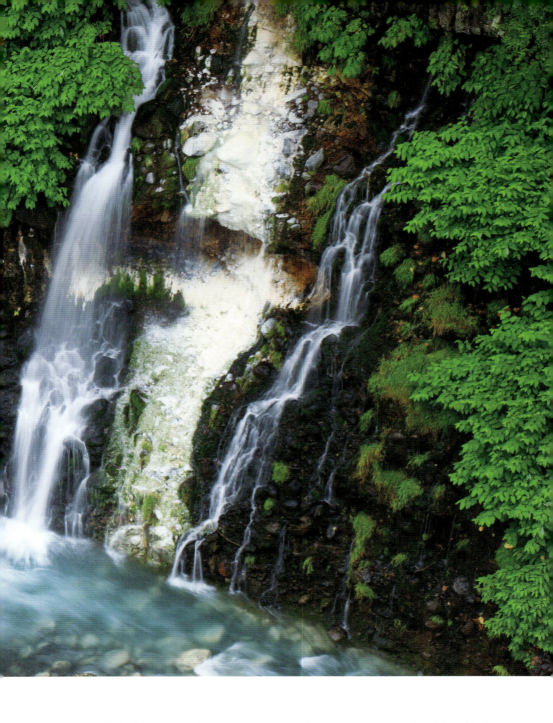

This fall is located in the Shirogane-onsen hot springs area. The ground water emerges among rocks and drops into the upper stream of the Biei River. Its vivid blue color comes from the hot spring ingredients.

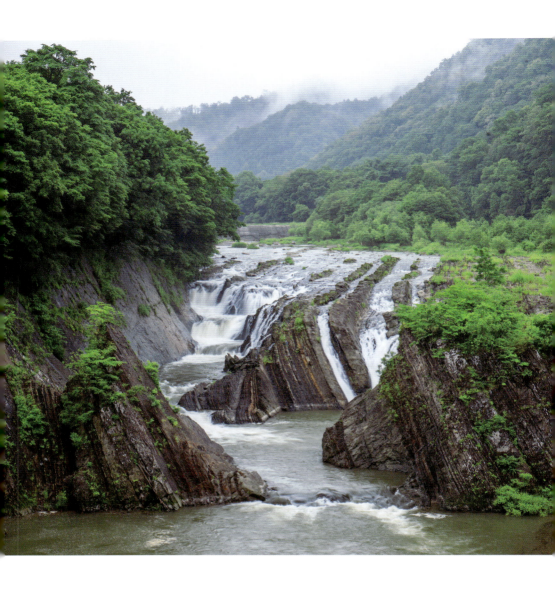

千鳥ヶ滝 〈Chidori-ga-taki〉 北海道夕張市／Hokkaido Pref.　落差：推定 10 m

滝の上公園にある、夕張川にかかる滝。この公園のあたりはアイヌ語で「ポンソウカムイコタン（北方の神の住まうところ）」と呼ばれ、荘厳な景観が広がる。
This fall is located in Taki-no-ue koen Park and drops into the Yubari River. The area is called "Ponsokamuikotan" (The field in which the northern gods live) in the Ainu language and offers magnificent views.

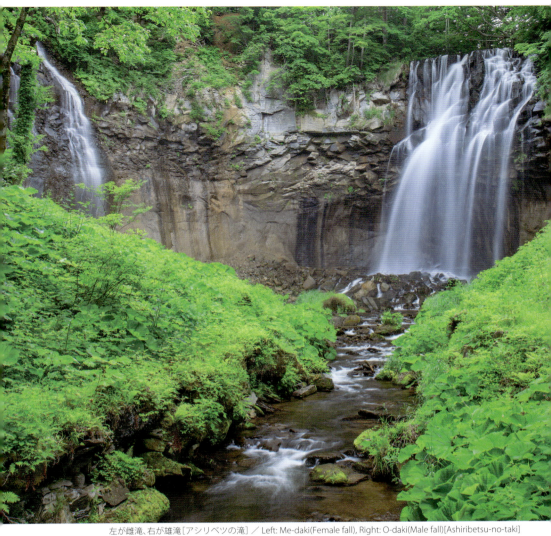

左が雌滝、右が雄滝［アシリベツの滝］／ Left: Me-daki(Female fall), Right: O-daki(Male fall)[Ashiribetsu-no-taki]

アシリベツの滝 〈Ashiribetsu-no-taki〉 北海道札幌市／ Hokkaido Pref.　落差：26 m　★

厚別川本流にかかり、滝野すずらん丘陵公園の渓流ゾーンに位置する。豊かな水量で流れ落ちる姿はもちろんのこと、冬季の氷瀑は圧巻。
This fall is located in the mountain stream zone of Takino-suzuran-kyuryo-koen Park and drops into the Atsubetsu River. It is swollen with a large volume of water from spring to autumn, and the icefall view in winter is awesome.

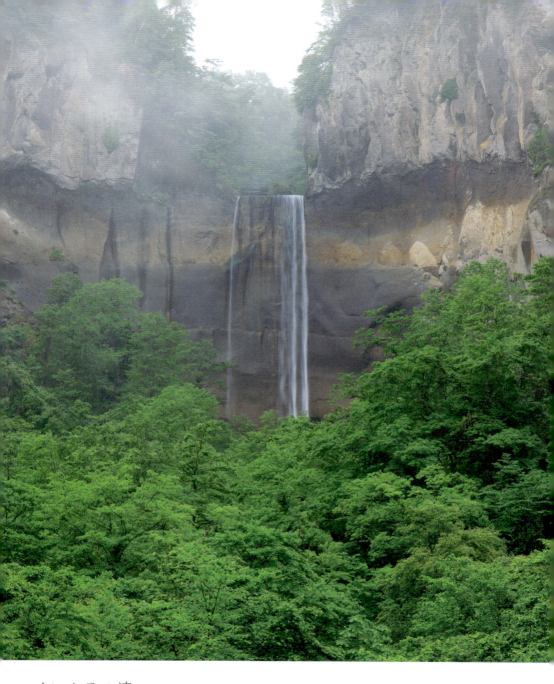

インクラの滝 〈Inkura-no-taki〉 北海道白老町／Hokkaido Pref. 落差：44 m ★

別々川の支流・西別々川にかかる滝。滝の名は木材の運搬に使われた「インクライン」に由来するという。
Since this fall drops into a branch of the Betsubetsu River, it is also called "Betsubetsu-gawa-no taki". The name, "Inkura", originates from the incline track, which was previously used for transporting wood.

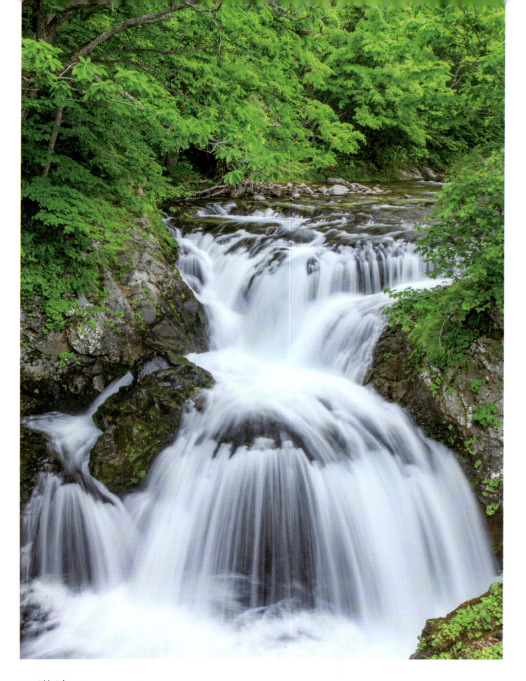

三階滝 〈Sangai-taki〉 北海道伊達市／Hokkaido Pref.　落差：14 m

三階滝公園にある。長流川支流・三階滝川にかかる段瀑。
This is a three-step fall located in Sangai-taki koen Park, and it descends into the Sangai-taki River, a branch of the Osaru River.

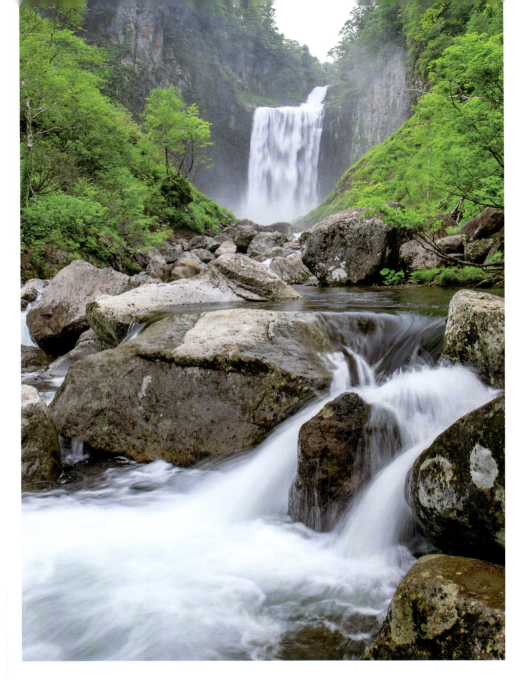

賀老の滝 〈Garo-no-taki〉 北海道島牧村／Hokkaido Pref.　落差：70 m　★

千走川上流にかかる水量豊かな滝。松前藩の財宝を龍が守っているという伝説も持つ滝。
Dropping into the upper stream of the Chihase River and having plenty of water. Legend has it that the dragon of the fall protects its treasures.

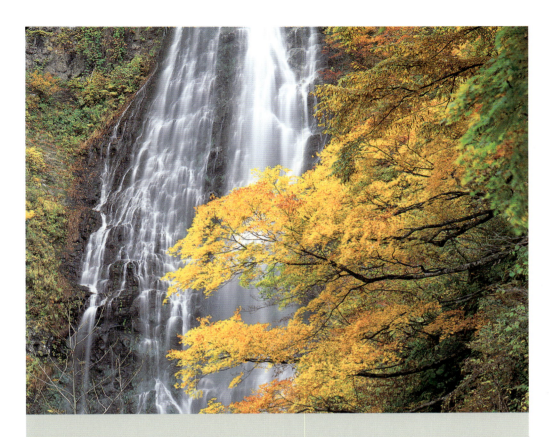

Tohoku (Northern Honshu) 東北

くろくまの滝 〈Kurokuma-no-taki〉 青森県鰺ヶ沢町／Aomori Pref.　落差：85 m　★

赤石川の支流「滝ノ沢」にかかる。原生林の奥深く、県内最大級の落差を誇り、流れ落ちる名瀑。
This fall drops into the Taki-no-sawa, a branch of the Akaishi River, and it is the highest waterfall in Aomori pref. It is surrounded by deep primeval forests and offers incredible views.

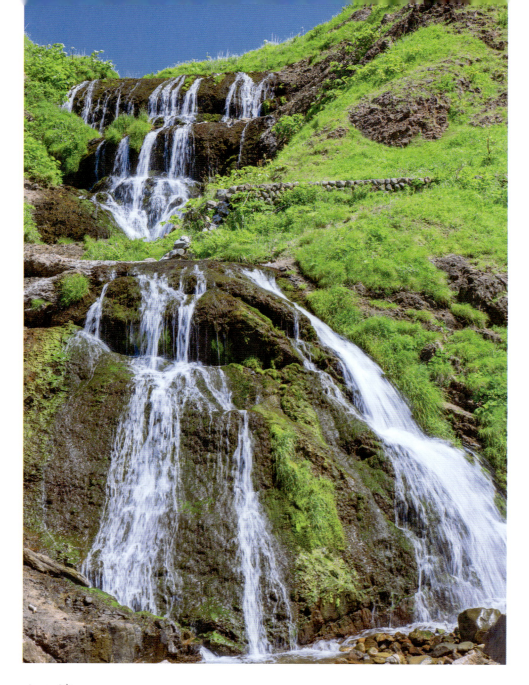

七ツ滝 〈Nanatsu-daki〉　青森県中泊町／ Aomori Pref.　落差：21 m

津軽半島の小泊〜龍飛崎をつなぐ国道339号(通称竜泊ライン)沿いにある。滝名は七段の岩肌を流れることに由来する。
This fall is located beside Route 339, which links Kodomari of the Tsugaru Peninsula and the Cape Tappi. The name "Nanatsu" means Seven and it has seven rock steps.

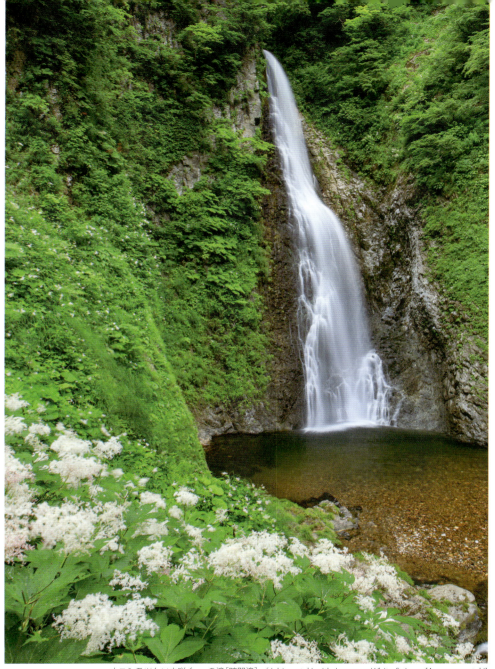

オニシモツケソウ咲く、一の滝［暗門滝］／ Ichi-no-taki with Japanese White Spiraea [Anmon-no-taki]

暗門の滝 〈Anmon-no-taki〉 青森県西目屋村／ Aomori Pref.　落差：一の滝 42 m　二の滝 37 m　三の滝 26 m

暗門川の源流部にかかり、上から「一の滝」「二の滝」「三の滝」。滝に至る「暗門渓谷ルート」は上級者向け。
Consisting of three waterfalls, "Ichi-no-taki", "Ni-no-taki", and "San-no-taki", and they drop into the headstream of the Anmon River. The trail to the falls, "Anmon-keikoku route" is steep and recommended only for experienced walkers.

29

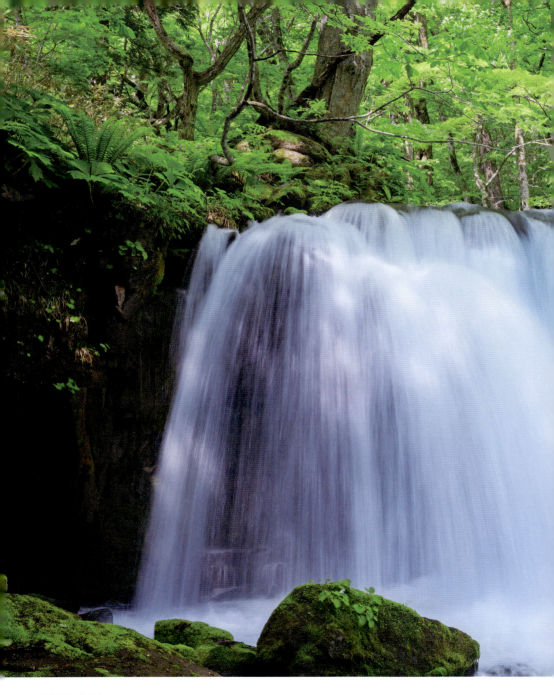

銚子大滝〈Choshi-otaki〉青森県十和田市／Aomori Pref. 落差：7m

奥入瀬川本流にかかる唯一の滝。十和田湖への魚の遡上を妨げるため、「魚止の滝」とも呼ばれる。幅が20mあり、轟音とともに水が流れる様は圧巻。

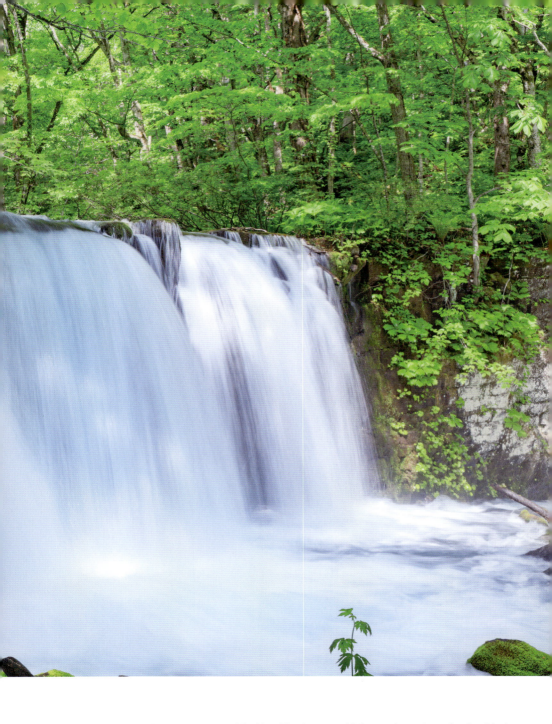

This is the only fall which drops into the main stream of the Oirase River. It prevents fish from moving upstream; therefore, it is also called "Uodome-no-taki" (Stopping fish fall). It is 20m wide and has much water descending, so it looks dynamic.

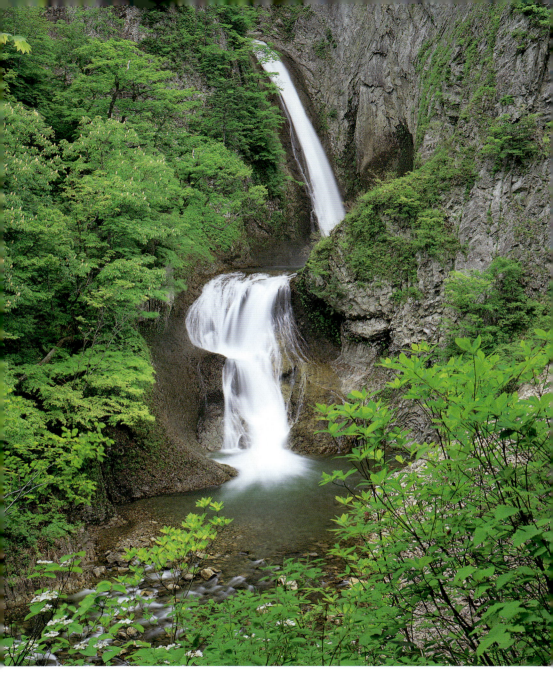

松見の滝 〈Matsumi-no-taki〉 青森県十和田市／Aomori Pref.　落差：90 m　★

奥入瀬川の支流・黄瀬川上流にかかる雄大な滝。滝名は滝の上方にある松に由来する。
This is a superb fall dropping into the upper stream of the Ose River, a branch of the Oirase River. The name "Matsumi" (Looking at pine trees) comes from the pine trees at the top of the fall.

雲井の滝 〈Kumoi-no-taki〉 青森県十和田市／ Aomori Pref.　落差：20 m

奥入瀬川の支流・養老沢にかかる滝。奥入瀬渓流沿いにはこの他にも滝が点在している。
This fall drops into the Yoro-sawa, a branch of Oirase River. Along the river, there are many waterfalls and this area is known as "Bakufu-kaido" (Great waterfalls route).

みろくの滝〈Miroku-no-taki〉青森県田子町／Aomori Pref. 落差：30 m

熊原川源流部にかかる。別名「ソーメンの滝」。弥勒菩薩の信仰を説く修行者の念が通じたのか大滝がかかり、凶作に苦しむ村を救ったという伝説を持つ。
This fall drops into the headstream of the Kumahara River. It is also known as "Somen-no-taki" (Somen noodle fall). Legend has it that a priest prayed to Miroku-bosatsu and then the big waterfall appeared, saving people from a poor harvest.

不動の滝 〈Fudo-no-taki〉 岩手県八幡平市／Iwate Pref.　落差：15 m　★

滝の手前にある桜松神社は、延享元年(1744)の棟札も残る歴史ある神社で、この滝も古くからの不動信仰を集めてきたことを物語っている。
Sakuramatsu-jinja Shrine, located at the entrance to this fall, has a munafuda (tag affixed to the inside of the buildings) dated 1744. This fall has also been worshiped by people since the old times.

鳥越の滝 〈Torigoe-no-taki〉 岩手県雫石町／ Iwate Pref.　落差：30 m

葛根田川上流部にかかる。滝の上部には秘湯・滝ノ上温泉があり、滝の周囲の岩間からも温泉の湯気が噴き出す。
This fall drops into the Kakkonda River. At the top of the fall, Taki-no-ue-onsen hot springs are there, and also around the fall there are many vapors from hot springs.

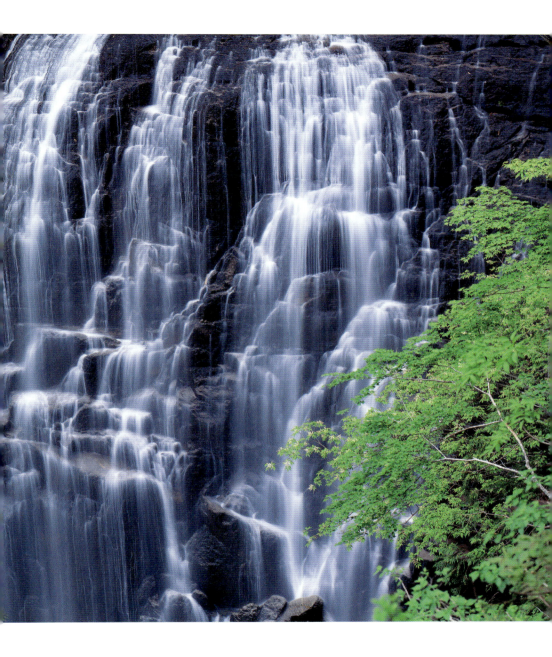

幸兵衛滝 〈Kobe-taki〉 秋田県北秋田市／Akita Pref. 落差：108 m

立又渓谷にかかる。この渓谷にはこの他に一ノ滝、二ノ滝がかかるが、幸兵衛滝は最大の落差を誇る。
This fall drops into the Tatemata Valley and it is the highest among the falls of the valley, such as Ichi-no-taki and Ni-no-taki.

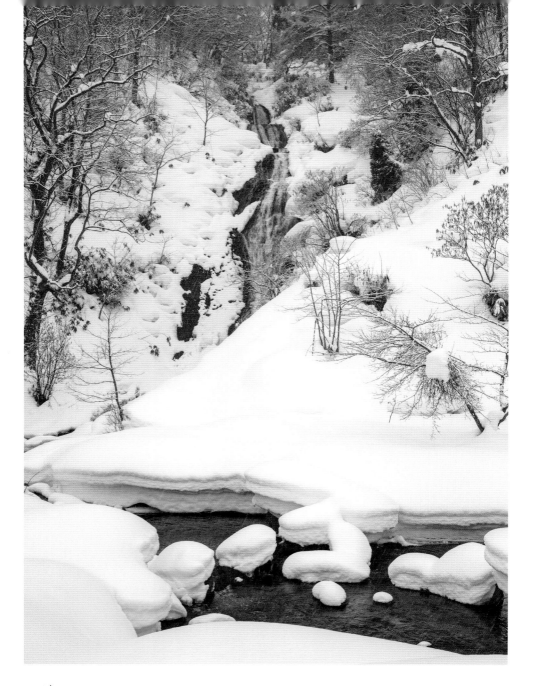

七滝 〈Nana-taki〉 秋田県小坂町／Akita Pref. 落差：60 m ★

7つの段をなして流れる。この滝は大蛇の化身であるという伝説が伝わり、近くの七滝神社は古くから信仰を集めている。
The water descends in seven steps. Legend has it that a dragon was incarnated as this fall and Nanataki-jinjya Shrine near this fall has been worshiped since the old times.

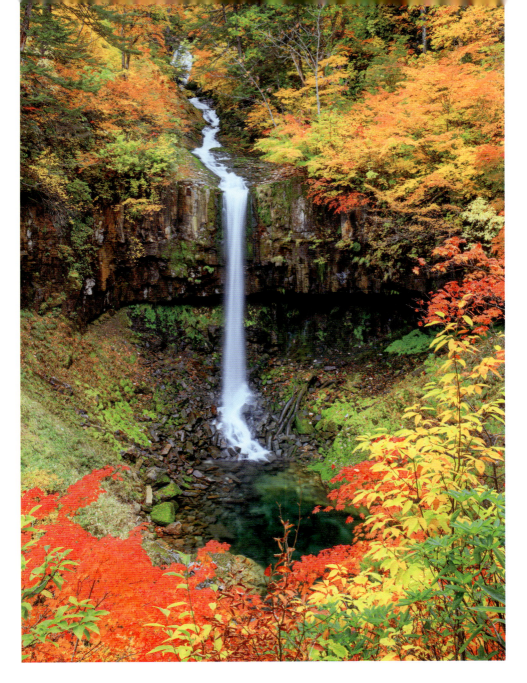

曽利滝 〈Sori-taki〉 秋田県鹿角市／Akita Pref.　落差：25 m

熊沢川源流域にかかる。切り立った断崖から一気に流れ落ちる様が美しい。
This fall drops into the headstream of the Kumazawa River. Water cascades over the sharp cliff and the sight is magnificent.

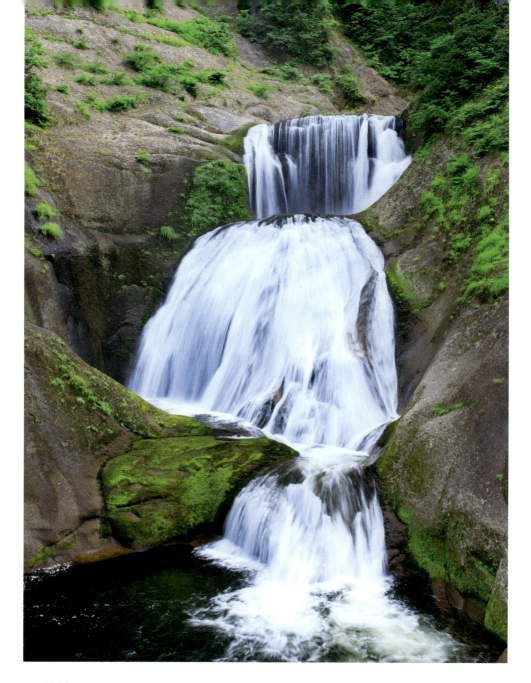

三階滝 〈Sangai-daki〉 秋田県北秋田市／Akita Pref. 落差：20 m
原生峡「小又峡(こまたきょう)」を代表する滝。太平湖を周遊する遊覧船が発着する桟橋から、遊歩道で1.8kmほど。
This fall is a symbol of the Komata Valley, which has primeval forests and many waterfalls. The fall is a 1.8km walk along the path from the landing place for the pleasure boat which cruises Lake Taihei.

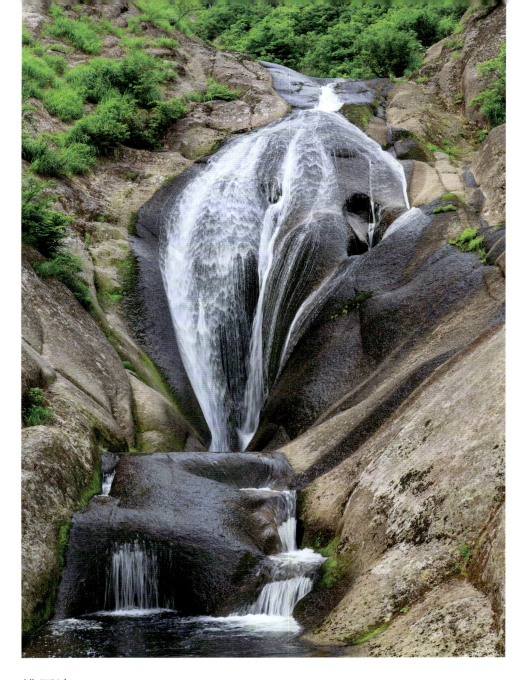

桃洞滝 〈Todo-no-taki〉 秋田県北秋田市／Akita Pref. 落差：20m

小又峡、ノロ川源流部の桃洞渓谷にある。その姿から「女滝」の名も持ち、安産・子宝・縁結びの滝としても知られる。
This fall drops into the Todo Valley which is located in the headstream of the Noro River. Because of the rounded figure of the fall, view, it is also called "Me-daki" (Female fall) and is believed to be good for pregnancy, a smooth delivery, and marriage.

41

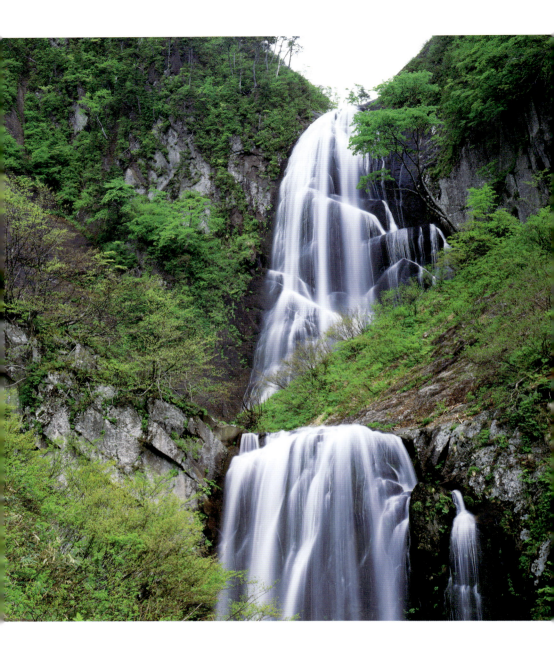

安の滝 〈Yasu-no-taki〉 秋田県北秋田市／Akita Pref.　落差：90ｍ　★

享保(1716〜36)の初め頃、ヤスという女性が恋人の名を呼んで、この滝に身を投じたという伝説が残る。中ノ又渓谷上流部にかかる二段の大瀑。
It is said that, in the Kyoho era (1716-1736), a woman whose name was Yasu, threw herself into this fall while calling out her boyfriend's name. It is a two-step fall dropping into the headstream of the Nakanomata Valley.

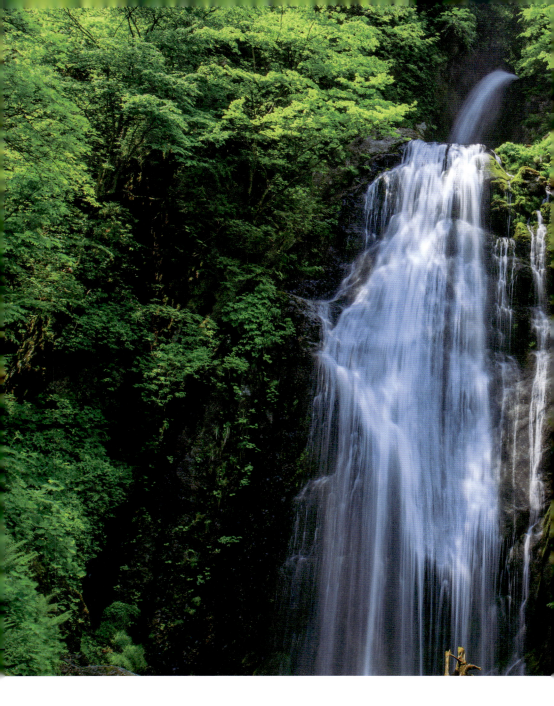

回顧の滝 〈Mikaeri-no-taki〉 秋田県仙北市／Akita Pref.　落差：30 m
抱返り渓谷を代表する滝。その名のとおり、振り返ってもう一度見たくなる美しい名瀑。

This beautiful fall has great views of the Dakigaeri Valley. "Mikaeri" means that people want to look back at the fall again.

法体の滝 〈Hottai-no-taki〉 秋田県由利本荘市／ Akita Pref.　落差：57.4 m　★

一の滝、二の滝、三の滝の三滝からなり、子吉川源流部にかかる。滝の上方に見られる多数の甌穴群は学術的にも貴重なものとされる。

Consisting of three waterfalls, "Ichi-no-taki", "Ni-no-taki", and "San-no-taki", and they drop into the headstream of the Koyoshi River. On the upper side of the fall, there are many potholes that have scientific value.

元滝伏流水 〈Moto-taki Fukuryusui〉 秋田県にかほ市／ Akita Pref. 落差：5 m

鳥海山にしみ込んだ水が幅約30mにわたって沁みだす。その水量は一日5万トンに達し、元滝川へと流れる。
This waterfall gushes out from beneath Mt. Chokai . It is 30m wide and 50,000 tons of water a day drop into the Mototaki River.

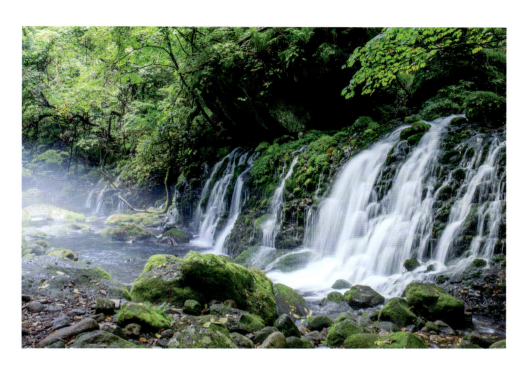

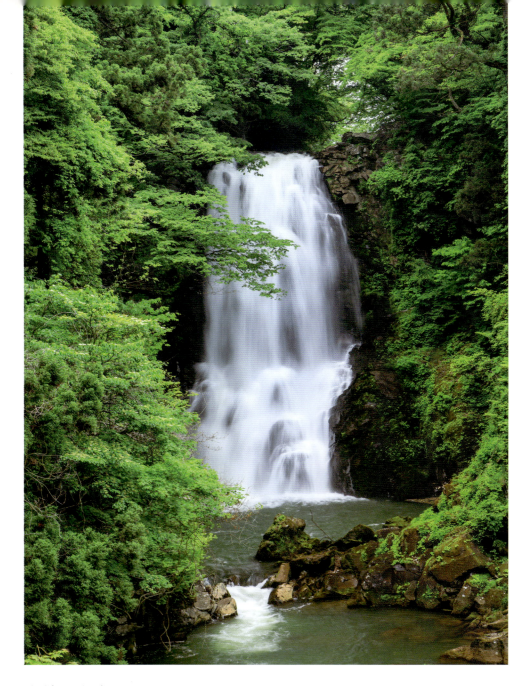

奈曽の白滝 〈Naso-no-shirataki〉 秋田県にかほ市／Akita Pref.　落差：26 m

奈曽川にかかる水量豊かな滝。金峰神社の境内を抜けて、石段参道を下ると滝の雄大な姿が見えてくる。
This fall drops into the Naso River with abundant water. Walking through the grounds of Kinpo-jinja Shrine and going down the stone steps, the giant fall appears.

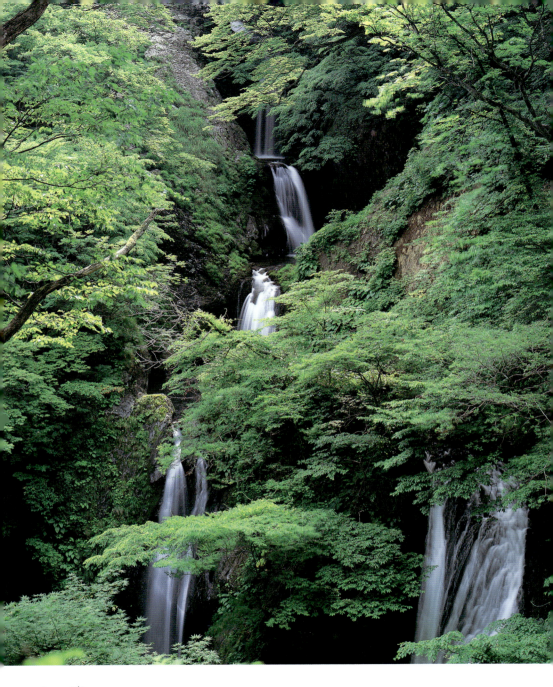

十二滝 〈Juni-taki〉 山形県酒田市／Yamagata Pref.　落差：30m

最上川の支流・相沢川にかかる。大小12の滝から構成され、その全容を見るために長さ28mの吊橋がかかっている。
Dropping into the Aizawa River, a branch of the Mogami River. "Juni-taki" is the general term for the 12 waterfalls here. It is possible to view the full picture of them from a 28m long suspension bridge.

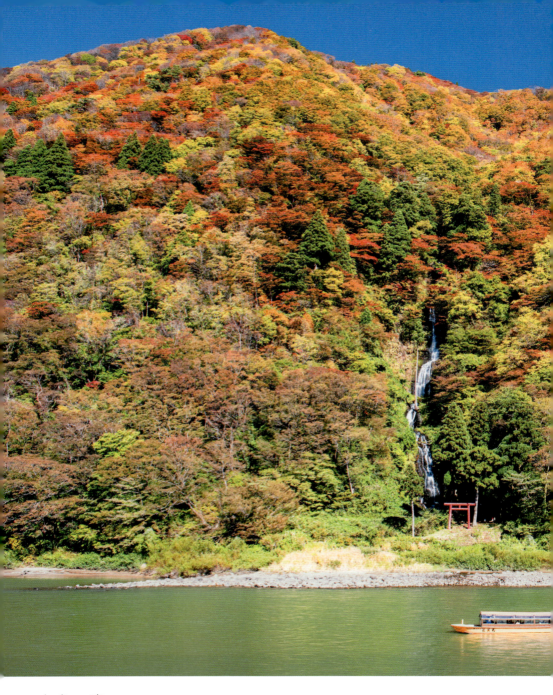

白糸の滝 〈Shiraito-no-taki〉 山形県戸沢村／Yamagata Pref. 落差：120 m ★

最上川の岸にかかる。『義経記』には、義経一行が平泉へと向かう道中、この滝を見た折の描写があり、また江戸時代には芭蕉も訪れたことが『おくのほそ道』に記されている。

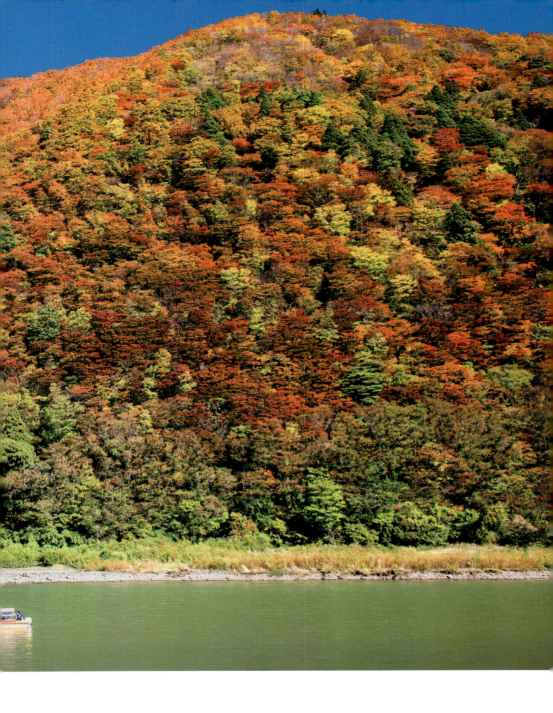
This fall drops into the Mogami River. A famous Haiku poet in the Edo period (1603-1867), MATSUO Basho visited this fall.

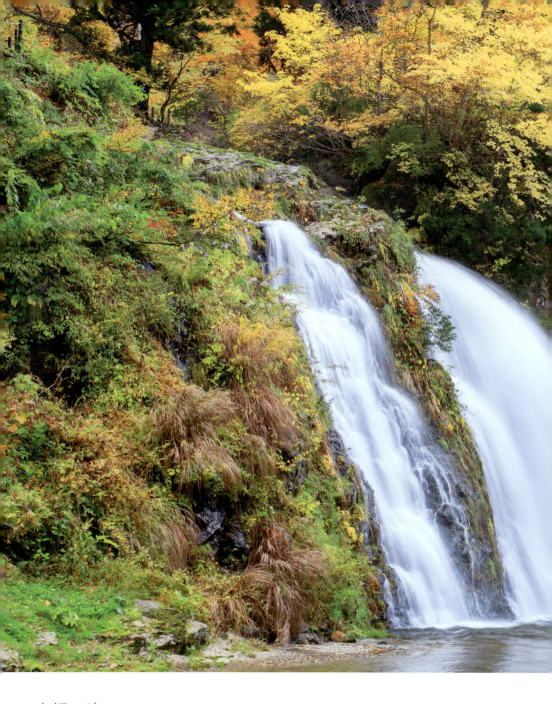

白銀の滝〈Shirogane-no-taki〉 山形県尾花沢市／Yamagata Pref. 落差：22ｍ
銀山川にかかる。銀山温泉の奥、白銀公園にある。

This fall drops into the Ginzan River. It is located in Shirogane-koen Park, close to Ginzan-onsen hot springs.

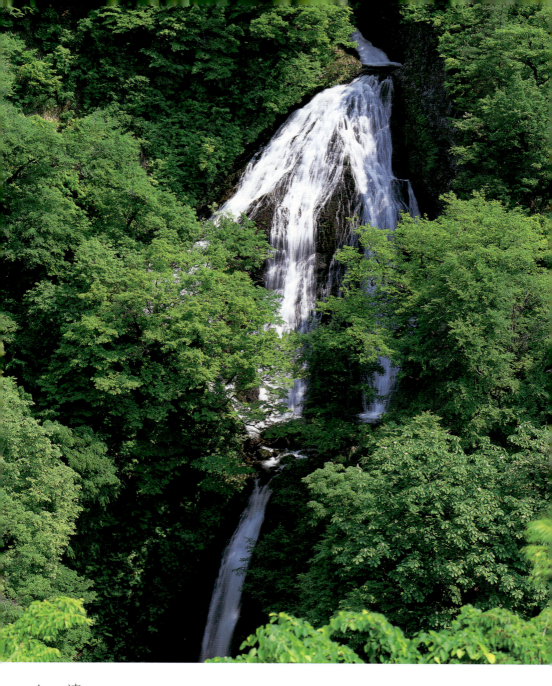

七ツ滝 〈Nanatsu-daki〉 山形県鶴岡市／Yamagata Pref. 落差：90 m ★

江戸時代、湯殿山や月山への参詣道として賑わった六十里越街道沿いにある。
This fall is located beside Rokujurigoe-kaido Road, which prospered as a pilgrimage route to Mt. Yudono and Mt. Gassan.

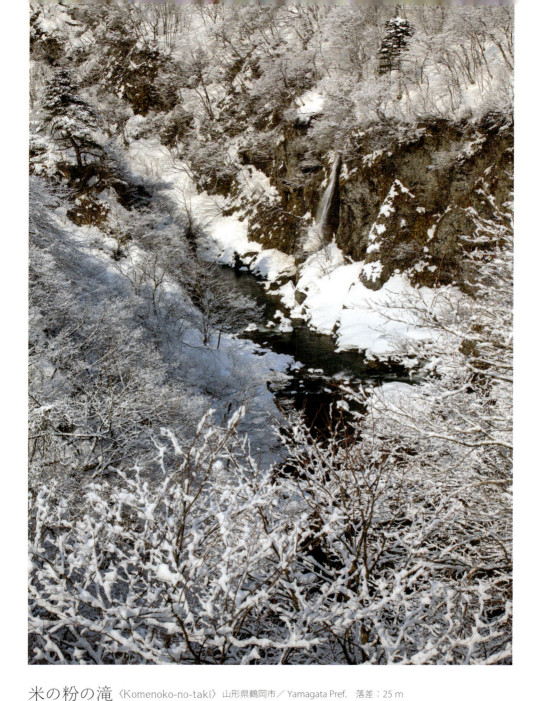

米の粉の滝 〈Komenoko-no-taki〉 山形県鶴岡市／Yamagata Pref.　落差：25m

梵字川にかかる滝。流れ落ちる水の様が米の粉のようであることが滝名の由来という。
This fall drops into the Bonji River. It is called "Komenoko" because the water descends like rice powder.

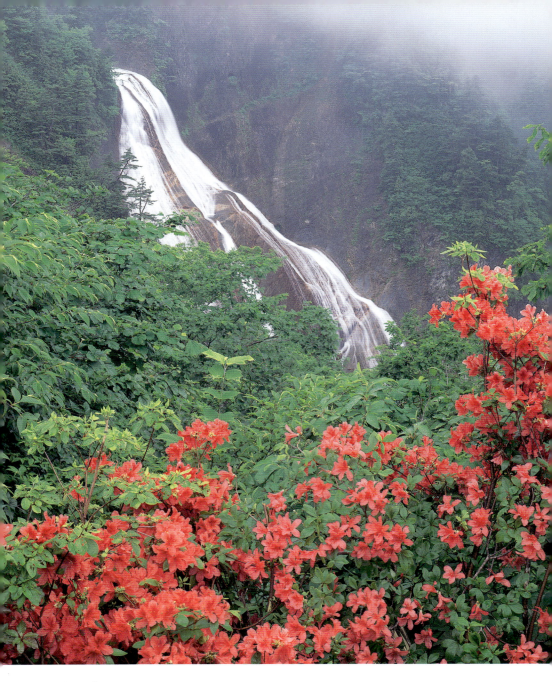

滑川大滝 〈Namegawa-otaki〉 山形県米沢市／Yamagata Pref. 落差：80 m ★

大滝沢にかかる大瀑。末広がりに水が落ちる姿は壮観。滑川温泉から登山道を30分ほど行くと大滝展望台がある。途中の吊り橋は老朽化による通行止め（2018年現在）となっており、吊橋下の渡渉が必要。
This is a large scale fall dropping into the Otaki Valley.

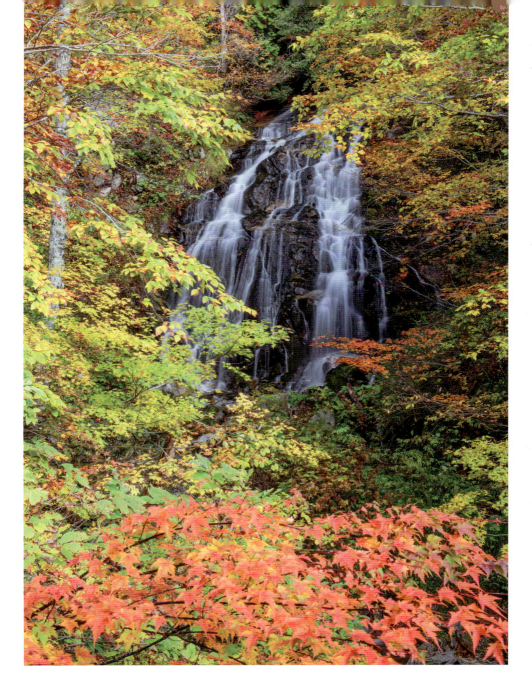

芳沢不動滝〈Yoshizawa-fudo-taki〉山形県米沢市／Yamagata Pref. 落差：15m

14世紀頃からの不動尊行場のひとつ。西吾妻スカイバレーの道路沿いから見ることができる。
This fall has been used for training ascetic Buddhist monks since the 14th century. It can be seen from the roadside of the Nishi-azuma Sky Valley road.

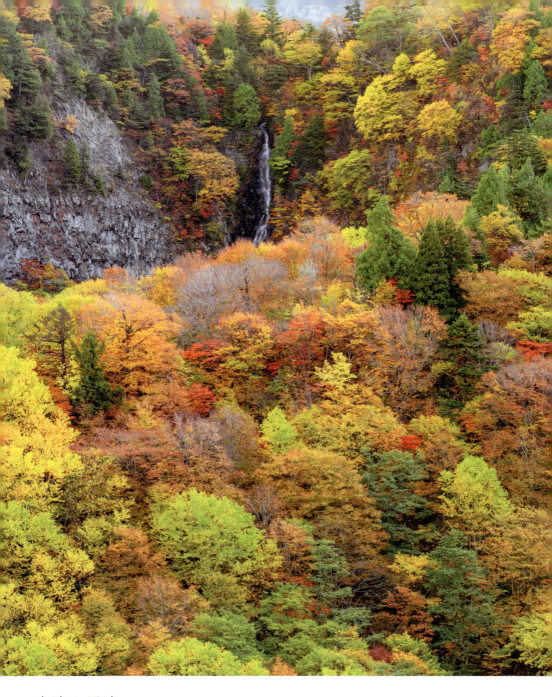

赤滝と黒滝 〈Aka-taki & Kuro-taki〉 山形県米沢市／Yamagata Pref.　落差：ともに落差100m

最上川源流のひとつとされる。西吾妻スカイバレーの双竜峡駐車場周辺から両滝を遠望することができる。赤滝は褐色の岩肌を、黒滝は黒い岩肌を流れ落ちる。

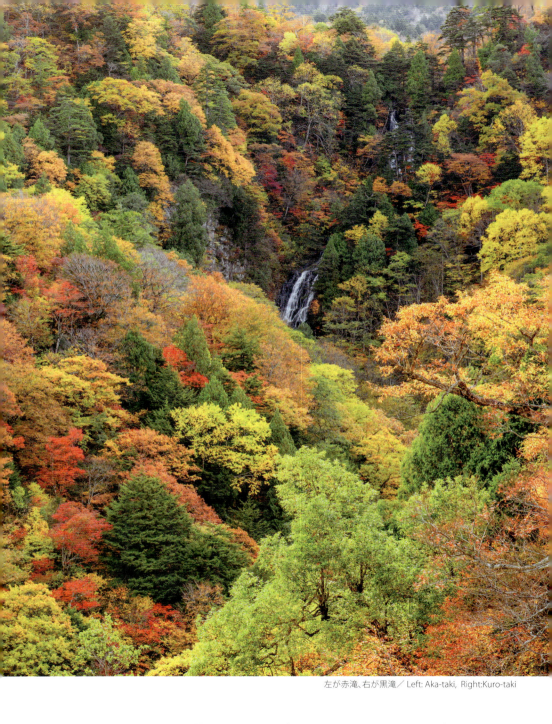

左が赤滝、右が黒滝／Left: Aka-taki, Right: Kuro-taki

These falls are from the headstreams of the Mogami River. From the Soryukyo parking area of the Nishi-azuma Sky Valley road, you can get a distant view of them. Aka-taki descends onto a bronzed cliff and Kuro-taki onto a black cliff.

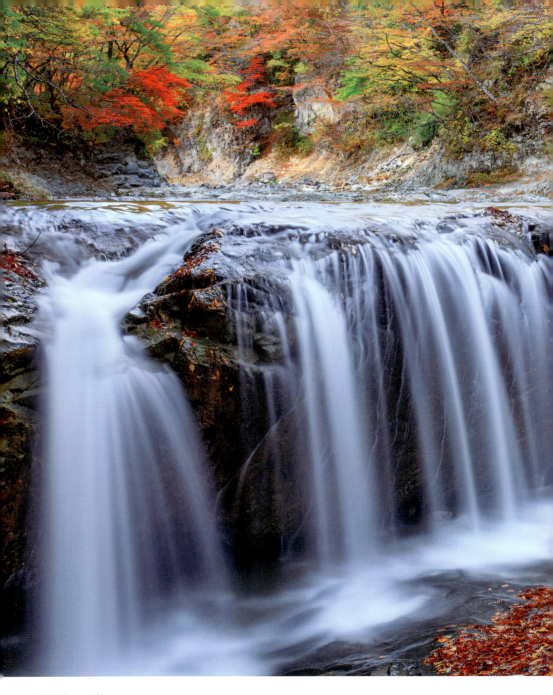

不動の滝 〈Fudo-no-taki〉 宮城県栗原市／ Miyagi Pref.　落差：3m
迫川上流、浅布渓谷にある。川幅いっぱいに流れ落ちる様は壮観。約1.6ｋｍにわたる渓谷にはこの滝の他、四巻の滝もある。

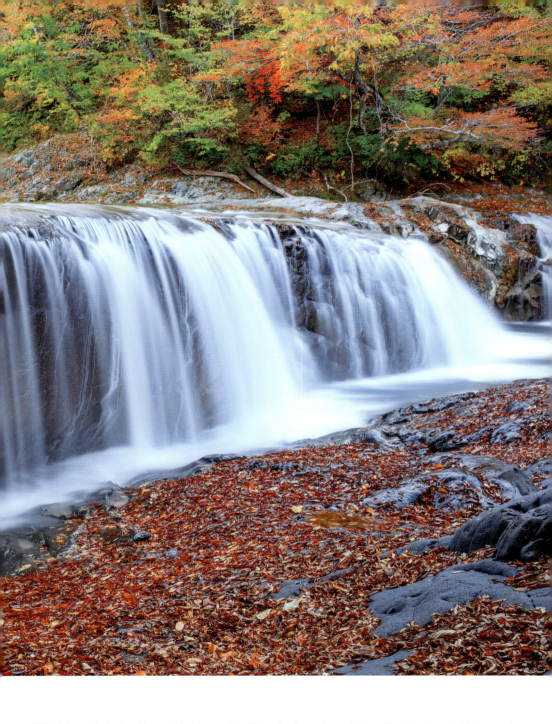

This fall drops into the headstream of the Hasama River. The water descends over the breadth of the river and it looks superb. Shimaki-no-taki is also near here.

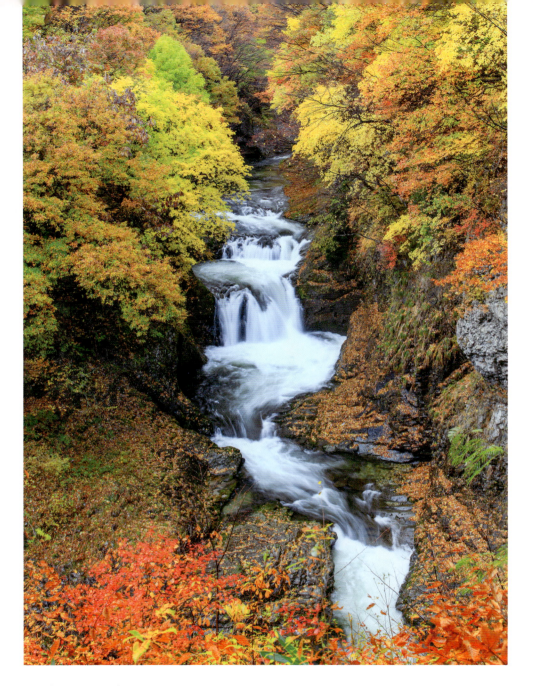

鳳鳴四十八滝 〈Homei-shijuhachi-taki〉 宮城県仙台市／Miyagi Pref. 落差：25 m

大小の滝が連なり、広瀬川にかかる。滝音の美しい響きを鳳凰の鳴き声にたとえ、この滝名となったという。
This is a series of waterfalls, one after another, of various sizes, each dropping into the Hirose River. "Homei" means beautiful singing of a mythical Chinese Phoenix.

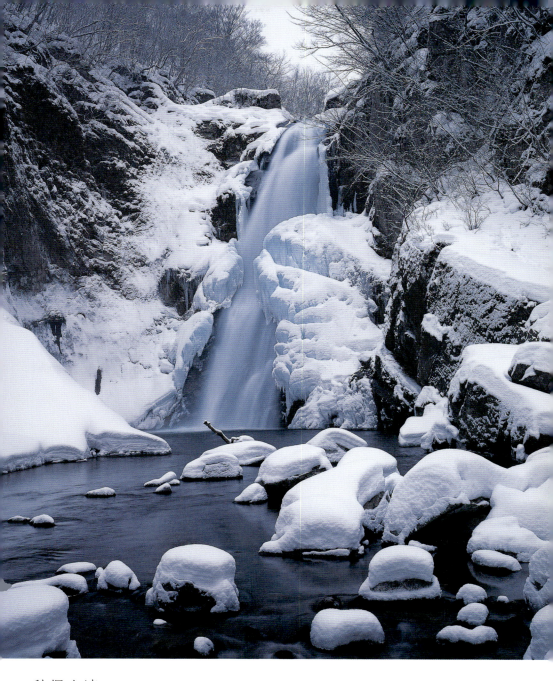

秋保大滝 〈Akiu-otaki〉 宮城県仙台市／Miyagi Pref.　落差：55 m　★
名取川上流。豊かな水量を誇り、轟音をたてて流れ落ちる。滝壺までは遊歩道で下りていくことができる。
This fall has much water and drops forcefully into the headstream of the Natori River. You can walk to the waterfall basin along a hiking path.

65

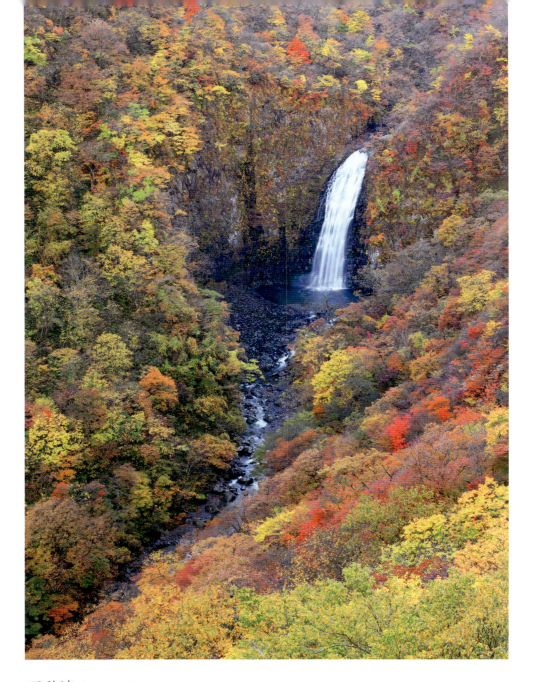

不動滝 〈Fudo-taki〉 宮城県蔵王町／Miyagi Pref.　落差：53.5 m

蔵王山中、澄川渓谷にある。滝見台には文人・宇田零雨が不動滝を詠んだ「萬緑の底に瀧あり裏けり」の句碑がある。
This fall drops into the Sumikawa Valley of Mt. Zao. There is a stone monument inscribed with a Haiku poem by a famous poet, UDA Reiu, near the viewing deck.

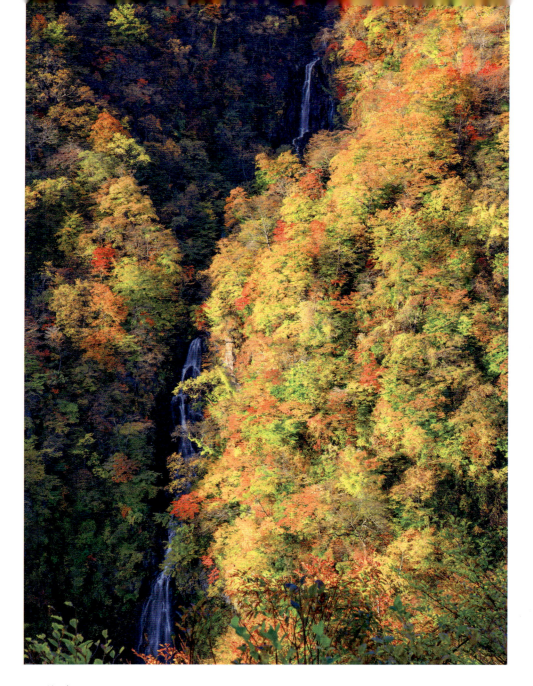

三階滝 〈Sankai-taki〉 宮城県蔵王町／Miyagi Pref. 落差：181 m ★

澄川渓谷にあり、石子沢から澄川へと落下する。三階滝に住むカニが不動滝のウナギと戦った伝説がある。
This fall is also located in the Sumikawa Valley. The water descends over a series of three rock steps from the Ishiko-sawa to the Sumi River. Legend has it that a crab in this fall battled with a river eel in Fudo-taki.

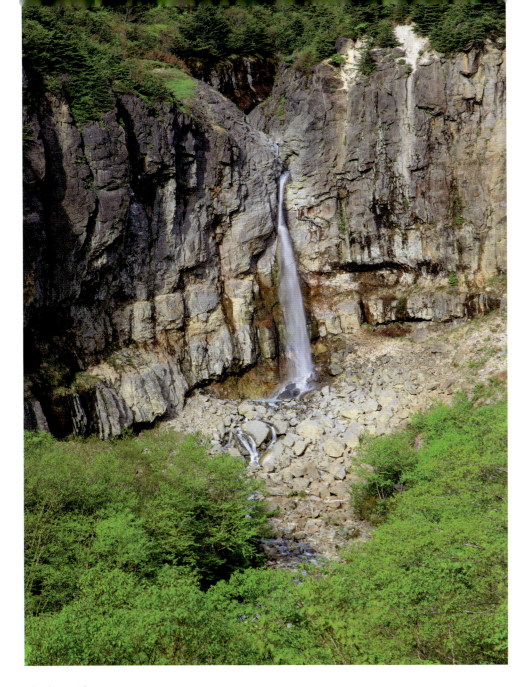

白糸の滝 〈Shiraito-no-taki〉 福島県猪苗代町／Fukushima Pref. 落差：60 m
安達太良山中にかかる。硫黄鉱山の跡地から湧き出る温泉水が流れ落ちて滝となっている。
This fall drops onto Mt. Adatara. It is a hot spring waterfall that emerges from the sites of former sulfur mines.

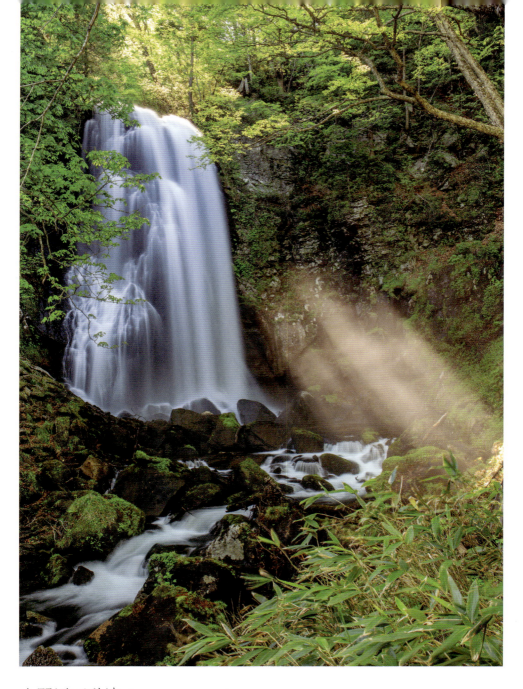

小野川不動滝 〈Onogawa-fudo-daki〉 福島県北塩原村／Fukushima Pref.　落差：25m
小野川湖の上流にある。名水「百貫清水」からの水が流れ落ちる大瀑。
This fall drops into the upper stream of Lake Onogawa. It is the largest fall in the Urabandai Area.

八幡滝 〈Hachiman-taki〉 福島県二本松市／Fukushima Pref. 落差：10 m
安達太良連峰の表登山口である湯川渓谷にある。この渓谷には他に三階滝、霧降り滝などいくつかの滝がある。
This fall is located in the Yukawa Valley Area, which is a starting point for climbing the Adatara mountain range. Sangai-daki Fall and Kirifuri-taki Fall are also in this area.

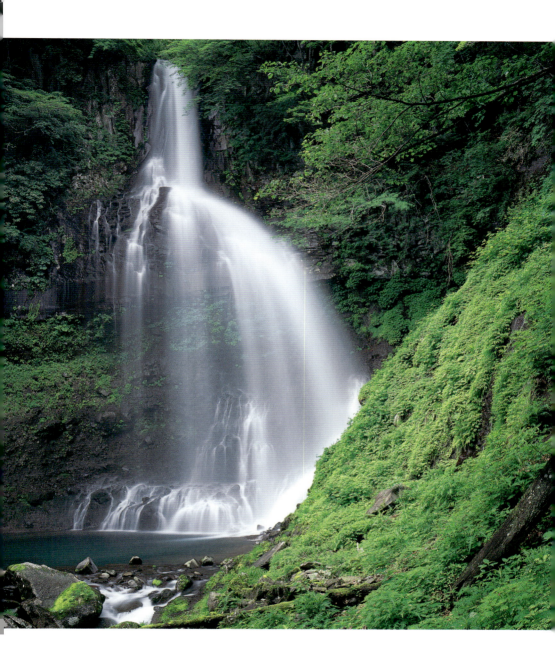

銚子ヶ滝 〈Choshi-ga-taki〉 福島県郡山市／Fukushima Pref.　落差：48 m　★

安達太良山麓、石筵川にかかる。その姿が酒を入れる銚子に似ていることからこの滝名がついた。
This fall drops into the Ishimushiro River, running through Mt. Adatara piedmont. It is named "Choshi" because of its shape that resembles a Choshi, a Japanese sake bottle.

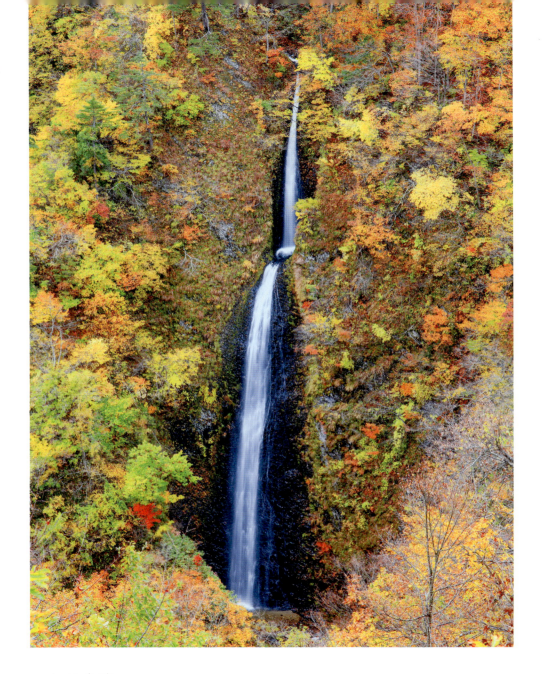

つむじ倉滝 〈Tsumujikura-taki〉 福島県柳津町／Fukushima Pref.　落差：85m

博士山麓にあり、只見川の支流・滝谷川の上流部にかかる滝。上段25m、下段60mから成る。水の流れる姿から、「つむじを曲げた」滝の意でこの名がついたという。
This fall drops into the headstream of a branch of the Tadami River, running through Mt. Hakase piedmont. The upper step is 25m high, and the lower step is 60m high.

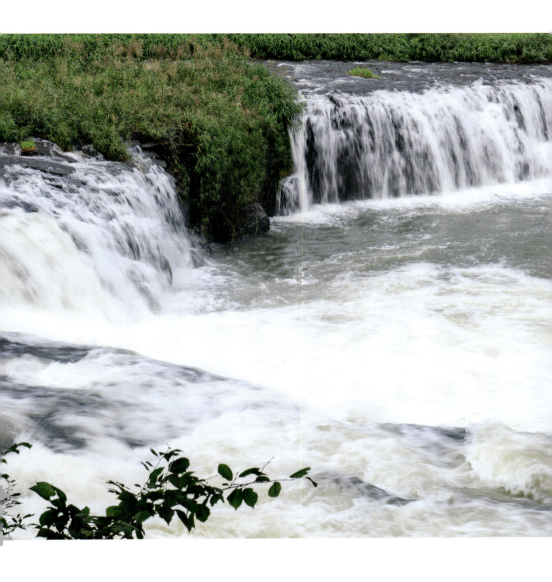

乙字ヶ滝 〈Otsuji-ga-taki〉 福島県玉川村／Fukushima Pref. 落差：6ｍ ★

阿武隈川にかかる。滝名は滝の落ち口のラインが乙の形に見えることから。芭蕉がこの滝を詠んだ「五月雨の滝降りうづむ水かさ哉」の句碑がある。
This fall drops into the Abukuma River. It is named "Otsuji" because of its shape that resembles the character Otsu in Japanese Kanji. A famous Haiku poet, MATSUO Basho, composed a Haiku poem about this fall.

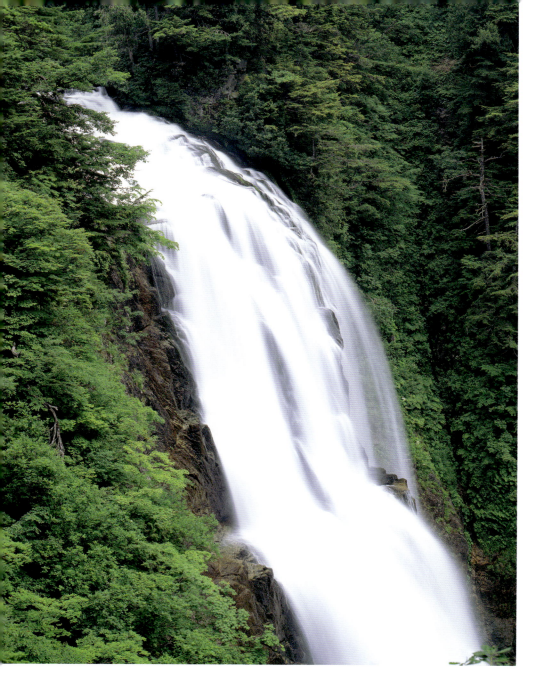

三条ノ滝 〈Sanjo-no-taki〉 福島県檜枝岐村／Fukushima Pref. 落差：100 m ★

尾瀬一帯の水を集めて下る只見川が急峻な崖を轟音を響かせて流れ落ちる滝。この滝の上流には平滑ノ滝がある。
The Tadami River, running down from the Oze marshlands area gathering plenty of water, descends vertically with a roaring sound. Hiraname-no-taki is located in the upper stream of this fall.

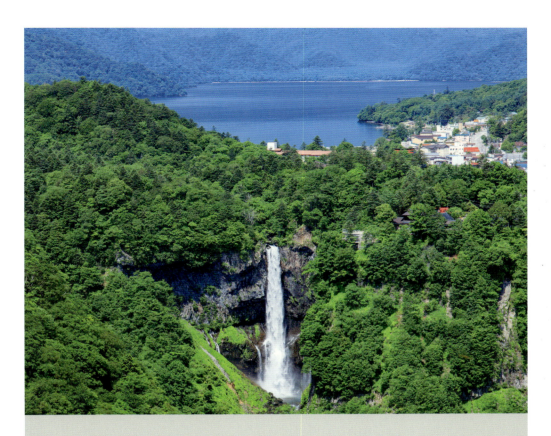

関東 Kanto (Around Tokyo)

華厳の滝〈Kegon-no-taki〉栃木県日光市／Tochigi Pref.　落差：97m　★

中禅寺湖を流れ出た水が大尻川を経て流れ落ちるのが華厳の滝である。その後流れは大谷川と名前をかえ、やがて鬼怒川へと注ぐ。日本三名瀑のひとつ。
One of the best three waterfalls in Japan. The water running from Lake Chuzenji becomes the Ojiri River and descends as a fall. After dropping, the stream becomes the Daiya River and joins up with the Kinu River.

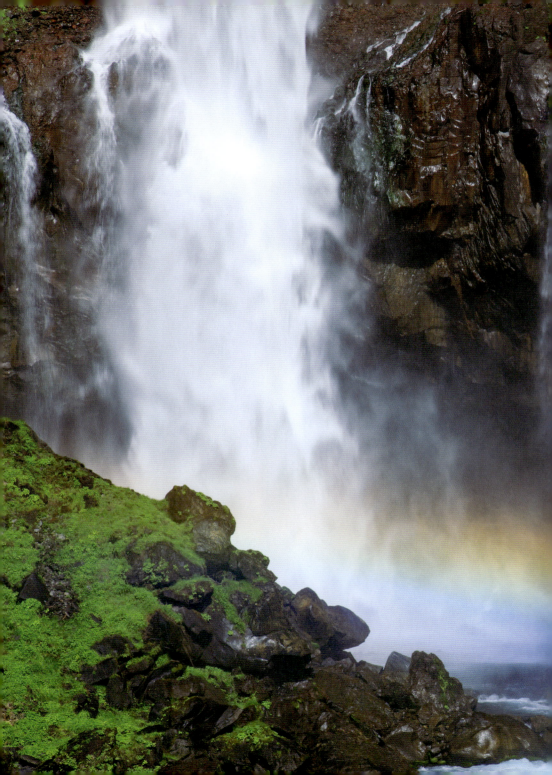

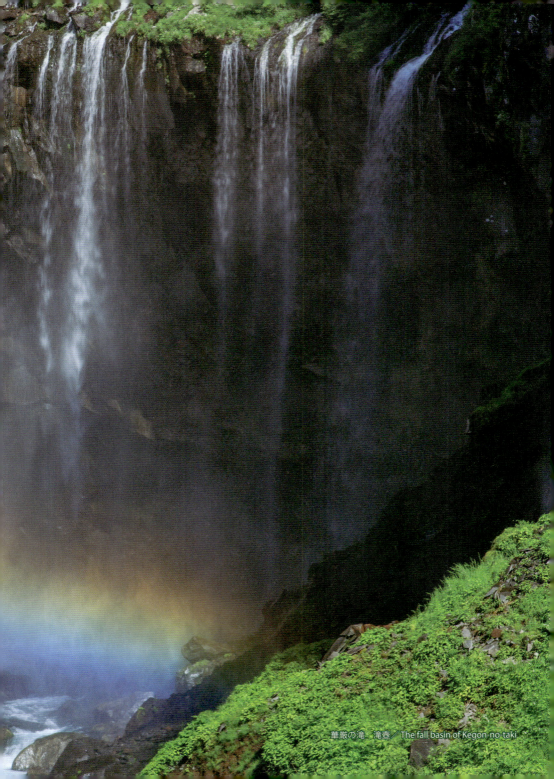

華厳の滝　滝壺　The fall basin of Kegon-no-taki

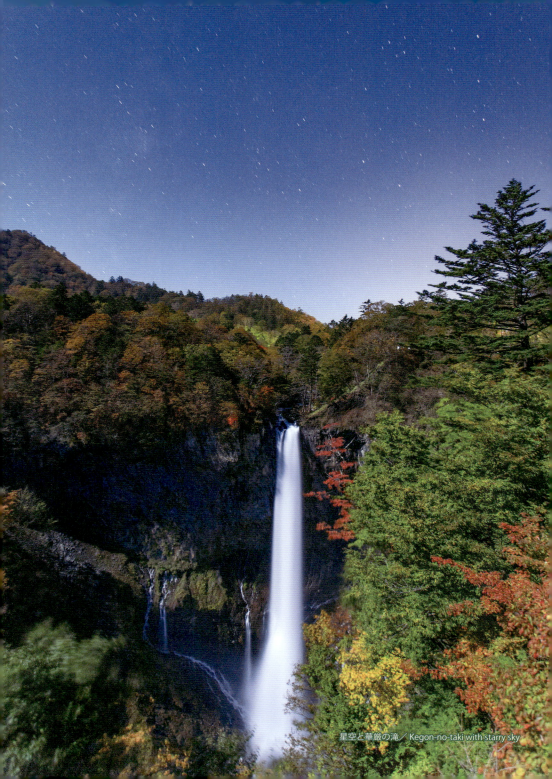

星空と華厳の滝 / Kegon-no-taki with starry sky

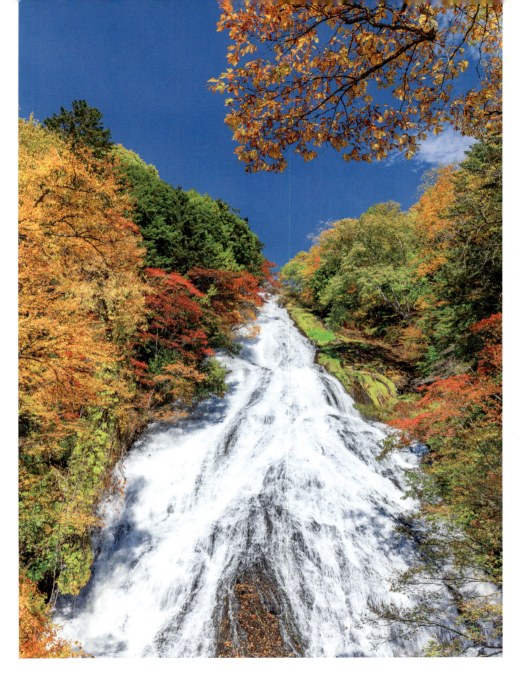

湯滝 〈Yu-daki〉 栃木県日光市／Tochigi Pref. 落差：70 m

湯ノ湖の湖水はこの湯滝を流れ落ちて、湯川となる。
The water of Lake Yuno descends here and becomes the Yu River.

竜頭の滝 〈Ryuzu-no-taki〉 栃木県日光市／Tochigi Pref. 落差：全長210m

湯ノ湖から流れ出た湯川は竜頭の滝を経て、中禅寺湖へと流れ込む。滝名は滝壺近く、二筋の滝の流れに挟まれた巨岩が竜の頭のように見えることから。

Via these falls, the Yu River runs into Lake Chuzenji. "Ryuzu", which means the head of a dragon, is named after the giant rock between the two falls which looks like a dragon's head.

竜頭の滝と中禅寺湖／ Ryuzu-no-taki & Lake Chuzenji

秋の竜頭の滝　滝壺付近／ Ryuzu-no-taki in autumn

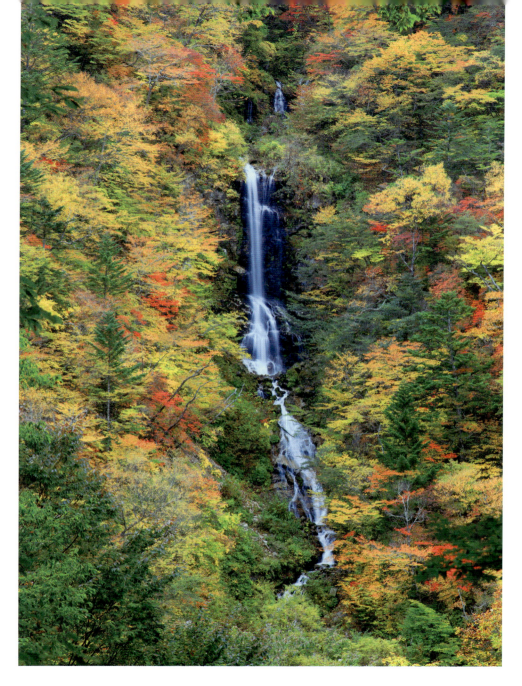

蛇王の滝 〈Jao-no-taki〉 栃木県日光市／Tochigi Pref. 落差：30 m

鬼怒川右岸にかかる滝。滝の流身が白蛇のようにみえることからこの滝名がついた。
This fall drops into the right bank of the Kinu River. "Jao" means the king of snakes and the fall has this name because it looks like a white snake.

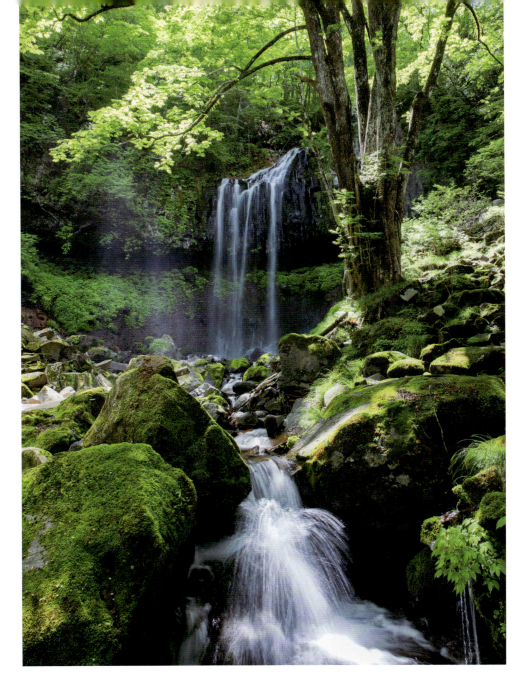

マックラ滝 〈Makkura-taki〉 栃木県日光市／Tochigi Pref. 落差：30 m

霧降川の支流・冷沢にかかる。かつては樹木が鬱蒼と茂り、昼でも暗かったためこの名がついたという。
This fall drops into a branch of the Kirifuri River. "Makkura" means complete darkness. In the past, there were dense forests and it was dark even in the daytime.

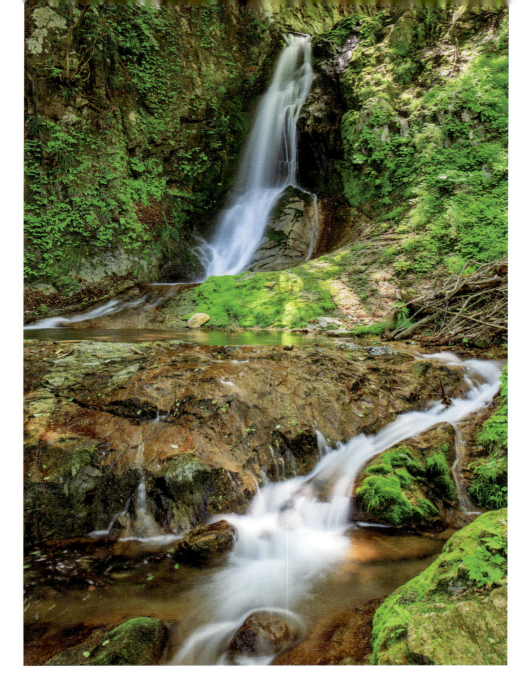

丁字の滝 〈Choji-no-taki〉 栃木県日光市／Tochigi Pref.　落差：10 m

霧降川の支流・丁字沢にかかる。マックラ滝とこの丁字の滝、そして玉簾滝をあわせて、霧降の隠れ三滝と呼ばれる。
This fall drops into Choji-sawa, a branch of the Kirifuri River.　Makkura-daki,Tamasudare-no-taki and this one are called "The three hidden falls of Kirifuri".

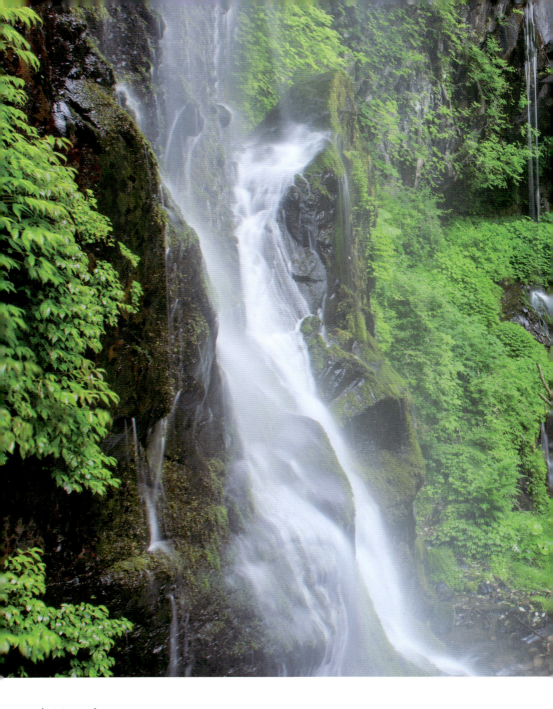

裏見の滝 〈Urami-no-taki〉 栃木県日光市／Tochigi Pref.　落差：20m
大谷川の支流・荒沢川上流にかかる。滝の裏には不動明王が祀られているが、現在参拝はできない。

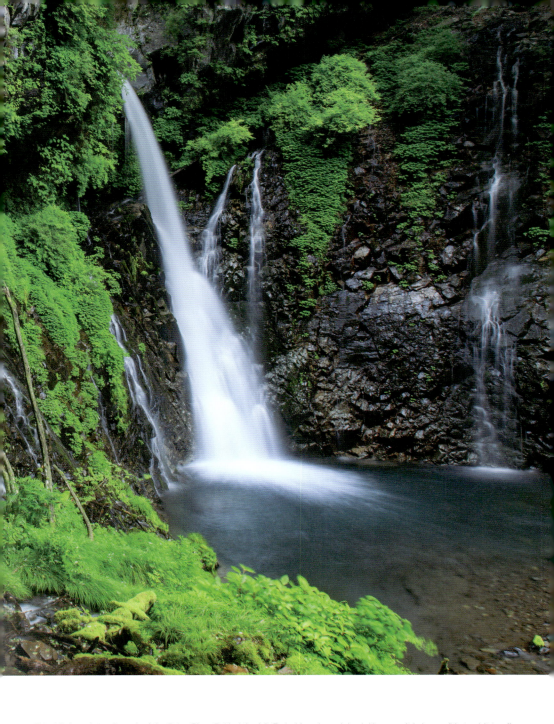

This fall drops into a branch of the Daiya River. Behind the fall, Fudo Myoo is enshrined. However, it is impossible to visit to offer prayers now.

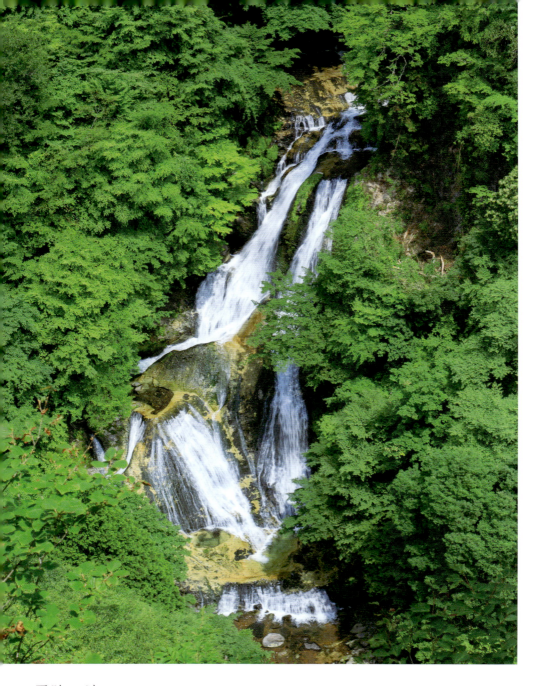

霧降の滝 〈Kirifuri-no-taki〉 栃木県日光市／Tochigi Pref. 落差：75 m ★

霧降川上流にかかる。上段25m、下段は26mある。流れ落ちる水が霧のように飛び散る様からこの名がついている。
This fall drops into the headstream of the Kirifuri River. The upper step is 25m high and the lower step is 26m. The descending water looks like mist; therefore, it is named Kirifuri, which means 'falling mist'.

白滝 〈Shira-taki〉 栃木県日光市／Tochigi Pref. 落差：不明

鬼怒川温泉と塩原温泉を結ぶ高原道路・日塩もみじライン沿いにある滝。
This fall is located beside the Nichien-Momiji Line Highway, which links the Kinugawa-onsen area and the Shiobara-onsen area.

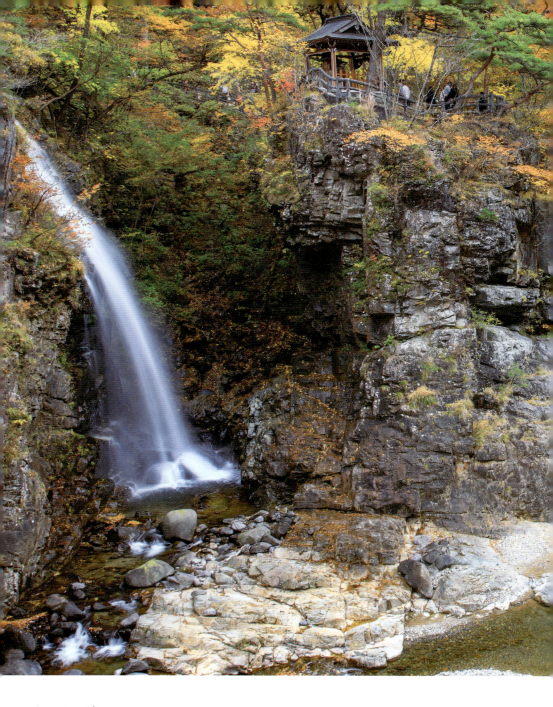

虹見の滝〈Nijimi-no-taki〉栃木県日光市／Tochigi Pref.　落差：不明
龍王峡にかかる。滝に陽光が差し込むと美しい虹がかかることが滝名の由来。

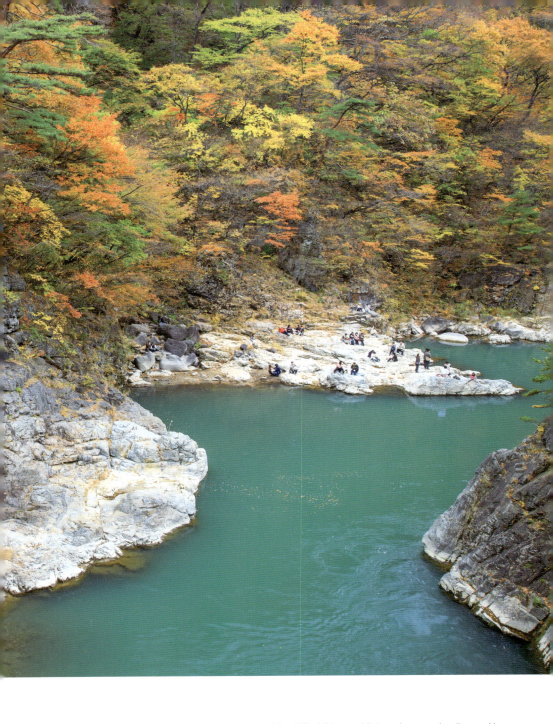

This fall drops into the Ryuo Valley. "Nijimi" means 'looking at a rainbow'. The fall is named that way because when the sun shines, a beautiful rainbow appears.

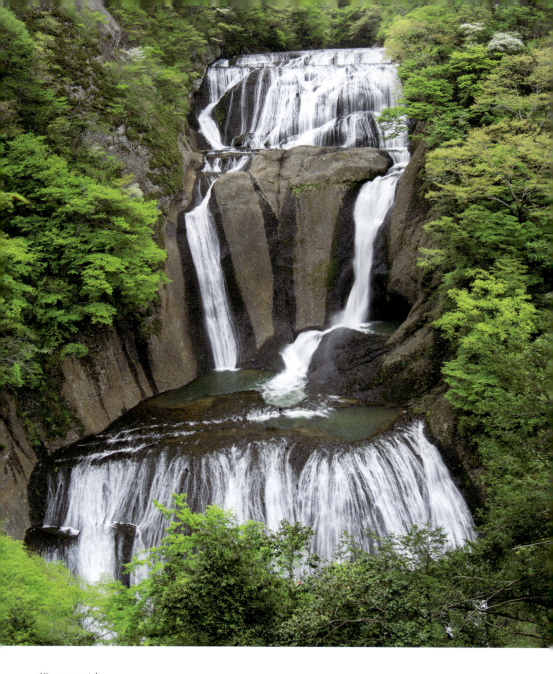

袋田の滝 〈Fukuroda-no-taki〉 茨城県大子町／Ibaraki Pref. 落差：120ｍ ★
久慈川の支流・滝川上流部にかかる。別名の「四度の滝」は四段に流れるからとも、西行が四季に一度ずつ来てこそ本当の良さがわかると絶賛したからともいわれる。
This fall drops into a branch of the Kuji River. Also known as "Yodo-no-taki" (Four-time fall), because it has four steps.

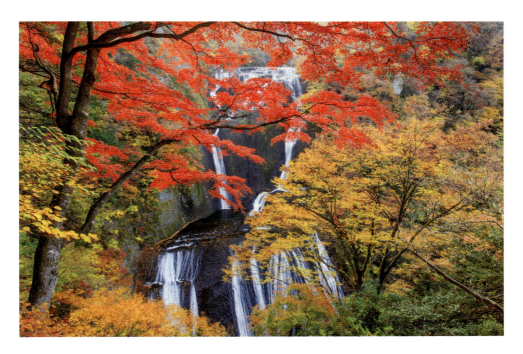
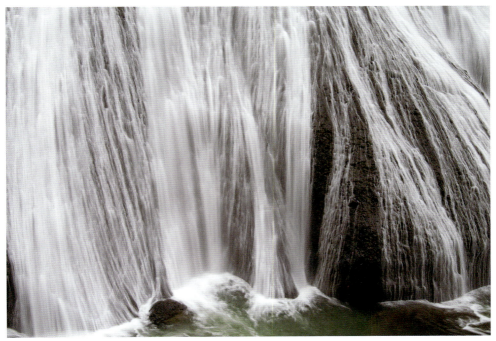

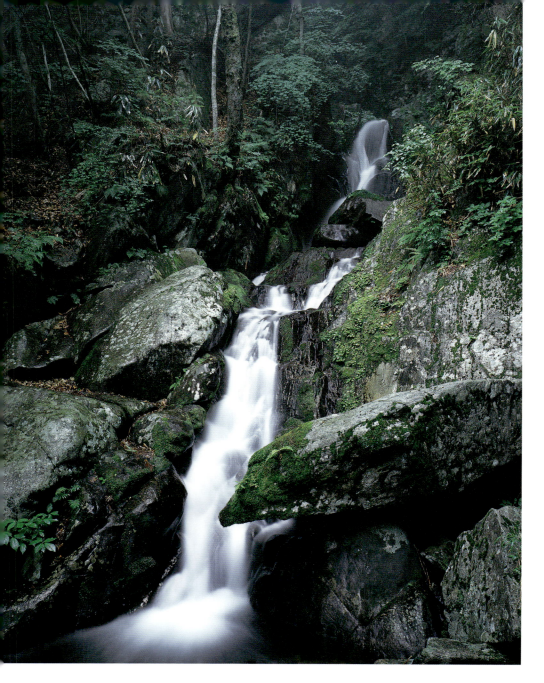

七ツ滝 〈Nanatsu-taki〉 茨城県北茨城市／Ibaraki Pref. 落差：60 m

花園川の上流、花園渓谷にかかる滝。渓谷には与四郎の滝、落雲の滝、千猿の滝、箱滝など大小の滝がかかる。
This fall drops into the Hanazono Valley. There are also many large and small falls, Yoshiro-no-taki, Rakuun-no-taki, and Senen-no-taki, etc.

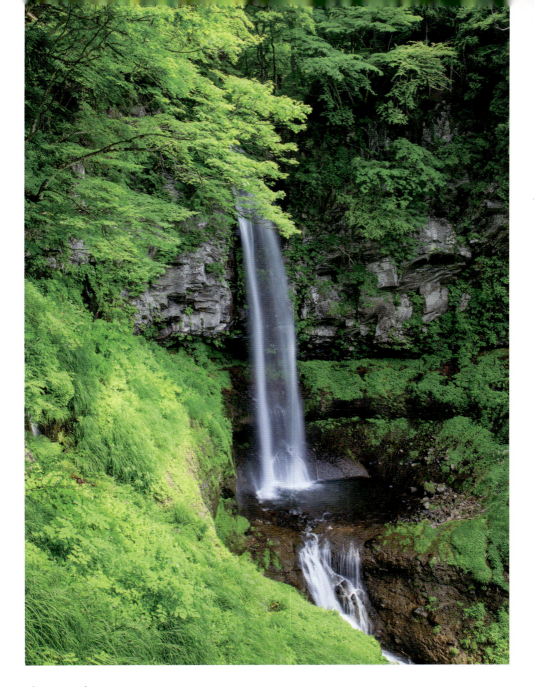

裏見の滝 〈Urami-no-taki〉 群馬県みなかみ町／Gunma Pref.　落差：50 m

別名「宝来の滝」。武尊川にかかる。かつては滝の裏側から見ることができたが、現在は滝の裏側は通行不可。
Also known as "Horai-no-taki". This fall drops into the Hotaka River. Previously, it was possible to walk behind the fall, but now it is impossible due to the possibility of falling rocks.

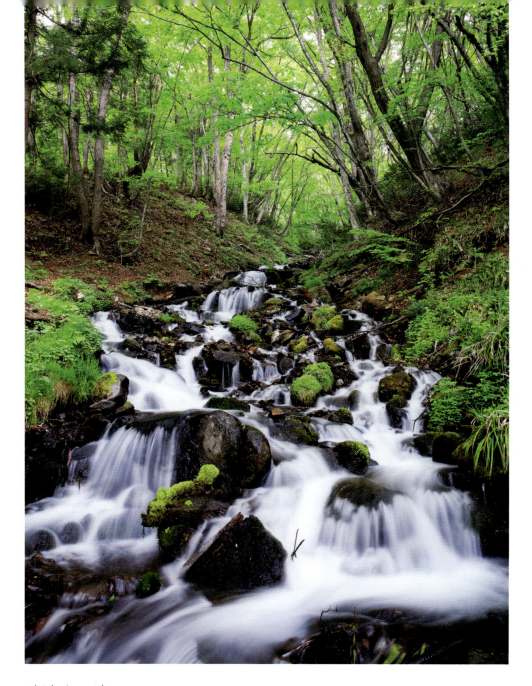

強清水の滝 〈Kowashimizu-no-taki〉 群馬県沼田市／Gunma Pref.　落差：10m
沼田市北部、鹿俣山と尼ケ禿山から湧き出した地下水が滝となった潜流瀑。流れはやがて発知川へと流れ込む。
Water emerging from Mt. Kanomata and Mt. Amagahage forms this fall and it leads to the Hocchi River.

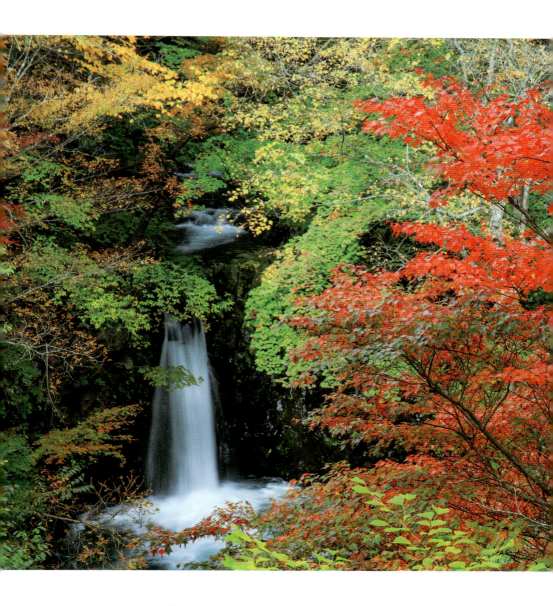

小泉の滝 〈Koizumi-no-taki〉 群馬県中之条町／Gunma Pref.　落差：6 m
四万温泉の近く、四万川にかかる滝。このあたりは楓仙峡と呼ばれる紅葉の名所でもある。
This fall drops into the Shima River, near Shima-onsen hot springs. This area is called "Fusenkyo" and is well known as one of the best scenic spots for autumn foliage.

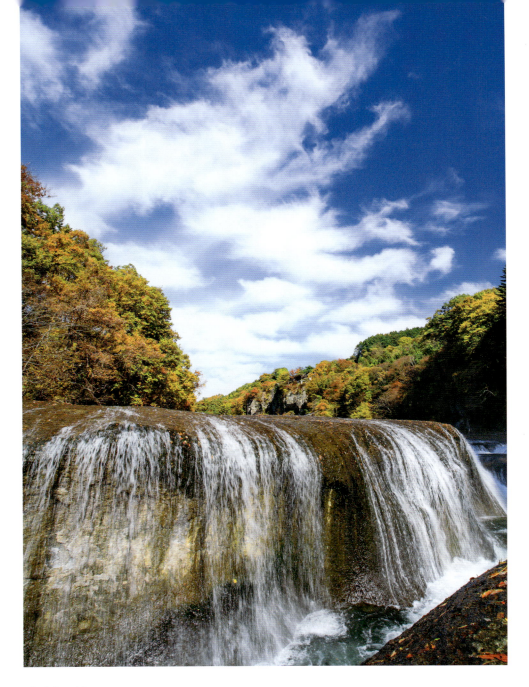

吹割の滝 〈Fukiware-no-taki〉 群馬県沼田市／Gunma Pref. 落差：7ｍ ★
片品川の流れが川床の岩質の軟らかい部分を浸食したことによって形成された滝で、「東洋のナイアガラ」とも呼ばれる。
The stream of the Katashina River ate away its banks and formed this fall. It is also called the "Niagara falls of the East".

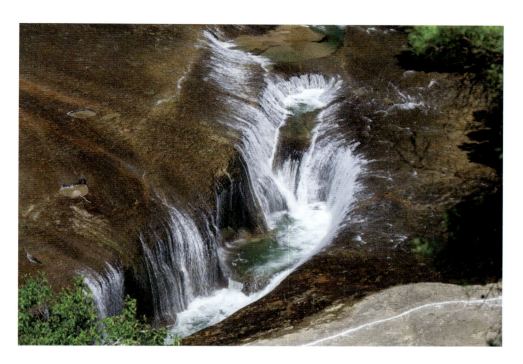
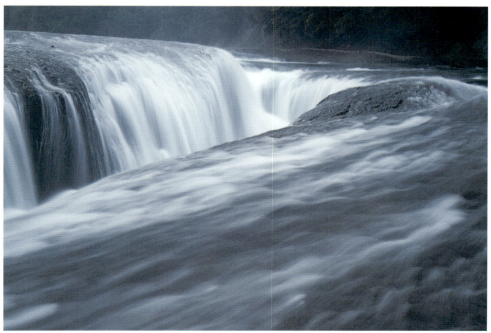

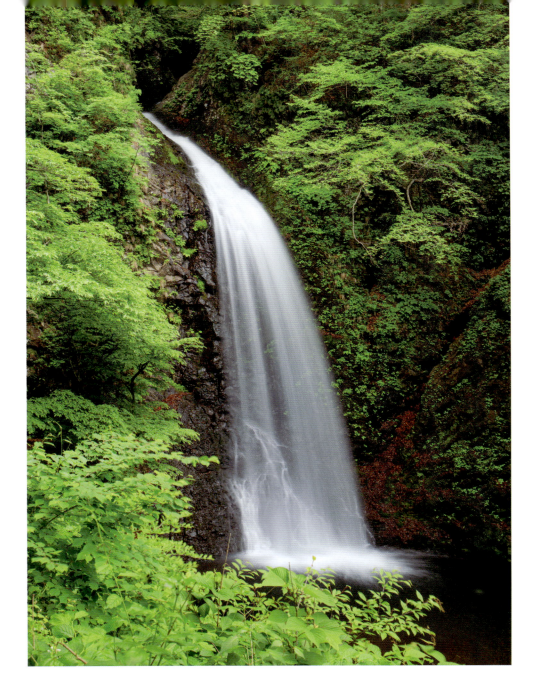

大仙の滝 〈Ozen-no-taki〉 群馬県中之条町／Gunma Pref. 落差：20 m

白砂川支流・八石沢川にかかる。このあたりの八つの滝を総称して世立八滝という。
This fall drops into the Hachikokuzawa River, a branch of the Shirasuna River. The eight falls including this one are called "Yodate Hachitaki". This is the easiest to reach among the eight falls.

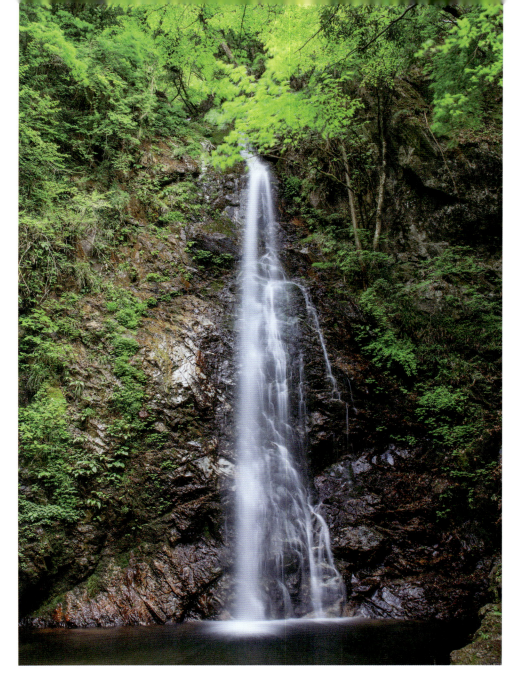

払沢の滝 〈Hossawa-no-taki〉 東京都檜原村／Tokyo Pref. 落差：62 m ★

秋川源流の沢にかかる。全4段からなる滝だが、遊歩道から見られるのは落差23.3ｍの最下段のみ。
This fall drops into the headstream of the Aki River. Although it has four steps, the lowest one, 23.3m high, can be seen from the trail path.

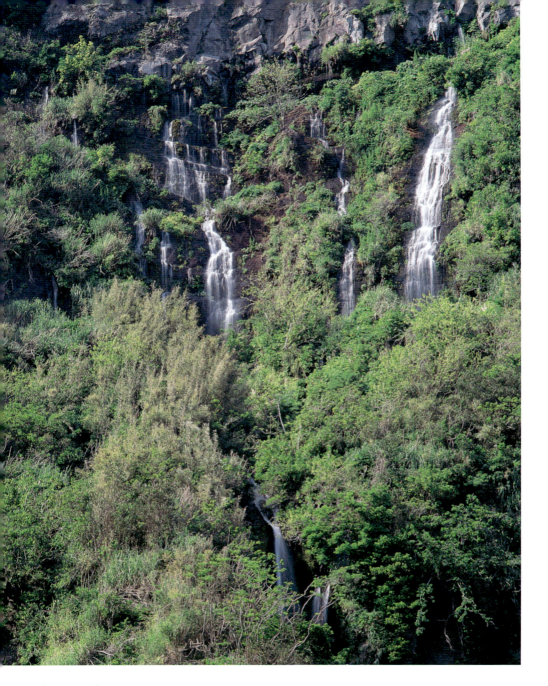

名古の滝 〈Nago-no-taki〉 東京都八丈町／Tokyo Pref. 落差：推定 80 m

八丈島にある。三原山の断崖を、岩間から湧き出した水が流れ落ちる滝。
This fall is situated in Hachijo-jima Island. The water emerging from among rocks descends from the cliff of Mt. Mihara.

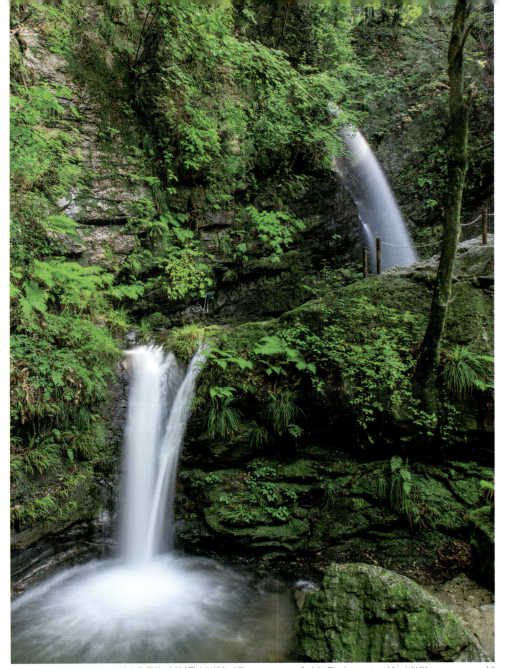

上流から男滝、女滝[黒山三滝] ／ The upper step: O-daki, The lower step: Me-daki [Kuroyama-san-taki]

黒山三滝 〈Kuroyama-san-taki〉 埼玉県越生町／Saitama Pref. 落差：男滝11m 女滝5m

越辺川支流の三滝川にかかる三つの滝の総称。写真の男滝・女滝の他、落差14mの天狗滝がある。
Three falls dropping into a branch of the Oppe River are generally referred to as Kuroyama-san-taki Falls. The two falls (pictured) are "O-daki" and "Me-daki". Another is "Tengu-taki" which is 14m high.

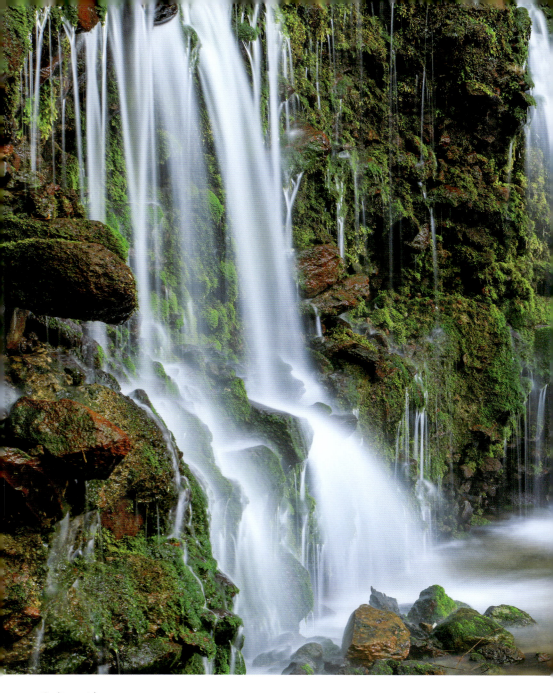

千条の滝 〈Chisuji-no-taki〉 神奈川県箱根町／Kanagawa Pref.　落差：3 m

蛇骨川上流。幅約20mにわたって岩盤から湧き出した水が静かに流れ落ちる。落ちる水がいく条もの糸のようであることから千条の滝と名付けられた。

This fall drops into the upper stream of the Jakotsu River. It has a width of 20m and the water quietly descends. The lines of descending water look like many strings; therefore, it is named "Chisuji", which means 'one thousand strings'.

一の滝 [洒水の滝] ／ Ichi-no-taki [Shasui-no-taki]

洒水の滝 〈Shasui-no-taki〉 神奈川県山北町／ Kanagawa Pref. 落差：一の滝 69 m ★

酒匂川支流・滝沢川にかかる。一の滝の他、さらに上流には二の滝（落差16 m）、三の滝（落差29 m）がある。
This fall drops into a branch of the Sakawa River. This one is named "Ichi-no-taki (The first fall)", and other falls, Ni-no-taki (16m high) and San-no-taki (29m high) are near here.

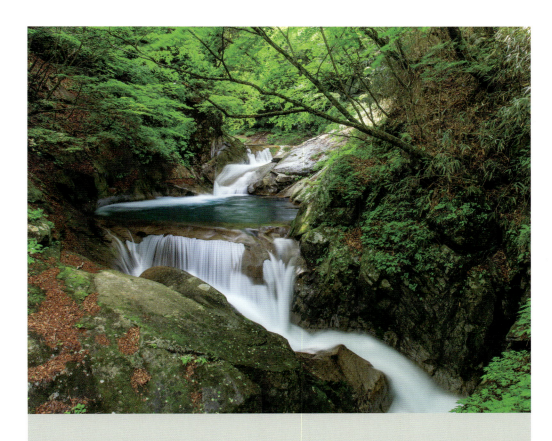

Koshinetsu Region
(Yamanashi, Nagano & Niigata)

甲信越

三重の滝〈Mie-no-taki〉山梨県山梨市／Yamanashi Pref.　落差：10 m
西沢渓谷の入り口から一時間ほど歩くと着く三段の滝。
This is the three-steps fall. You can reach it in an hour walking from the entrance to the Nishizawa Valley.

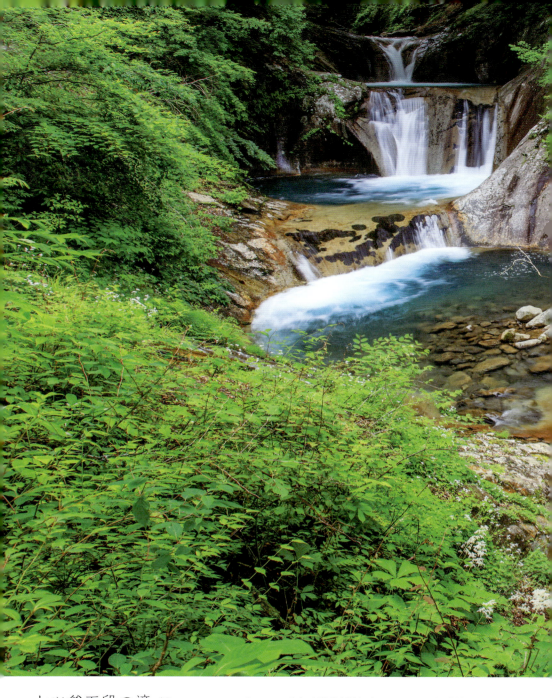

七ツ釜五段の滝 〈Nanatsugama-godan-no-taki〉 山梨県山梨市／Yamanashi Pref.　落差：30ｍ　★

富士川の支流・笛吹川の源流のひとつ、西沢が作る西沢渓谷にある。5つの滝と7つの滝壺からなる滝で渓谷の最奥で待ち構える名瀑。

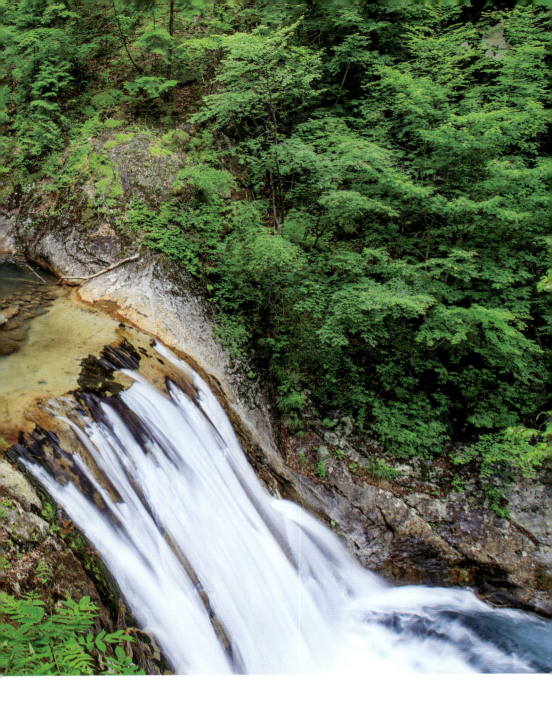
This fall drops into the Nishizawa Valley, a branch of the Fuji River. It consists of five falls and seven fall basins.

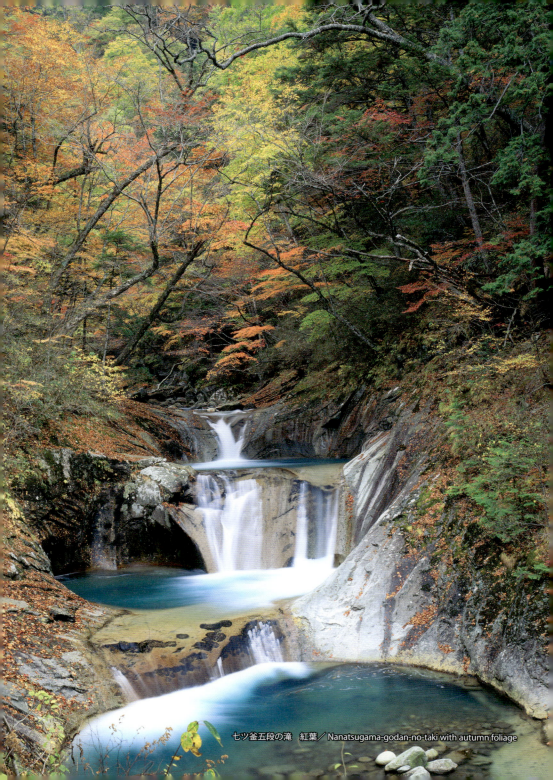

七ツ釜五段の滝 紅葉／Nanatsugama-godan-no-taki with autumn foliage

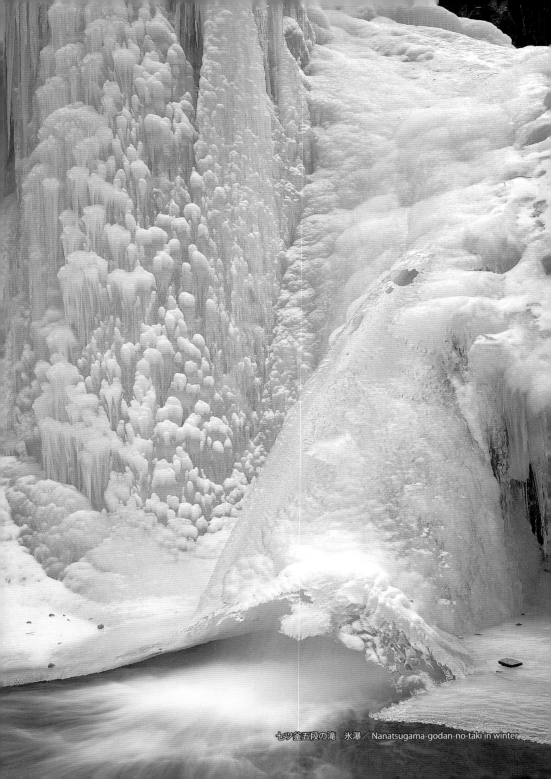

七ツ釜五段の滝　氷瀑／Nanatsugama-godan-no-taki in winter.

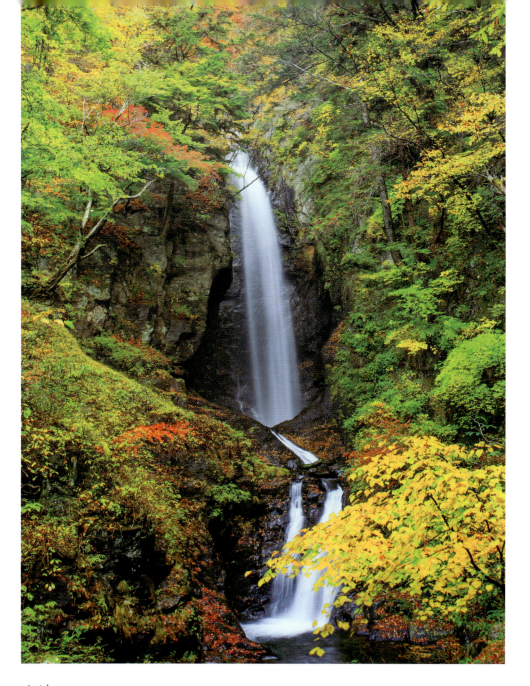

大滝 〈O-taki〉 山梨県甲府市／Yamanashi Pref. 落差：30 m
笛吹川の支流・荒川の上流部にある昇仙峡の奥、荒川ダムを超えたところにある板敷渓谷にかかる滝。
This fall drops into the Itajiki Valley, which is located behind the Arakawa Dam on the Ara River, in an inland area of Shosenkyo.

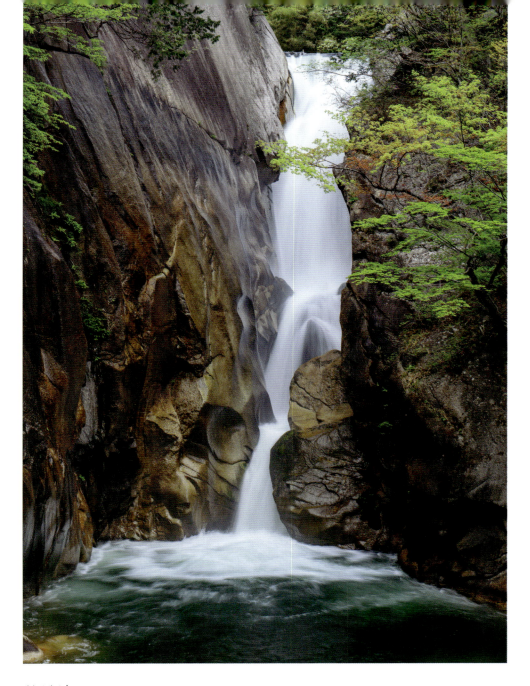

仙娥滝〈Senga-taki〉山梨県甲府市／Yamanashi Pref.　落差：30ｍ　★

荒川上流にかかる、昇仙峡を代表する滝。「仙娥」とは、中国の神話に登場する月に行った仙女「嫦娥」のこと。
This fall is one of the main sights of the Shosenkyo Valley containing the headstream of the Ara River. The name "Senga" is the name of a Chinese mythical fairy.

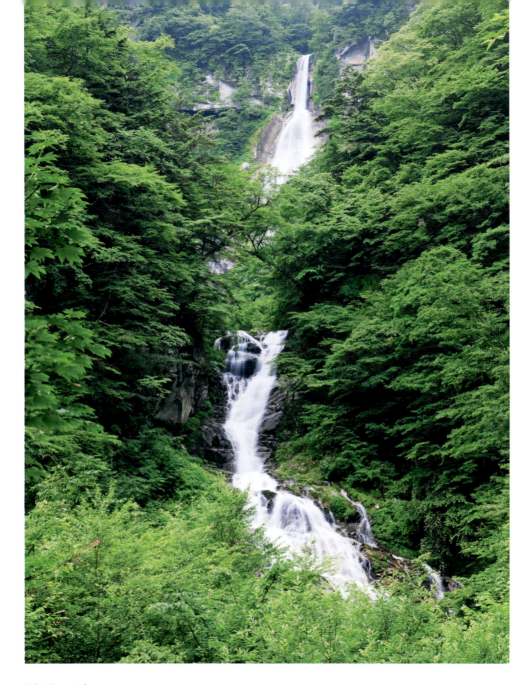

精進ヶ滝 〈Shoji-ga-taki〉 山梨県北杜市／Yamanashi Pref.　落差：121 m　★

石空川渓谷にかかる。かつて、神仏祈願の折、この滝で身を清めたことが名の由来。別名「北精進ヶ滝」。
This is a large scale fall dropping into the Ishiutoro River. In previous times, people visited here to purify themselves before praying to God.

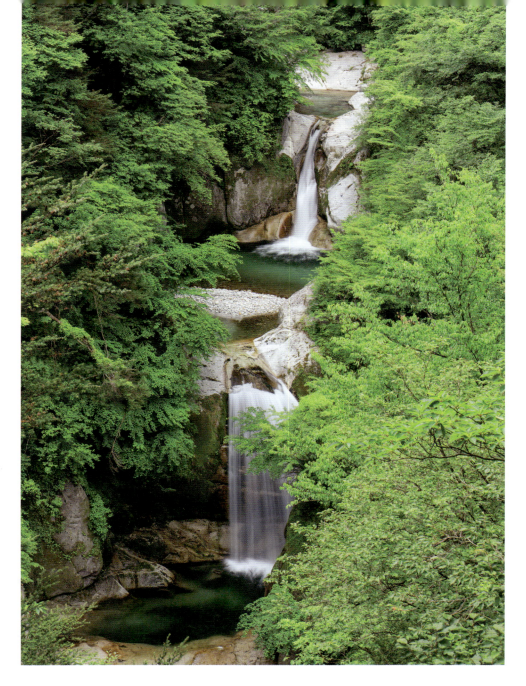

神蛇滝 〈Jinja-daki〉 山梨県北杜市／Yamanashi Pref. 落差：約40m
甲斐駒ケ岳に源を発する尾白川渓谷を代表する滝。三段に流れ落ちる姿が美しい。
This fall is a symbol of the Ojira River Valley, which originates in Mt. Kai-komagatake. It has three steps and the view is superb.

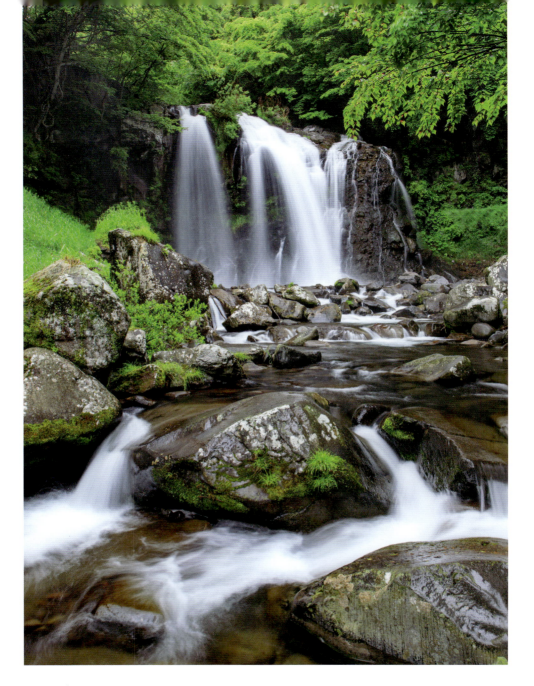

千ヶ滝 〈Senga-taki〉 山梨県北杜市／Yamanashi Pref. 落差：20ｍ

大門川にかかり、幅20ｍにかけて流れ落ちる。大門川にかかる大滝、宮詞の滝と合わせて、大門川三滝という。
This fall drops into the Daimon River. The water descends over a 20m width and it looks very powerful. This fall and other two falls along Daimon River are called "The three falls of the Daimon River".

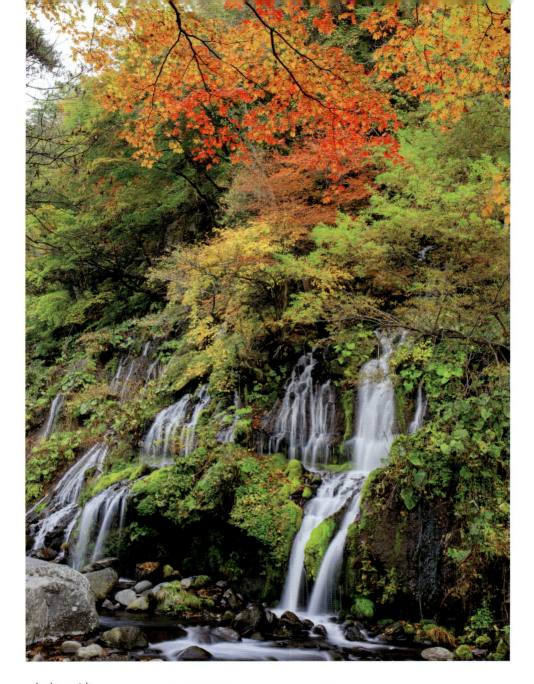

吐竜の滝 〈Doryu-no-taki〉 山梨県北杜市／Yamanashi Pref. 落差：10 m

川俣川東沢にかかる。岩間から湧き出した水が絹糸のように流れる様が神秘的で「竜の吐く滝」という名になった。
This fall drops into the Kawamata River. The water emerges among rocks and descends like silk strings. This mysterious view gave this fall the name "Doryu" (Dragon breathing).

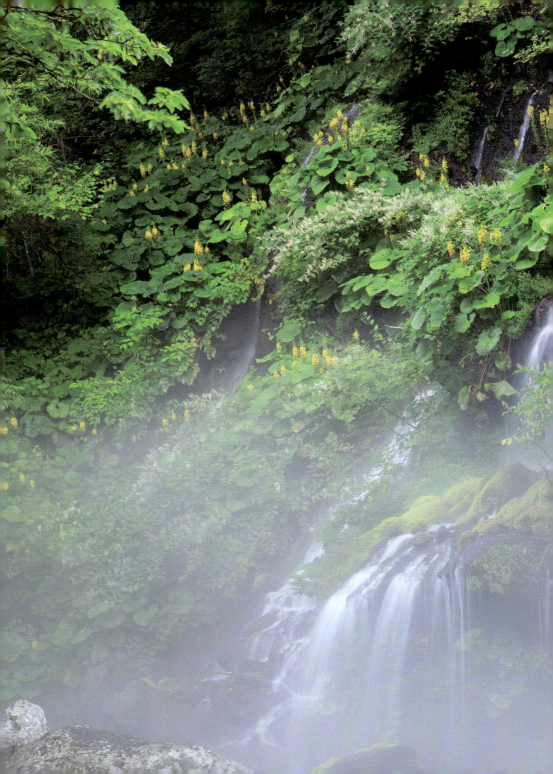

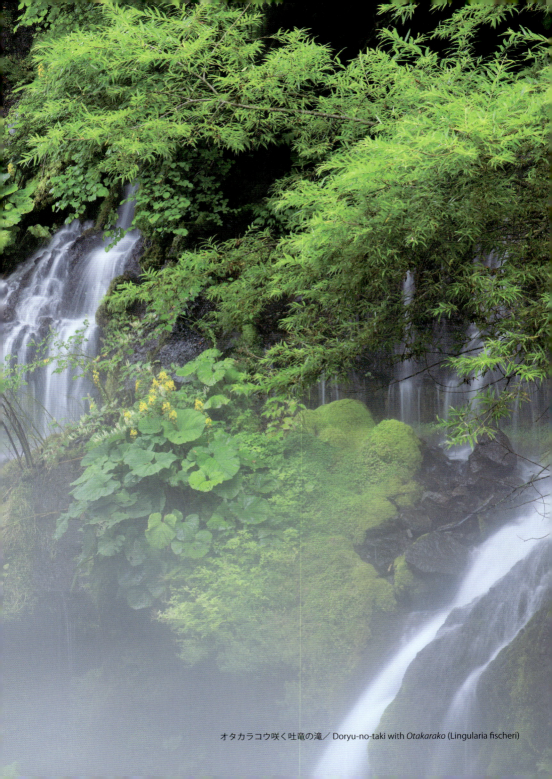

オタカラコウ咲く吐竜の滝／Doryu-no-taki with *Otakarako* (Lingularia fischeri)

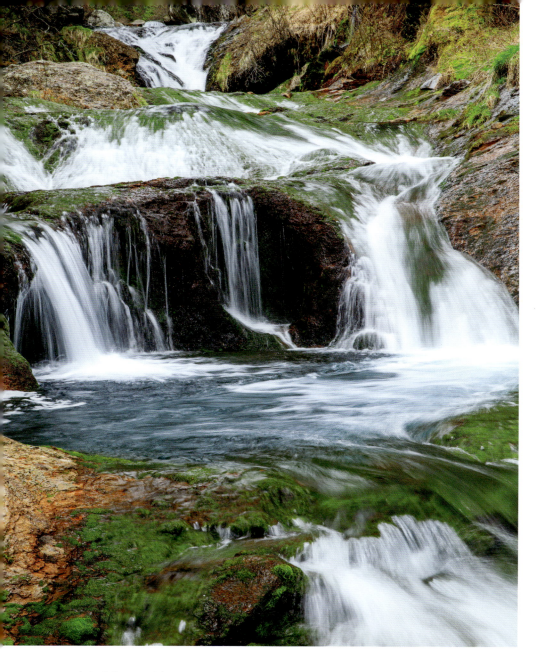

おしどり隠しの滝 〈Oshidorikakushi-no-taki〉 長野県茅野市／ Nagano Pref. 落差：不明

横谷渓谷の渋川には多くの滝がかかるが、その中でも最上流にかかる渓流瀑。チャツボミゴケが群生し、コケの緑と岩肌の赤が美しいコントラストをみせる。
This is the uppermost fall among many falls dropping into the Yokoya Valley. *Chatsubomigoke*, a special kind of moss, grows in clusters there and contrasts well with the red colored rocks.

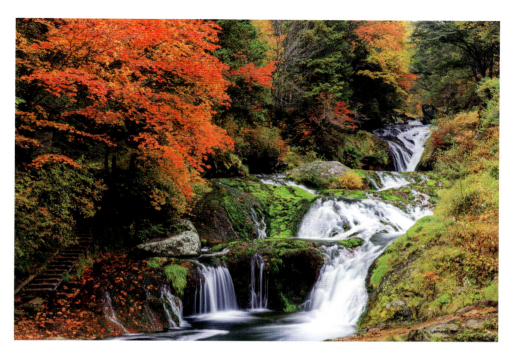
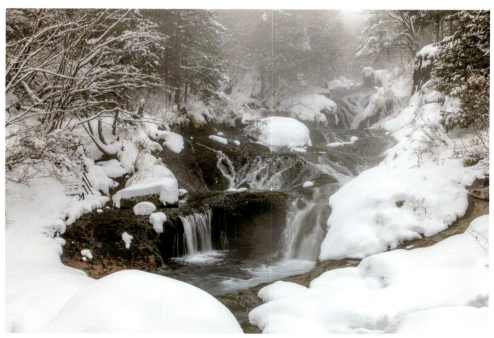

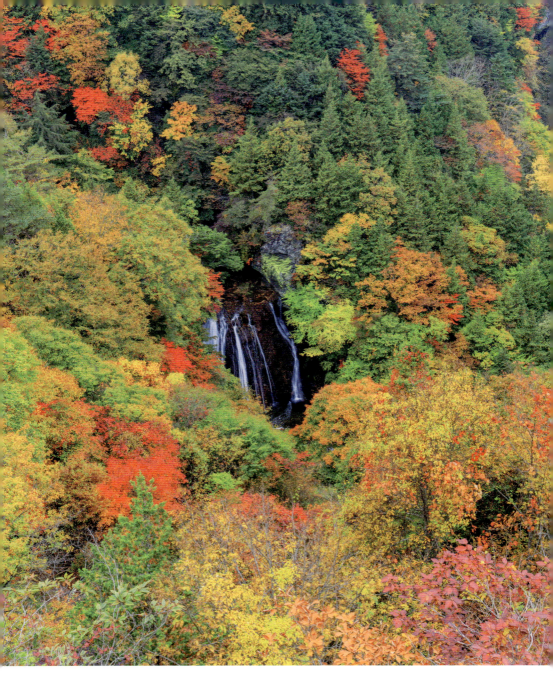

王滝 〈O-taki〉 長野県茅野市／ Nagano Pref. 落差：30 m

横谷渓谷最大の落差を誇る滝。渋川が二段になって落ちる段瀑。
The Shibu River descends in two steps. It drops the most among the falls of the Yokoya Valley.

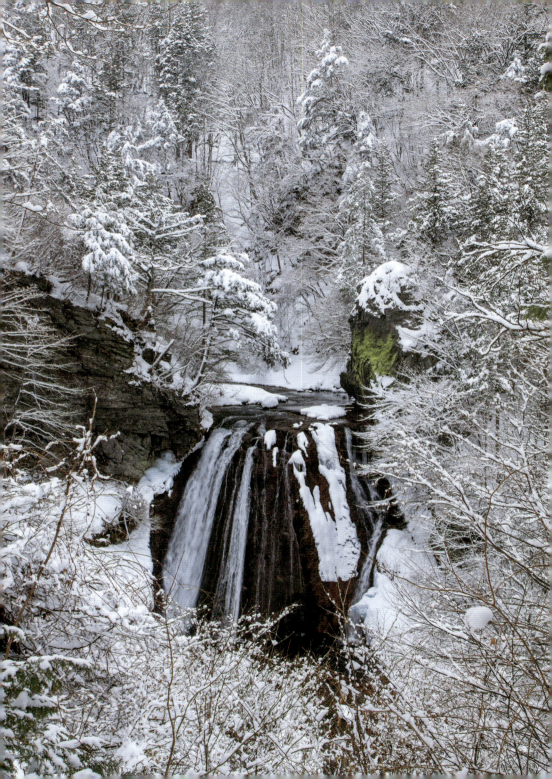

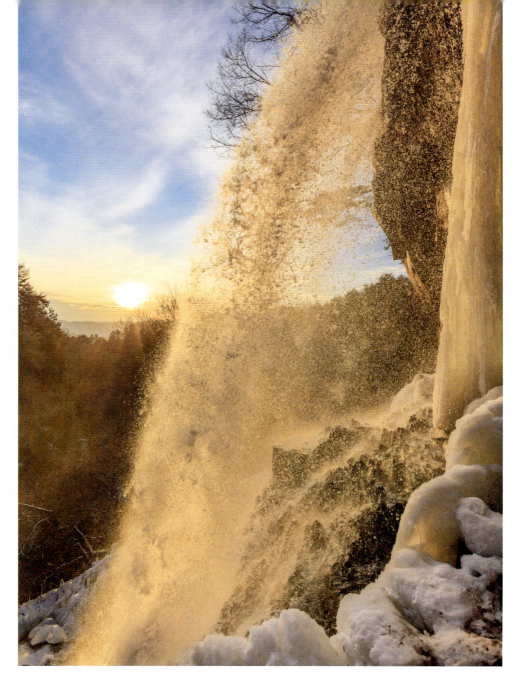

乙女滝 〈Otome-daki〉 長野県茅野市／ Nagano Pref.　落差：30 m

横谷渓谷の中で最下流にかかる滝。江戸時代に坂本養川により開削された農業用水路「大河原せぎ」の一部である。
This is the lowest among many falls along the Yokoya Valley. It is a part of "Ogawarasegi", an agricultural waterway established by SAKAMOTO Yosen in the Edo period (1603-1867).

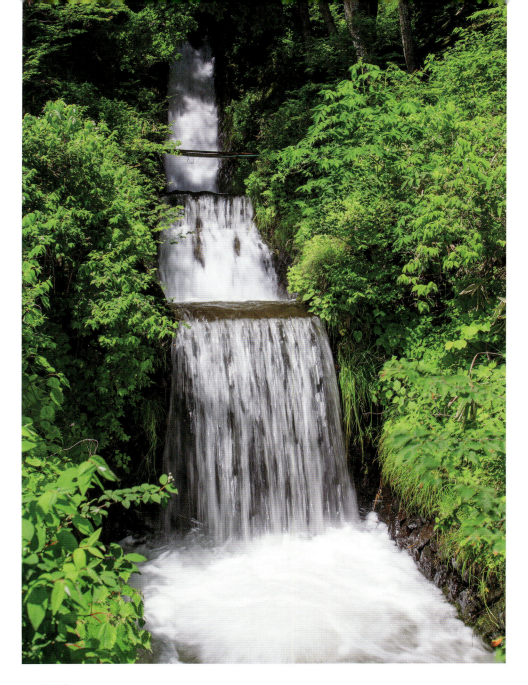

乙見滝 〈Otomi-daki〉 長野県茅野市／Nagano Pref. 落差：40 m

「音見滝」とも「乙美滝」とも表記される。乙女滝と同じく、「大河原せぎ」の一部でこの後水は柳川へと注ぐ。
This is also a part of "Ogawarasegi", an agricultural waterway established by SAKAMOTO Yosen. It drops into the Yanagi River.

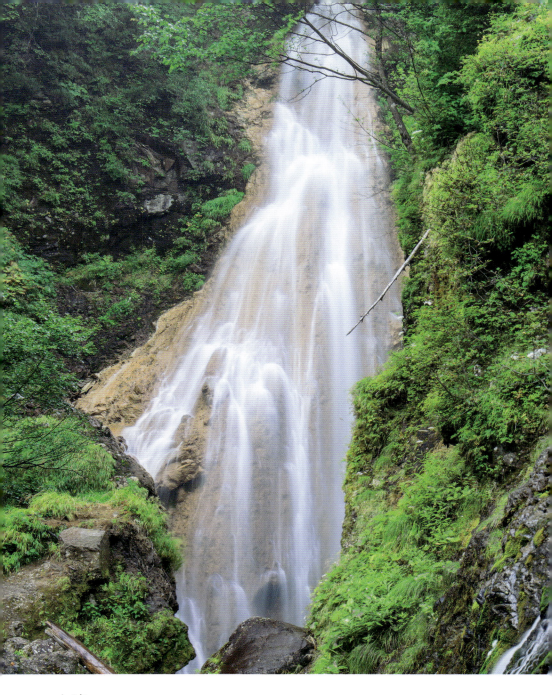

三本滝 〈Sanbon-daki〉 長野県松本市／Nagano Pref. 落差：50～60 m ★

乗鞍高原の小大野川源流に位置し、3つの滝が一か所に合流する。向かって右側と左側がそれぞれ小大野川の支流・クロイ沢、無名の沢に、中央が小大野川本流にかかる滝である。

126

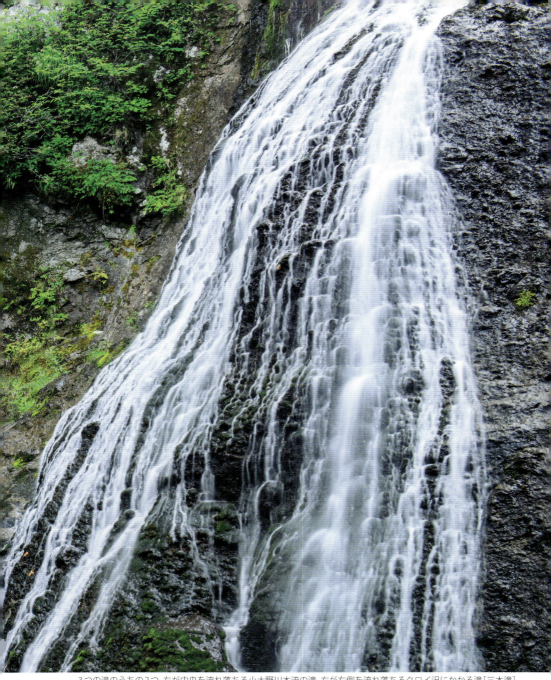

3つの滝のうちの2つ。左が中央を流れ落ちる小大野川本流の滝、右が右側を流れ落ちるクロイ沢にかかる滝［三本滝］
The two of the three falls of Sanbon-daki.

At this point, three falls, dropping into the headstreams of the Koono River in the Norikura highland, join together. The middle one descends into the mainstream and the other two drop into the branches.

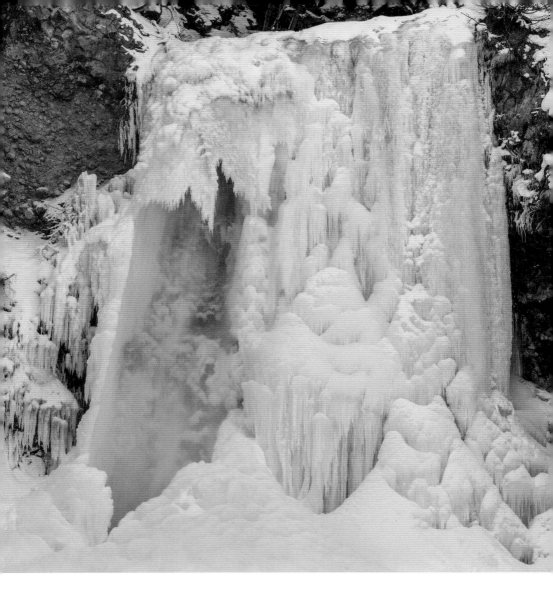

善五郎の滝 〈Zengoro-no-taki〉 長野県松本市／Nagano Pref. 落差：22 m

三本滝の下流に位置する。この滝と三本滝、番所大滝を総称して「乗鞍三滝」という。滝の名はイワナに滝壺へ引き込まれた釣りの名手「善五郎」の言い伝えによる。
This fall lies downstream of Sanbon-daki Fall. "The Norikura three falls" consists of Sanbon-daki, Bandokoro-otaki, as well as this. Legend has it that Zengoro, a man, who was good at fishing, was pulled into the stream by mountain trout and found this fall.

唐沢の滝 〈Karasawa-no-taki〉 長野県木曽町／Nagano Pref.　落差：100 m
古くから飛騨街道の名所として知られてきた。かつては高さ135mを誇ったが、道の改修により、落ち口が低くなった。
This fall has been widely known as one of the best scenic spots along the Hida-kaido Old Road since the old times. Before, it was 135m high, but now it has become lower because of road improvements.

こもれびの滝 〈Komorebi-no-taki〉 長野県木曽町／Nagano Pref. 落差：15 m

御嶽山の裾野にひろがる原生林・油木美林にある。その名の通り木漏れ日の美しいところにある2段の滝。
This fall drops into the primeval forest of Aburagibirin of Mt. Ontake. It has two steps. When it is lit by the sunlight streaming down through the foliage, it looks magnificent.

不易の滝 〈Fueki-no-taki〉 長野県木曽町／Nagano Pref. 落差：30 m

油木美林にある滝。岩肌から沁みだした清水が流れ落ちる。滝名は古くからその姿を変えない滝という意。
This fall also drops into the primeval forest of Aburagibirin. The water emerges among rocks, separating into white lines and descends. "Fueki" means that the shape of the fall never changes.

千ヶ滝 〈Senga-taki〉 長野県軽井沢町／Nagano Pref. 落差：20 m

浅間山東麓に位置し、軽井沢最大の落差をほこる。遊歩道「せせらぎの道」が整備されている。
This fall is located at the eastern foot of Mt. Asama. It is the highest among the falls in the Karuizawa area. The walking path, "Seseragi-no-michi" leads there.

白糸の滝 〈Shiraito-no-taki〉 長野県軽井沢町／Nagano Pref. 落差：3m

浅間山東麓、湯川源流部。半円を描く岩盤を、岩肌から湧き出した水が、まさしく白糸のように流れ落ちる。

This fall is the headstream of the Yu River at the eastern foot of Mt. Asama. The water descends like white strings from the semicircular bedrock.

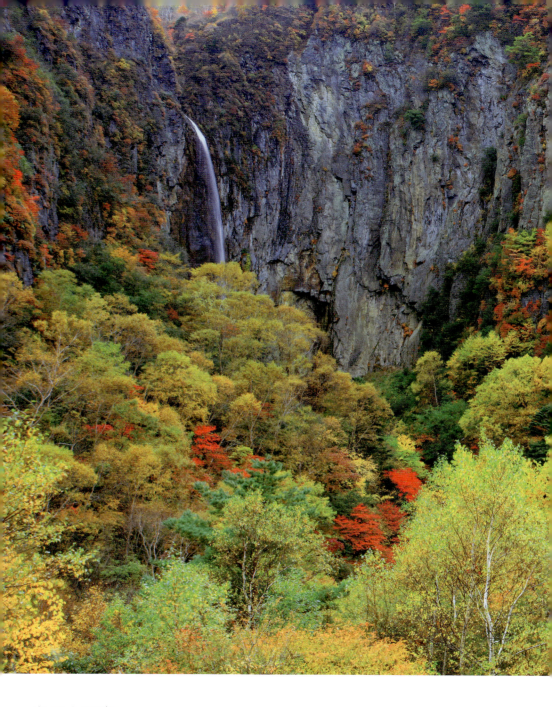

米子大瀑布 〈Yonako-dai-bakufu〉 長野県須坂市／Nagano Pref.　落差：不動滝 85 m　権現滝 80 m　★
米子大瀑布は四阿山の北麓にかかる権現滝(向かって左)と不動滝(向かって右)の総称。

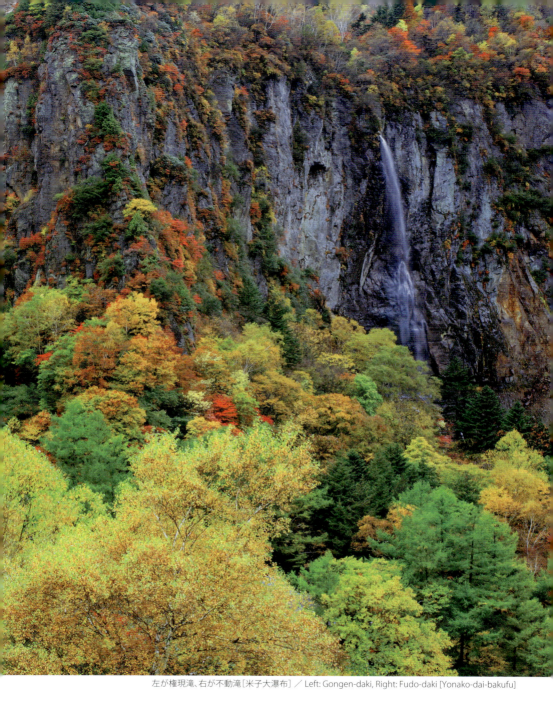

左が権現滝、右が不動滝［米子大瀑布］／ Left: Gongen-daki, Right: Fudo-daki [Yonako-dai-bakufu]

The two falls drop into the northern foot of Mt. Azumaya. The left one is called "Gongen-daki" and the right is called "Fudo-daki".

唐沢の滝 〈Karasawa-no-taki〉 長野県上田市／Nagano Pref.　落差：15 m
菅平高原の入り口にある。しぶきが高くあがり、滝が落ちた後の流れも美しい。
This fall is located at the entrance of the Sugadaira Highland. The water descends with big splashes, and after descending the stream runs beautifully.

八滝 〈Ya-taki〉 長野県高山村／Nagano Pref. 落差：180 m

松川渓谷にある。松川は千曲川の支流。8つの滝壺を持つ段瀑。紅葉の季節もまたすばらしい。
This fall drops into the Matsukawa Valley, a branch of the Chikuma River. It has eight waterfall basins and descends in eight steps. The view of the autumn foliage is excellent.

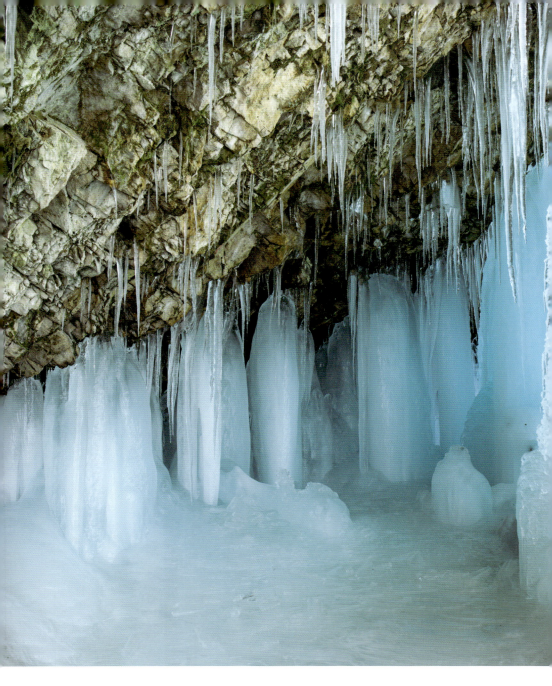

雷滝 〈Kaminari-daki〉 長野県高山村／Nagano Pref.　落差：30 m

松川渓谷、八滝の上流にある。別名「裏見の滝」。裏側からも滝をみることができる。
This fall is located in the upper stream of Ya-taki. It is also known as "Urami-no-taki", which means that you can see the fall from behind.

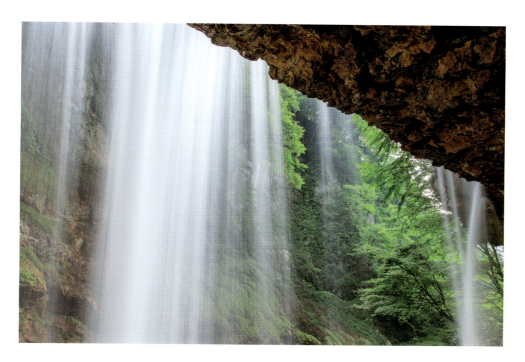
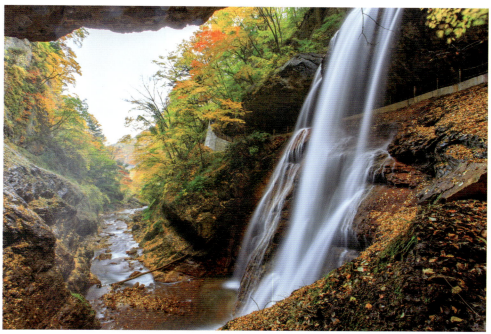

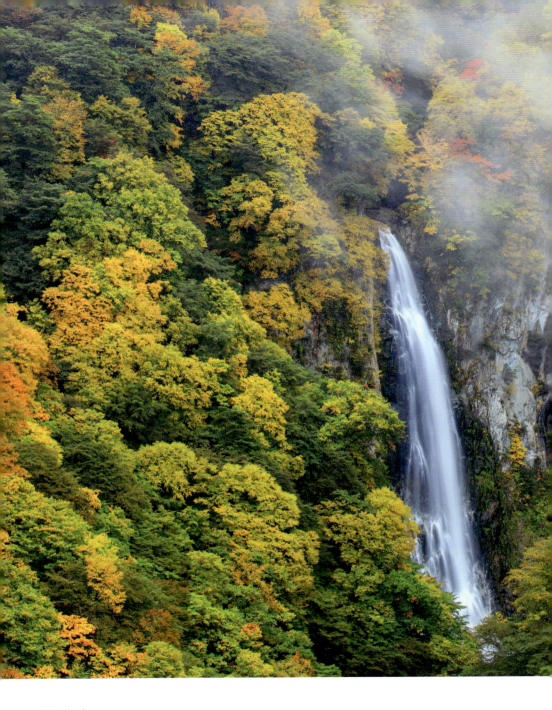

澗満滝 〈Kanman-daki〉 長野県山ノ内町／ Nagano Pref. 落差：107 m
角間川が断崖を流れ落ちる落差の大きな滝。志賀草津高原ルート沿いに展望台がある。

The Kakuma River descends dynamically from a cliff and it becomes a large scale fall. You can see it from the viewing deck along the Shiga-Kusatsu Kogen Route Driveway.

苗名滝 〈Naena-taki〉 新潟県妙高市／ Niigata Pref.　落差：55 m　★

長野県との県境を流れる関川本流にかかる。地響きをたてて流れ落ちることから「地震滝」の別名を持つ。
This fall drops into the Seki River that runs on the border between Niigata Pref. and Nagano Pref. The water descends with heavy rumble; therefore, it is known by the name of "Jishin-taki" (Earthquake fall).

惣滝 〈Sou-taki〉 新潟県妙高市／ Niigata Pref. 落差：80 m ★
大田切川源流部・大倉谷にかかる。「燕溶岩」と呼ばれる安山岩の切り立った断崖を流れ落ちる。

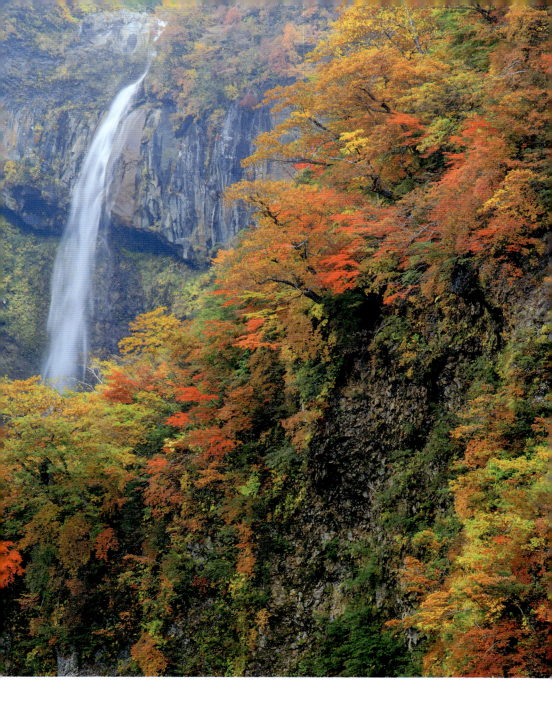

This fall drops into the headstream of the Otagiri River. The water descends on a sheer rocky cliff called "Tsubame-yogan".

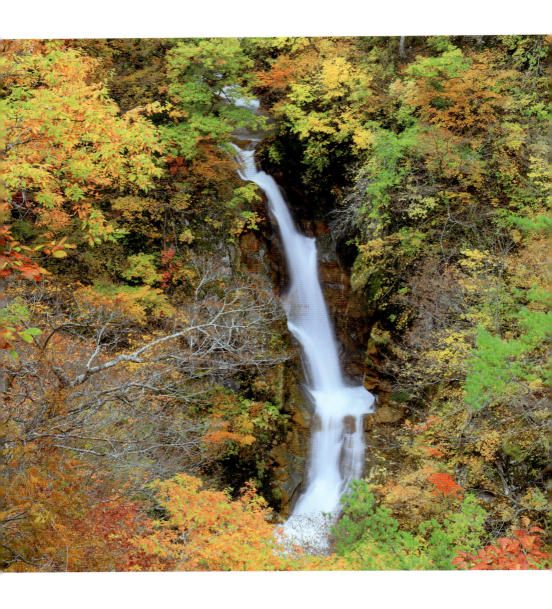

蛇淵の滝 〈Jabuchi-no-taki〉 新潟県津南町／Niigata Pref.　落差：30 m

長野県との県境・秋山郷にかかる滝。その昔、熊取名人が熊を追ってこのあたりに来た時、川にかかった丸太と思い、渡ったところ、それは大蛇であった、という伝説が滝名の由来。
This fall is located in Akiyama-go district, which is on the border between Niigata Pref. and Nagano Pref. Legend has it that a long time ago, an expert bear hunter mistook a giant snake as a log bridge. Therefore, it is named "Jabuchi" (Snake pond).

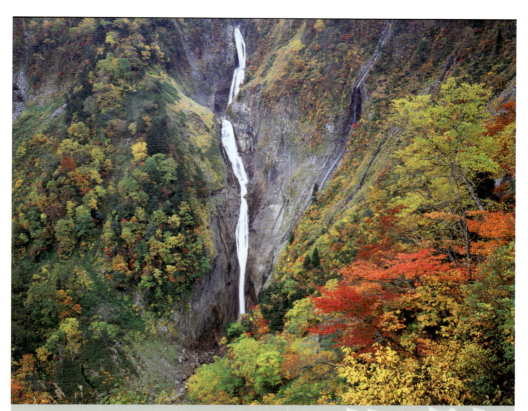

Hokuriku & Tokai
(Central Honshu)

北陸 東海

称名滝 〈Shomyo-daki〉富山県立山町／Toyama Pref.　落差：350 m　★

称名滝は立山連峰を源流とする落差日本一の滝。滝の音が「南無阿弥陀仏」と称名念仏を唱えるように聞こえるというのが滝名の由来。融雪期には向かって右にハンノキ滝が現れる。

The drop of this fall, which originates from its headstream in Mt. Tateyama Range, is the greatest in Japan. In the snowmelt season, Hannoki-daki appears at the right side of the main drop.

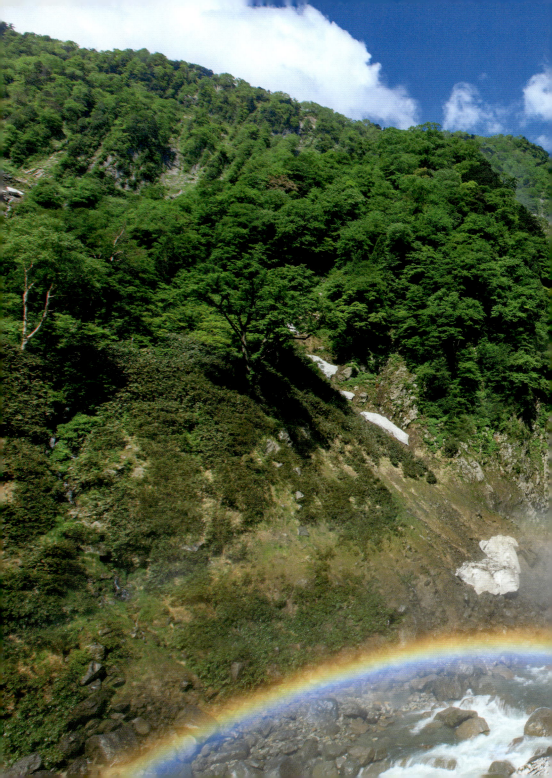

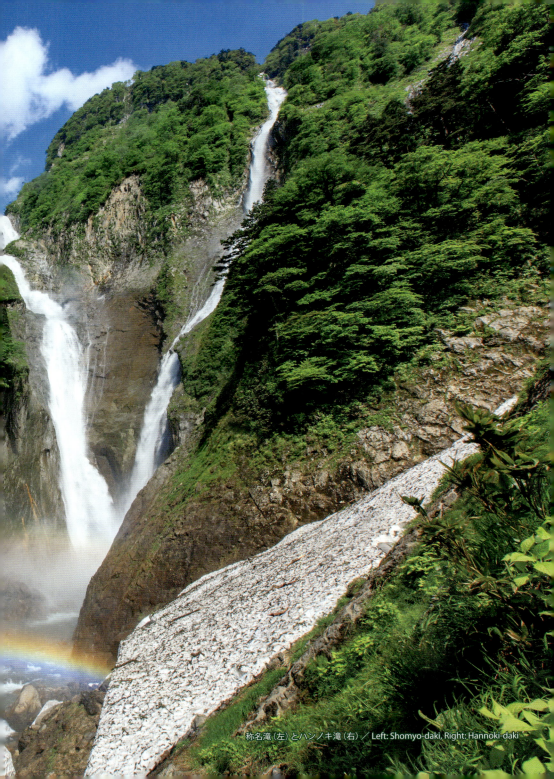

称名滝（左）とハンノキ滝（右）／ Left: Shomyo-daki, Right: Hannoki-daki

常虹の滝 〈Tokoniji-no-taki〉 富山県富山市／Toyama Pref.　落差：蛇歯見の滝 25 m　夫婦滝 20 m
猪谷川下流にある。蛇歯見の滝、五色の滝、二筋の夫婦滝、大滝(不動滝)の総称。

左が夫婦滝（水量の関係で一筋となっている）、右が蛇歯見の滝［常虹の滝］
Left: Meoto-daki, Right: Jabami-no-taki [Tokoniji-no-taki]

"Tokoniji-no-taki" is the general term for the falls dropping into the downstream of the Inotani River, such as Jabami-no-taki, Goshiki-no-taki, Meoto-daki, and O-taki.

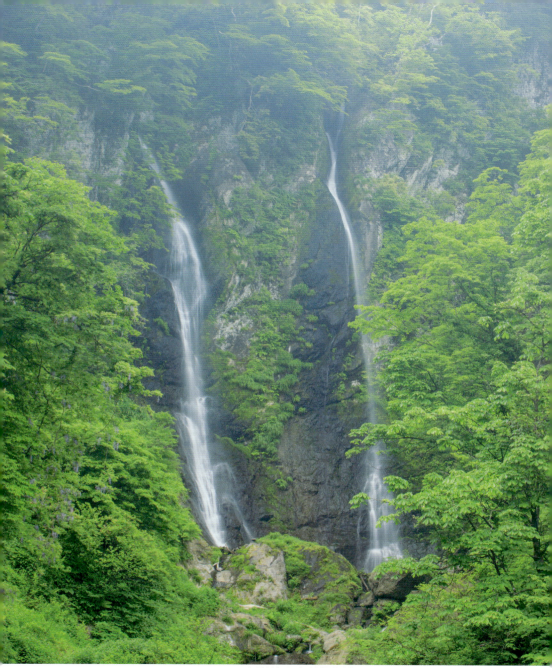

左が女滝、右が男滝［夫婦滝］／ Left: Me-daki, Right: O-daki [Meoto-daki]

夫婦滝 〈Meoto-daki〉 富山県南砺市／Toyama Pref. 落差：38 m

夫婦の仲が良く、夜になると重なり合うという伝説がある。向かって右が男滝、左が女滝。
"Meoto" means a married couple. There are two falls. The right one is called "O-daki"(Husband fall) and the left one is "Me-daki" (Wife fall). Legend has it that at night they overlap each other.

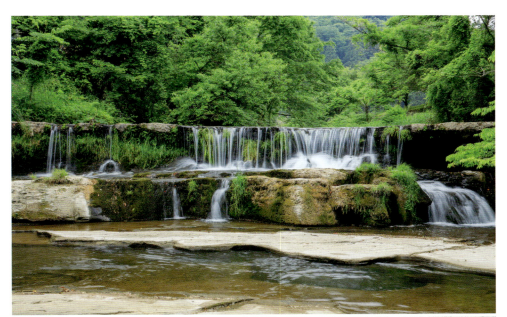

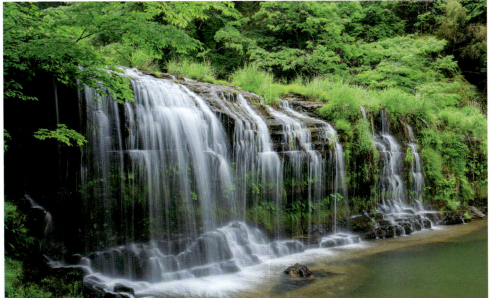

上:一の滝　下:二の滝　[宮島峡一の滝・二の滝]／Top: Ichi-no-taki, Bottom: Ni-no-taki [Miyajimakyo Ichi-no-taki & Ni-no-taki]

宮島峡一の滝・二の滝 〈Miyajimakyo Ichi-no-taki & Ni-no-taki〉 富山県小矢部市／
Toyama Pref.　落差：一の滝 3 m　二の滝上段 1 m・中段 2 m・下段 5 m

子撫川が流れ落ちて形成される滝。上流から三の滝・二の滝・一の滝と流れる。一の滝周辺の甌穴群も有名。
The Konade River descends and turns into this fall. The upper step, "San-no-taki", goes down as "Ni-no-taki", and leads to the lowest, "Ichi-no-taki". The group of potholes near Ichi-no-taki is famous.

垂水の滝 〈Tarumi-no-taki〉 石川県輪島市／Ishikawa Pref.　落差：35m

曽々木海岸にあり、山から海へと流れ落ちる。冬場の強風により、流れが下から上へ吹き上げられることがあるため、「吹き上げの滝」「逆さ滝」の別名を持つ。
This fall is located on the Sosogi coast and the water descends directly from the mountains to the sea. In winter, a strong wind sometimes blows the water into the air. Therefore, it also known as "Fukiage-no-taki" (Blowing upwards fall).

かもしか滝 〈Kamoshika-taki〉 石川県白山市／Ishikawa Pref.　落差：不明

滝名はこのあたりがニホンカモシカの有数の生息地であるため。五段で落ちるため別名「五重の滝」ともいわれる。蛇谷渓谷にかかる。3段目で流れが跳ねあがるのが特徴。白山白川郷ホワイトロード沿いの滝。
The area around this fall is one of the habitats of the "Kamoshika" (Japanese serow). It is also known as "Goju-no-taki" (Five-storied fall), because it has five steps. It drops into the Jadani Valley and is located beside the Hakusan Shirakawa-go White Road.

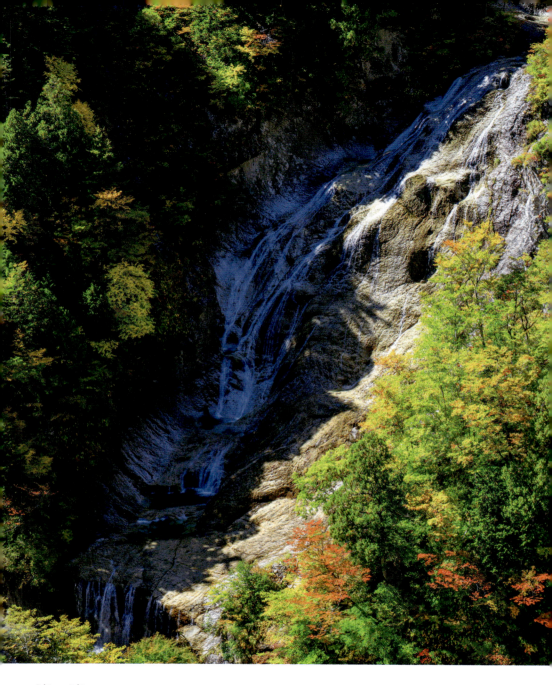

姥ヶ滝 〈Uba-ga-taki〉 石川県白山市／Ishikawa Pref.　落差：76m　★

白山白川郷ホワイトロード沿いの滝。流水が老婆の白髪を思わせることからこの名がついたという。
This fall is located beside the Hakusan Shirakawa-go White Road. "Uba" means an old woman. It is said that the descending water with its many lines looks like a white-haired old woman swinging her hair.

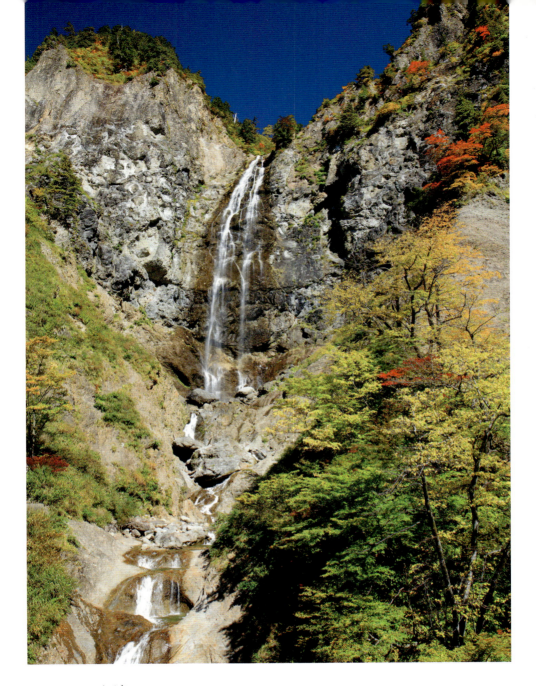

ふくべの大滝 〈Fukube-no-otaki〉 石川県白山市／Ishikawa Pref. 落差：86 m

白山白川郷ホワイトロード沿い、蛇谷渓谷の滝の中でも最大の落差を誇る滝。
This fall is located beside the Hakusan Shirakawa-go White Road. It is the highest among the falls in the Jadani Valley.

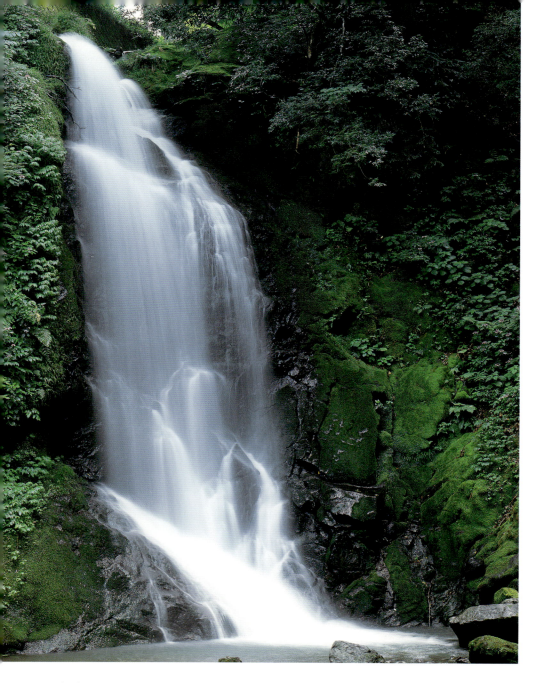

一乗滝 〈Ichijo-daki〉 福井県福井市／Fukui Pref. 落差：12m

一乗谷川にかかる滝。佐々木小次郎はこの滝で修行を積み、剣術の「燕返し」をあみだしたと伝わる。
This fall drops into the Ichijodani River. It is said that SASAKI Kojiro, a famous swordsman, trained himself here and developed a new type of swordplay.

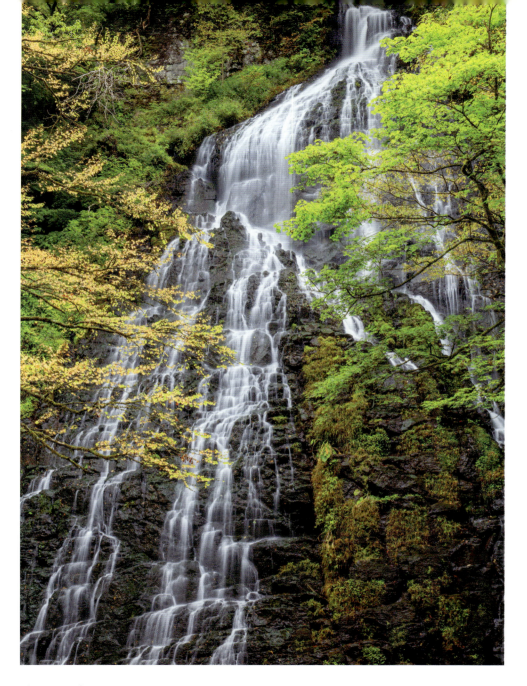

龍双ヶ滝 〈Ryuso-ga-taki〉 福井県池田町／Fukui Pref. 落差：60m ★

部子川上流にかかる滝。昔龍双(宗)という僧がこの地で修行したとも、滝壺に住む龍が時折滝上りをしたとも伝わる滝。
This fall drops into the upper stream of the Heko River. Legend has it that a long time ago, a monk named Ryuso trained here. Another legend says that a dragon living in the basin of this fall sometimes came up the fall.

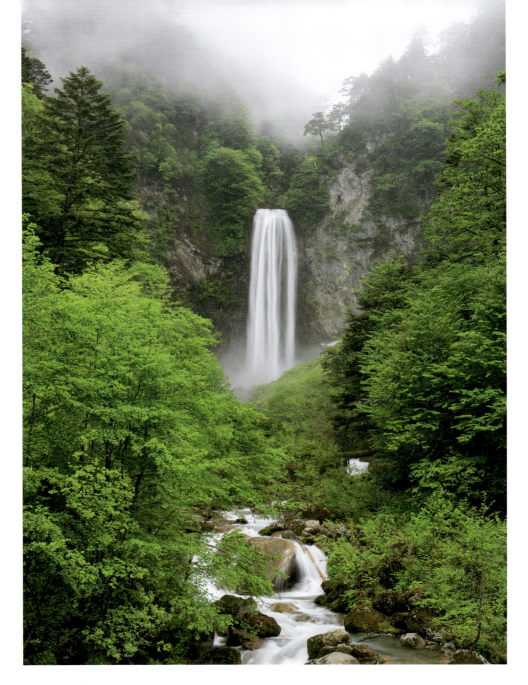

平湯大滝〈Hirayu-otaki〉岐阜県高山市／Gifu Pref. 落差：64 m ★

大滝川にかかる。飛騨三大名瀑のひとつ。水量豊かでダイナミックな滝。冬の氷瀑も圧巻である。
This fall drops into the Otaki River. It is one of the best three falls in the Hida Area. The ice fall in winter is magnificent.

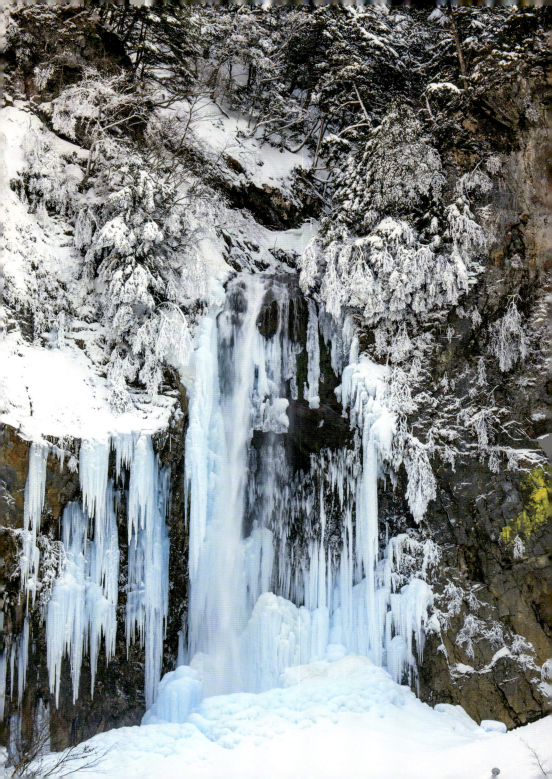

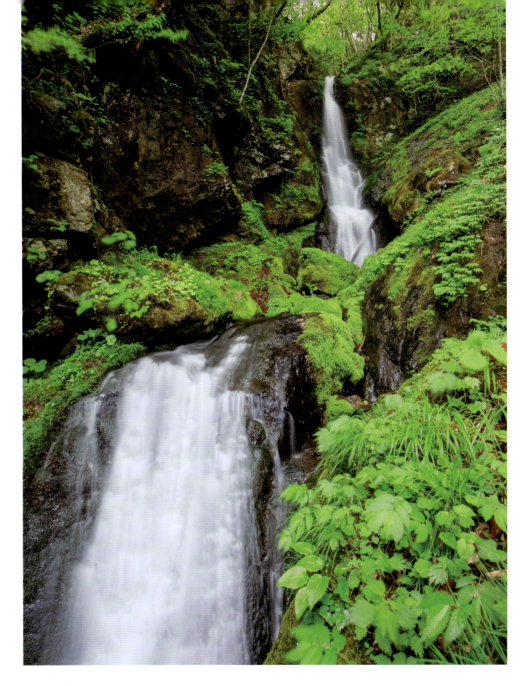

百間滝 〈Hyakken-daki〉 岐阜県高山市／Gifu Pref.　落差：不明
小八賀川支流にかかる滝。芦谷集落近くにある、延長百間（おおよそ180m）ともいわれる段瀑。
This fall drops into a branch of the Kohachiga River. It is located near the Ashidani Village.

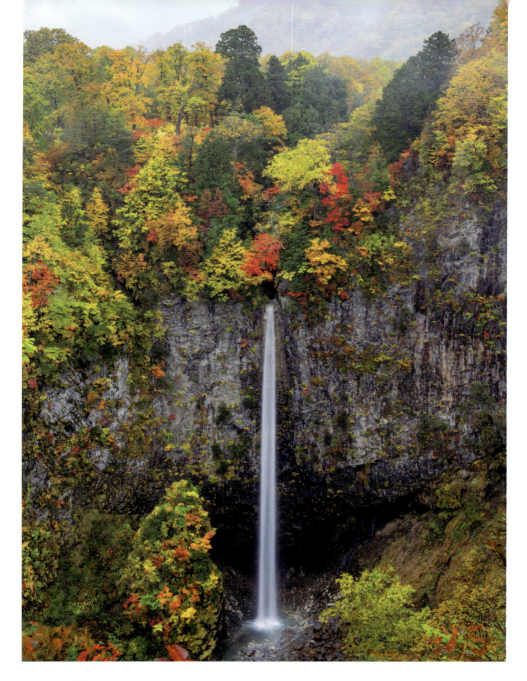

白水の滝 〈Shiramizu-no-taki〉 岐阜県白川村／Gifu Pref.　落差：72 m

3000年前、火山の噴火でできた湖から水があふれ、白水の滝となった。なお現在上流にある白水湖はダム湖。
About 3000 years ago, after the Oshira River backed up following a volcanic eruption, a lake appeared on the present site. The water that flowed from the lake became the fall. The current Hakusui Lake is a man-made lake, created by a dam.

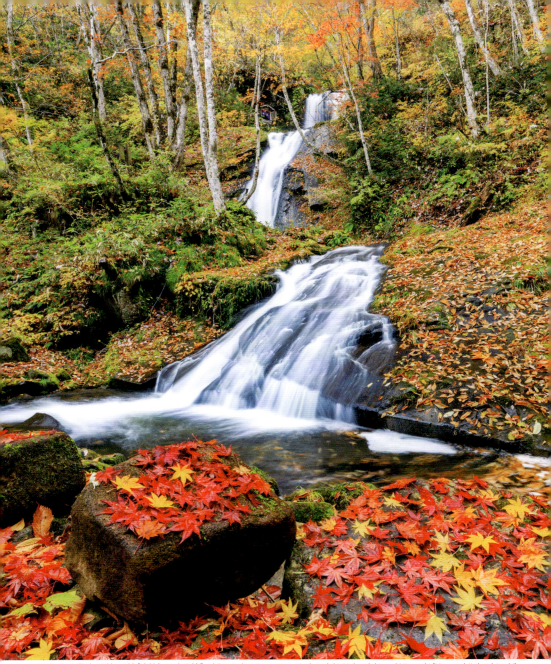

上流から上段滝、函滝、平滝［宇津江四十八滝］／From the upper step: Jodan-daki, Hako-daki and Hira-taki [Utsue-shijuhachi-taki]

宇津江四十八滝 〈Utsue-shijuhachi-taki〉 岐阜県高山市／Gifu Pref.　落差：王滝 18.8 m

四十八滝川にかかる大小の滝の総称。宇津江四十八滝県立自然公園として整備され、散策が楽しめる。
"Utsue-shijuhachi-taki" is the general term for the falls dropping into the Shijuhachi-taki River. The area around has been developed as a nature park and you can enjoy walking through along a 880m path to the innermost fall.

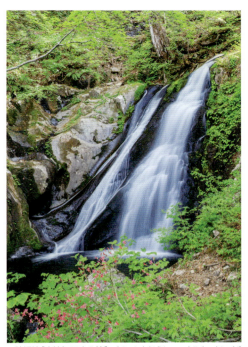

障泥滝［宇津江四十八滝］／ Aori-daki [Utsue-shijuhachi-taki]

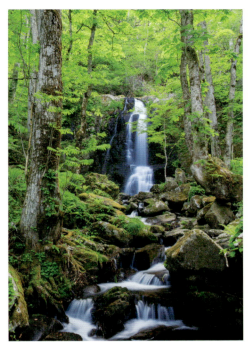

王滝［宇津江四十八滝］／ O-taki [Utsue-shijuhachi-taki]

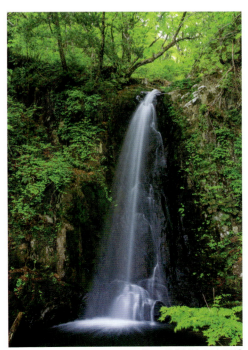

銚子口滝［宇津江四十八滝］
Choshikuchi-daki [Utsue-shijuhachi-taki]

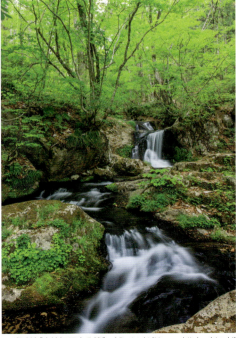

瑠璃滝［宇津江四十八滝］／ Ruri-taki [Utsue-shijuhachi-taki]

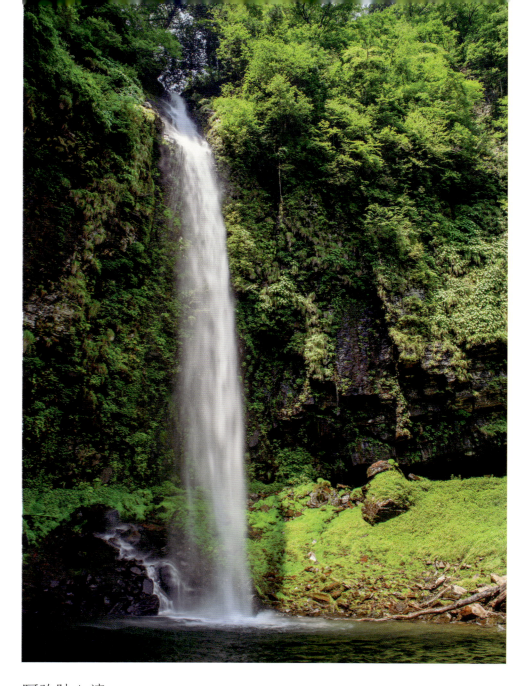

阿弥陀ケ滝 〈Amida-ga-taki〉 岐阜県郡上市／Gifu Pref.　落差：60 m　★

古くから名瀑として知られ、「郡上おどり」の歌詞にも登場し、また葛飾北斎の「諸国滝廻り」にも描かれた。
This fall has been well known as a superb fall since the old times. It appears in the lyrics of the song of a famous Bon-dance, "Gujo-Odori", and it was drawn in a picture by a famous Ukiyo-e painter, KATSUSHIKA Hokusai.

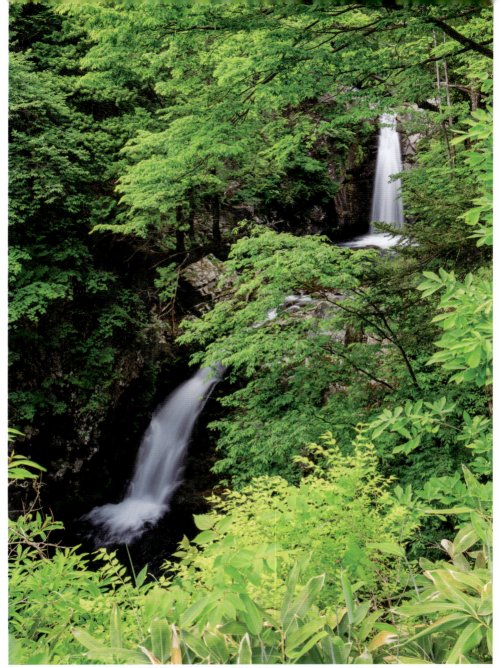

上段が女滝、下段が男滝［女男滝］／ The upper step: Me-daki, The lower step: O-daki [Meoto-daki]

女男滝 〈Meoto-daki〉 岐阜県高山市／ Gifu Pref. 落差：15 m

牛牧谷の渓流が益田川に合流するあたりにかかる。上段が女滝、下段が男滝。
This fall drops into the junction where the Ushimakidani River merges into the Mashita River. The upper step is called "Me-daki" (Female fall) and the lower step is called "O-daki" (Male fall).

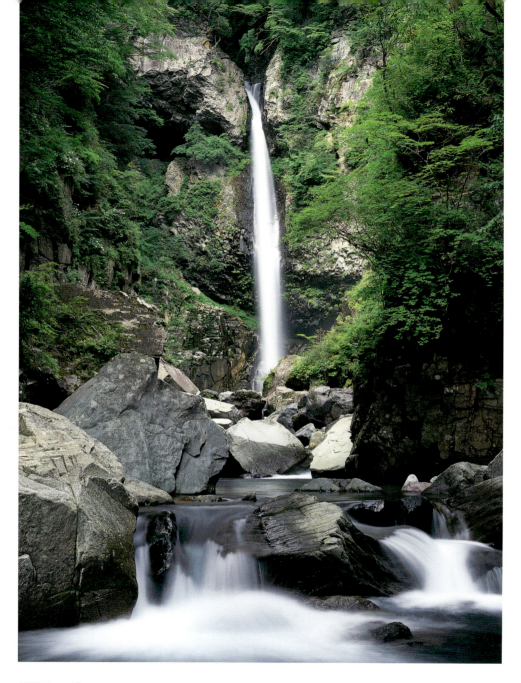

根尾の滝 〈Neo-no-taki〉 岐阜県下呂市／Gifu Pref. 落差：63 m ★

小坂川上流・濁河川にかかる。小坂は滝の多い所として知られ、200以上の滝が確認されている。
This fall drops into the Nigorigo River, the upper stream of the Kosaka River. The Kosaka River is known for its more than 200 falls.

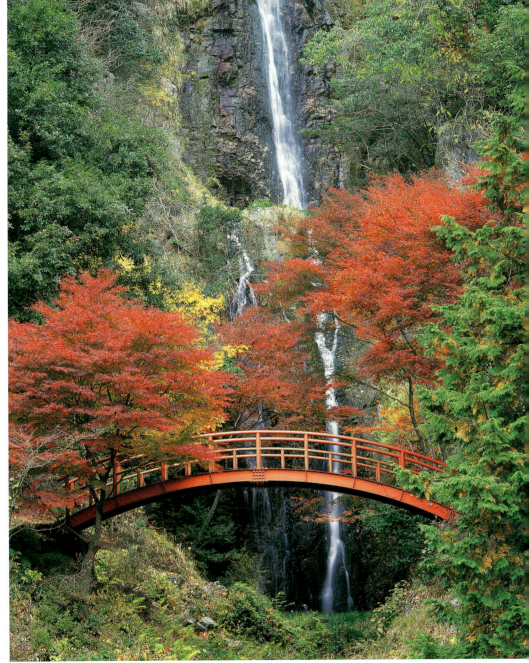

上流から一の滝、二の滝［五宝滝］／ The upper step: Ichi-no-taki, The lower step: Ni-no-taki [Goho-daki]

五宝滝 〈Goho-daki〉 岐阜県八百津町／ Gifu Pref. 落差：80 m（一の滝・二の滝・三の滝の 3 段を合わせた落差）

一の滝、二の滝、三の滝、二天の滝、円明の滝の総称。二天・円明の二滝は宮本武蔵が修行した滝といわれる。
Goho-daki is the general term for the five falls of Ichi-no-taki, Ni-no-taki, San-no-taki, Niten-no-taki and Enmei-no-taki. Niten-no-taki and Enmei-no-taki are said to be places where a famous swordsman, MIYAMOTO Musashi, trained.

171

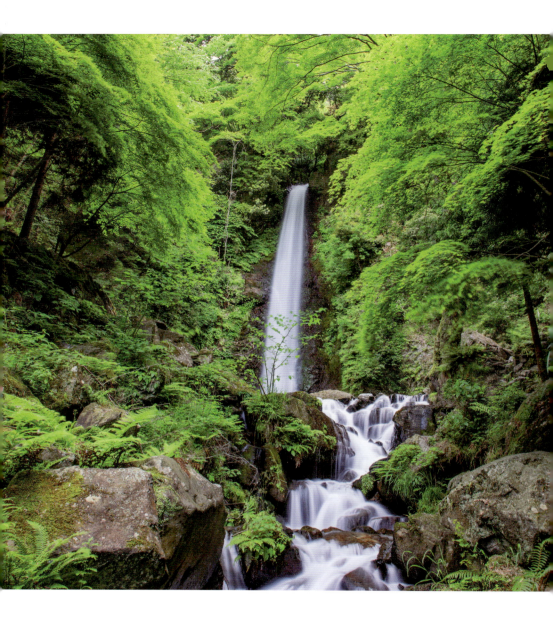

養老の滝 〈Yoro-no-taki〉 岐阜県養老町／Gifu Pref.　落差：30 m　★

病気の老父を案じる息子の思いが通じて滝近くの湧水が酒となり、それを飲んだ老父が元気になり、若返った。その話をきいた元正天皇がこの地を訪れ、この地を「養老」と名付けたと伝わる。

"Yoro" means to respect old people and take care of them. Legend has it that a long time ago, a son, who was concerned about his sick father, prayed for his father's recovery at the fall and his father got well. The emperor Gensho heard this story and named this area "Yoro".

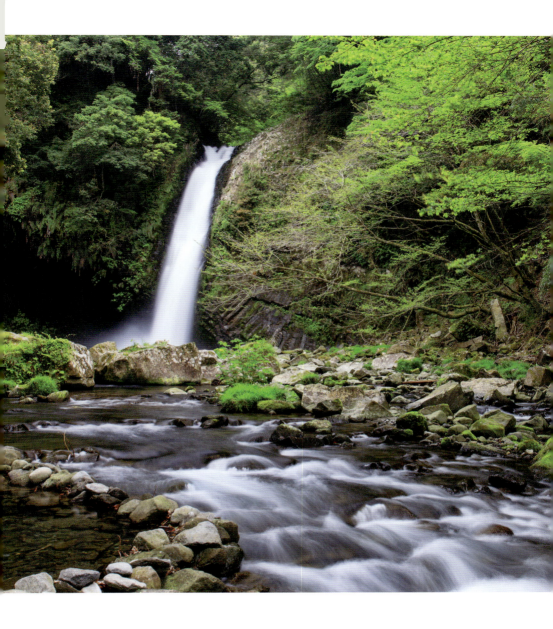

浄蓮の滝 〈Joren-no-taki〉 静岡県伊豆市／Shizuoka Pref. 落差：25 m ★

狩野川上流の本谷川にかかる滝。滝周囲の岩肌には県の天然記念物のハイコモチシダが群生している。「天城越え」の歌にも登場し、また女郎蜘蛛伝説でも名高い。
This fall drops into the Hontani River, the upper stream of the Kano River. On the surface of the rocks near the fall grows *Haikomochishida*, which is a kind of fern designated as a protected species.

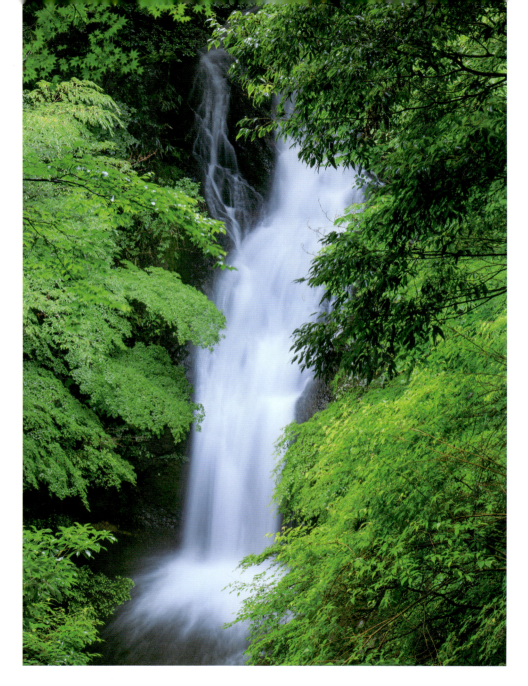

二階滝 〈Nikai-daru〉 静岡県河津町／Shizuoka Pref.　落差：20 m

本谷川（河津川）の源流にかかる滝。河津で滝を「たる」と呼ぶのは「垂水（たるみ）」に由来するという。
This fall drops into the headstream of the Hontani River. "Daru" in the fall name, Nikai-daru, means "taki" (fall).

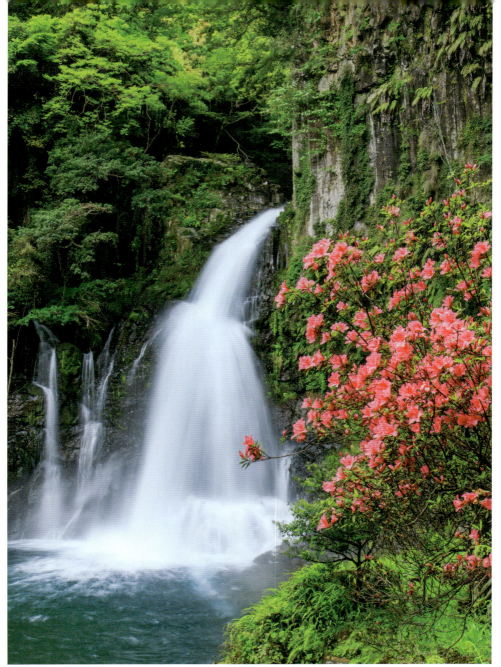

大滝[河津七滝]／O-daru[Kawazu-nana-daru]

河津七滝 〈Kawazu-nana-daru〉 静岡県河津町／Shizuoka Pref. 落差：大滝 30 m

河津川上流にかかる。大滝をはじめ、出合滝、カニ滝、初景滝、蛇滝、エビ滝、釜滝の7滝の総称。
"Kawazu-nana-daru" is the general term for the seven falls dropping into the upper stream of the Kawazu River. They include Deai-daru (2m high), Kani-daru (2m high), and Shokei-daru (10m high), etc.

175

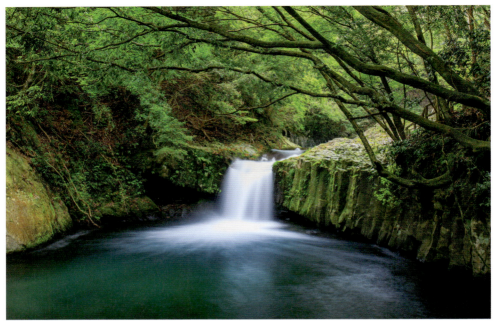

蛇滝［河津七滝］／Hebi-daru [Kawazu-nana-daru]

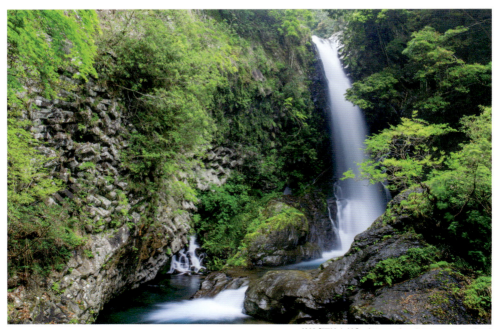

釜滝［河津七滝］／Kama-daru [Kawazu-nana-daru]

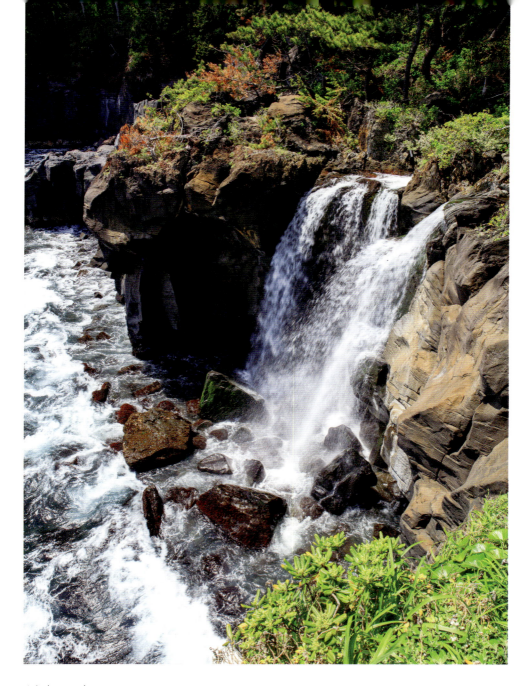

対島の滝 〈Tajima-no-taki〉 静岡県伊東市／Shizuoka Pref. 落差：10 m

対島川の清流が城ヶ崎海岸から海へと落ちる。近くの展望台からその迫力のある姿を見ることができる。
The pure water of the Tajima River drops into the sea from the cliffs of the Jogasaki Seashore. It is possible to see the dynamic view from the viewing deck nearby.

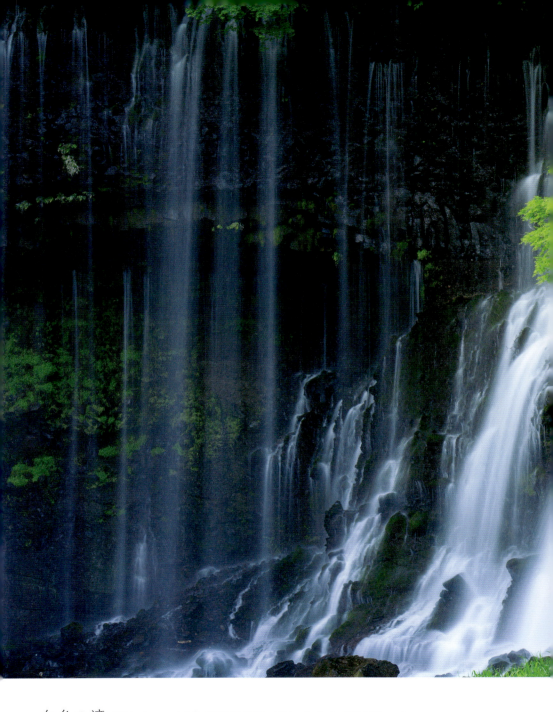

白糸の滝 〈Shiraito-no-taki〉 静岡県富士宮市／Shizuoka Pref. 落差：20 m ★
本滝の一部をのぞいて、無数の糸状の水は富士山の湧水である。湧水量は日に 15 〜 16 万㎥に達する。

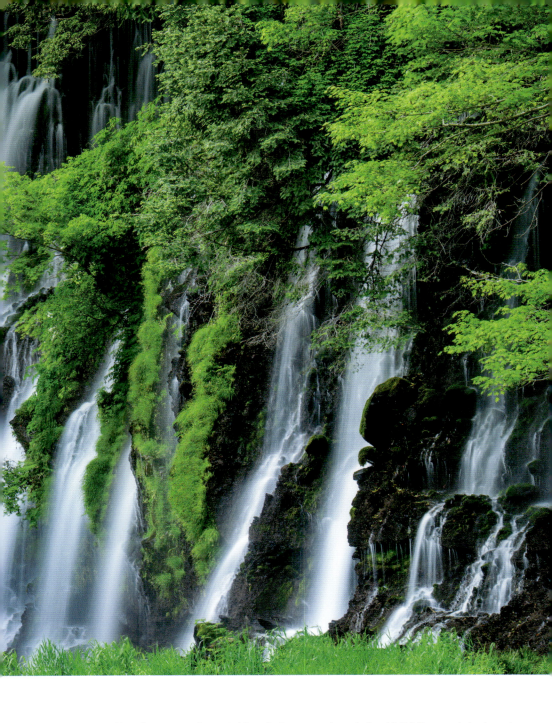

Countless numbers of lines of water, except for a part of the main stream, are spring water from Mt. Fuji. The amount of spring water is 150,000-160,000 m^3 a day.

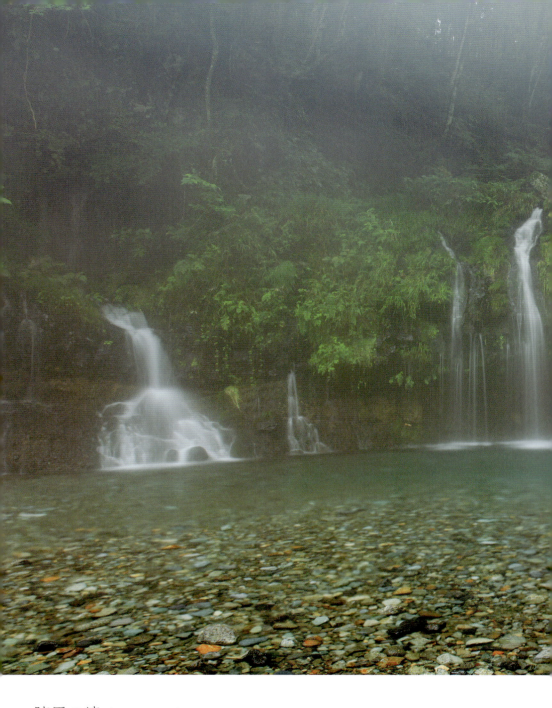

陣馬の滝 〈Jinba-no-taki〉 静岡県富士宮市／Shizuoka Pref. 落差：5 m
五斗目木川の川水と湧水からなる滝。滝名は源頼朝が富士の巻狩(狩猟)の際、この近くに陣をはったことに由来する。

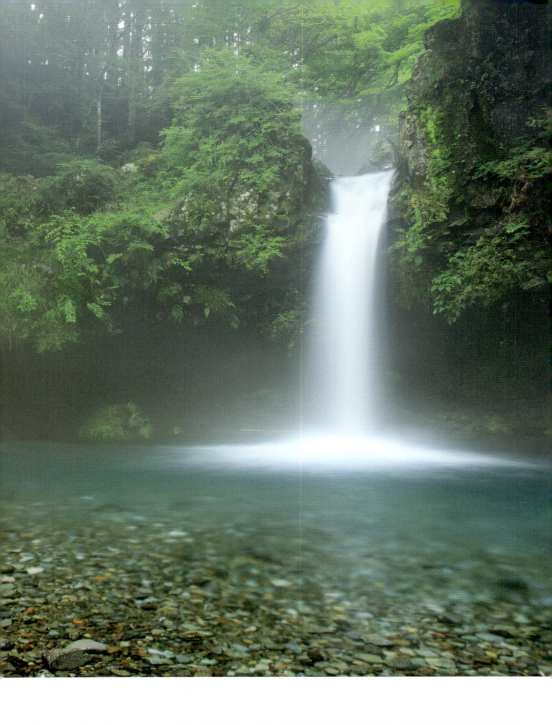

The descending water comes from both the Gotomeki River and spring water from around the area. "Jinba" means that, MINAMOTO Yoritomo, a Shogun of the Genji Shogunate family in the medieval age, set up a home, "Jin" in Japanese, for hunting near the fall.

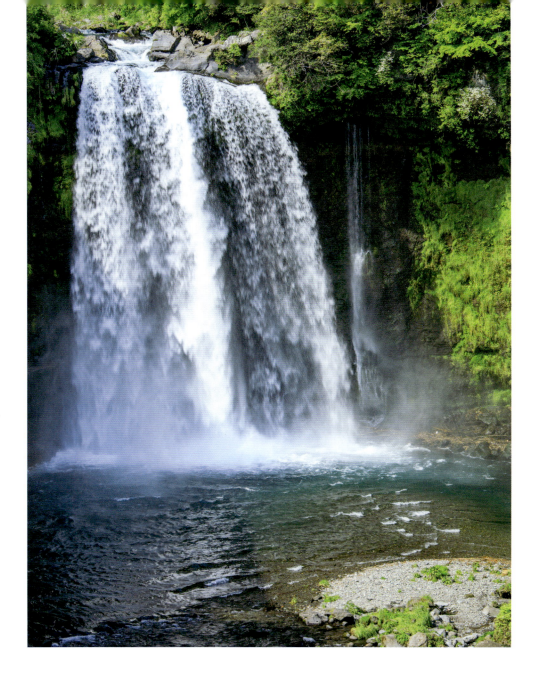

音止の滝 〈Otodome-no-taki〉 静岡県富士宮市／Shizuoka Pref. 落差：25 m ★

芝川本流にかかる滝。曽我兄弟が父の仇を討つ相談をするも滝音で密談ができず嘆いたところ、滝音が止んだという伝説を持つ。曽我兄弟は富士の巻狩の折に仇討を果たす。
This fall drops into the mainstream of the Shiba River. "Otodome" means to stop sound. Legend has it that when the Soga brothers, who wanted to avenge their father, talked about their plan, the sound of the waterfall stopped.

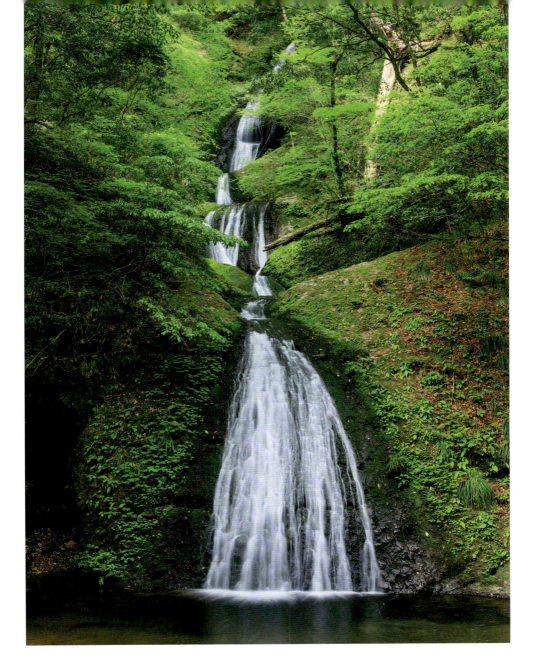

阿寺の七滝 〈Atera-no-nanataki〉 愛知県新城市／Aichi Pref. 落差：全長 62 m ★

阿寺川が七段にわたって流れ落ちる。陰陽師の安倍晴明が若いころに修行したと伝わる。子宝に恵まれるとの言い伝えもある。
The water of the Atera River descends in seven steps. It is said that praying to this fall will lead to easy childbirth.

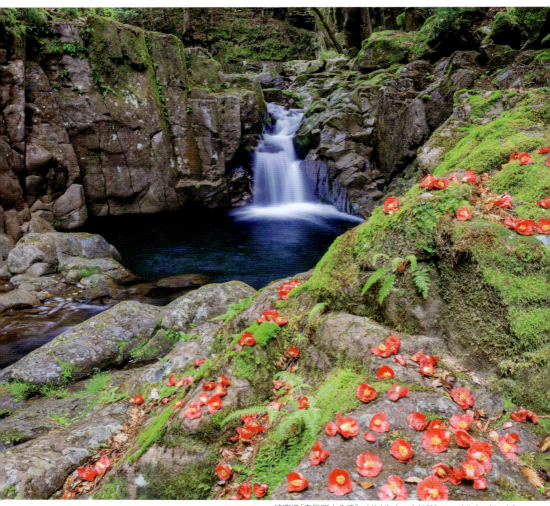

柿窪滝 [赤目四十八滝] ／ Kakikubo-daki [Akame-shijuhachi-taki]

赤目四十八滝 〈Akame-shijuhachi-taki〉 三重県名張市／ Mie Pref.　落差：柿窪滝 5 m　★

宇陀川の支流・滝川上流にかかる大小の滝の総称。その中でも特に見所とされる不動滝（落差15m）、千手滝（落差15m）、布曳滝（落差30m）、荷担滝（落差8m）、琵琶滝（落差15m）は赤目五瀑と呼ばれている。

Akame-shijuhachi-taki is the general term for many falls dropping into the upper stream of the Taki River, a branch of the Uda River. Among them, the five falls; Fudo-daki, Senju-daki, Nunobiki-daki, Ninai-daki, Biwa-daki, are called the best five falls of Akame.

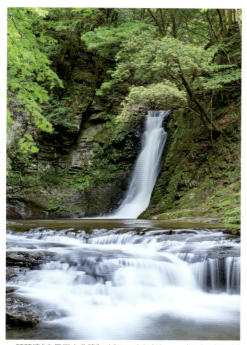
琵琶滝［赤目四十八滝］／ Biwa-daki [Akame-shijuhachi-taki]

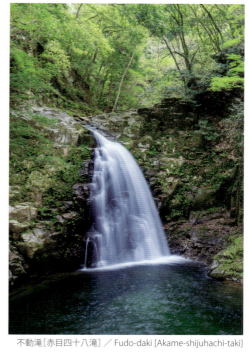
不動滝［赤目四十八滝］／ Fudo-daki [Akame-shijuhachi-taki]

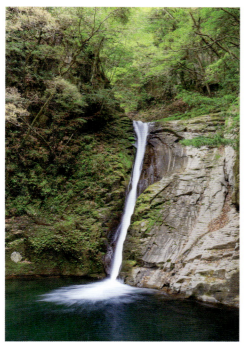
布曳滝［赤目四十八滝］／ Nunobiki-daki [Akame-shijuhachi-taki]

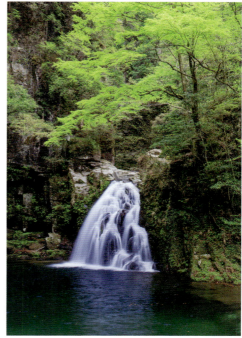
千手滝［赤目四十八滝］／ Senju-daki [Akame-shijuhachi-taki]

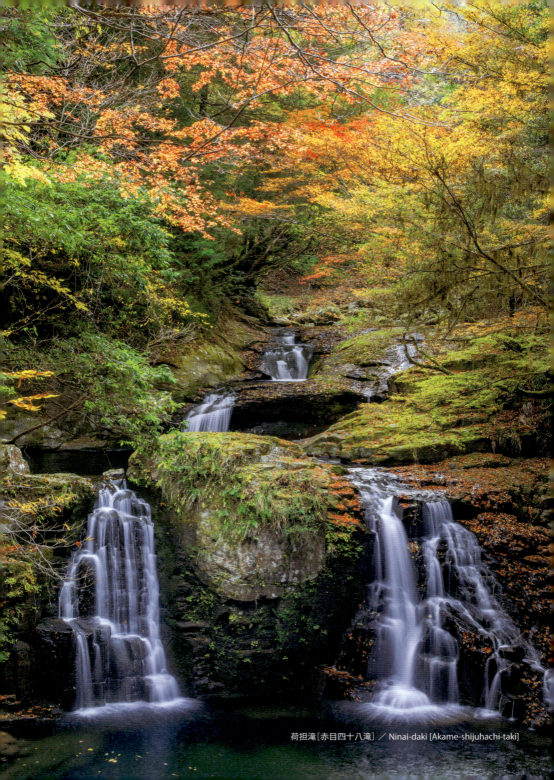

荷担滝［赤目四十八滝］／ Ninai-daki [Akame-shijuhachi-taki]

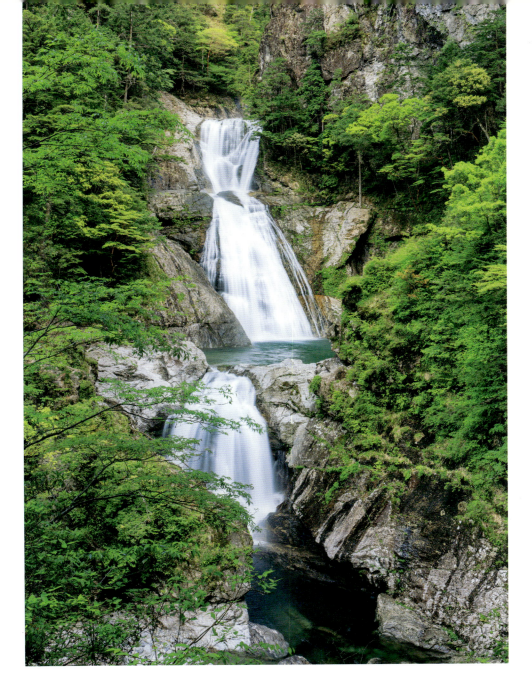

七ツ釜滝 〈Nanatsugama-daki〉 三重県大台町／Mie Pref.　落差：80ｍ　★

宮川上流、大杉谷にかかる大瀑。7段にわたって落ち、それぞれに美しい滝壺をもつ。
This is a large scale fall dropping into the Osugi Valley, the upper stream of the Miya River. It has seven steps and each of them has a splendid fall basin.

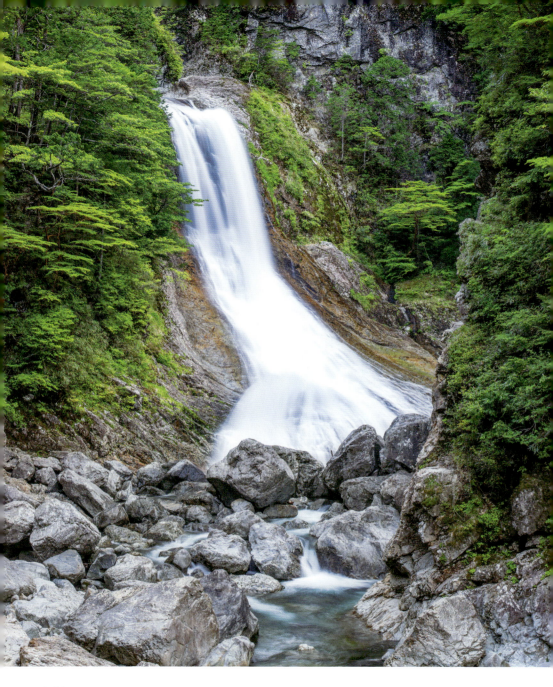

光滝 〈Hikari-daki〉 三重県大台町／Mie Pref. 落差：40 m

七ツ釜滝上流にかかる。裾広がりに落ち、迫力がある。
This fall is located at the upper stream of Nanatsugama-daki. The descending water spreads toward the bottom and it looks powerful.

荒滝 〈Ara-taki〉 三重県熊野市／Mie Pref. 落差：15 m

熊野川支流・楊枝川支流の布引谷にかかる滝。布引の滝とともにかつて修験者が修行した滝としても知られる。
This fall drops into the Nunobiki Valley, a branch of the Kumano River. It has been known as a place where ascetic Buddhist monks are trained.

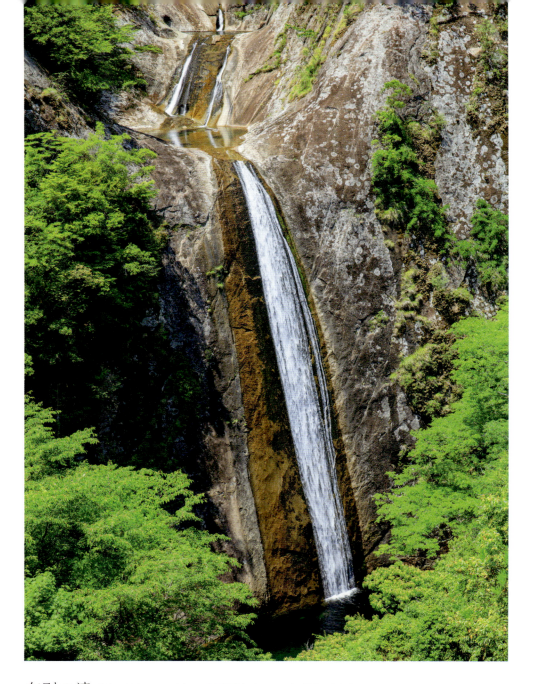

布引の滝 〈Nunobiki-no-taki〉 三重県熊野市／Mie Pref. 落差：上から 12m、3.5m、7.7m、29.1m、★

荒滝と同じく布引谷にかかる。四段に流れ、白布を垂らしたごとく、飛沫もたてることなく静かに落ちる。
This fall also drops into the Nunobiki Valley. It has four steps at heights of 12m, 3.5m, 7.7m, and 29.1m (measured from the top). The water descends very quietly without splashing and it looks like a long white cloth.

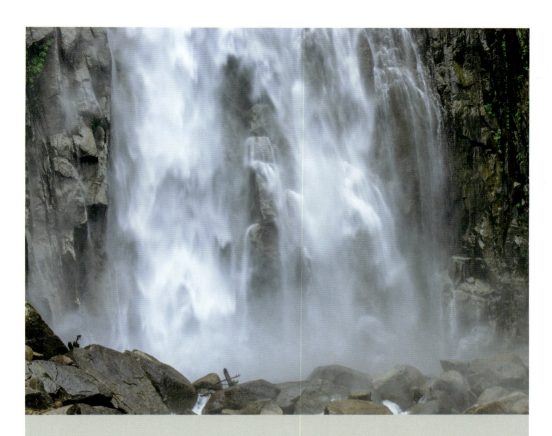

Kinki (Around Osaka) 近畿

那智の滝 〈Nachi-no-taki〉 和歌山県那智勝浦町／ Wakayama Pref.　落差：133 m　★

大雲取山の清水を集めた那智川本流が流れ落ちる名瀑。熊野那智大社の別宮・飛瀧神社のご神体。別名「一の滝」で、上流の二の滝、三の滝をあわせて「那智の大滝」とも称される。日本三名瀑のひとつ。

The mainstream of the Nachi River, which gathers pure water running down from Mt. Okumotori, descends as a great fall. This fall is the Goshintai (the symbol of the Shinto God) of Hiro Jinja Shrine, a branch shrine of Kumano-Nachi-Taisha Shrine.

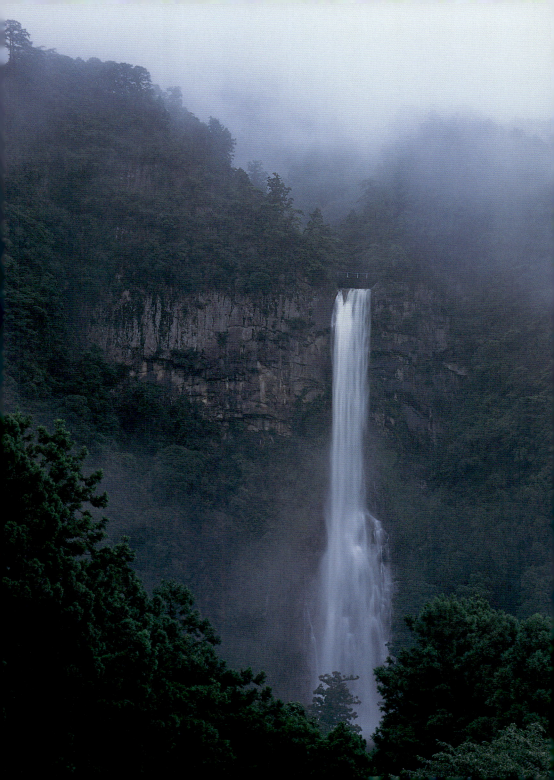

那智の滝／Nachi-no-taki

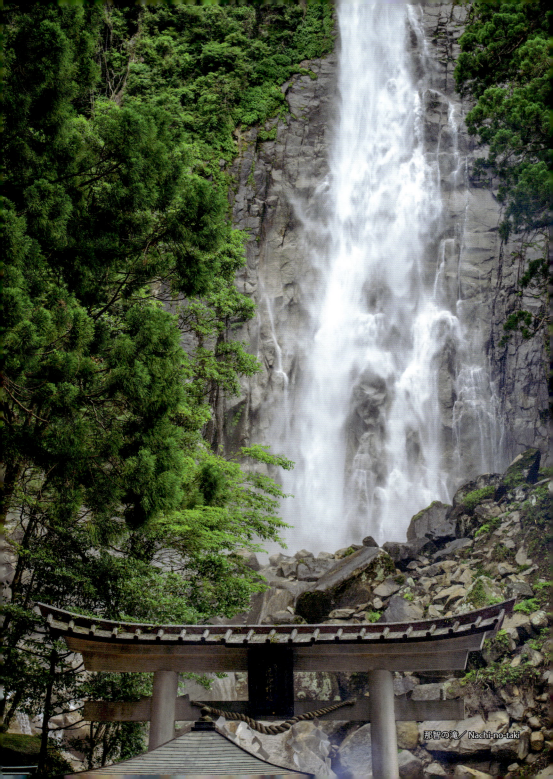
那智の滝／Nachi-no-taki

滝の拝 〈Taki-no-hai〉 和歌山県古座川町／Wakayama Pref.　落差：8 m

古座川の支流・小川にある。200mにわたり岩床上に無数の甌穴が見られ、その中央に滝がかかる。
This fall drops into a branch of the Koza River. Around the fall basin, there are lots of potholes stretching out for 200m.

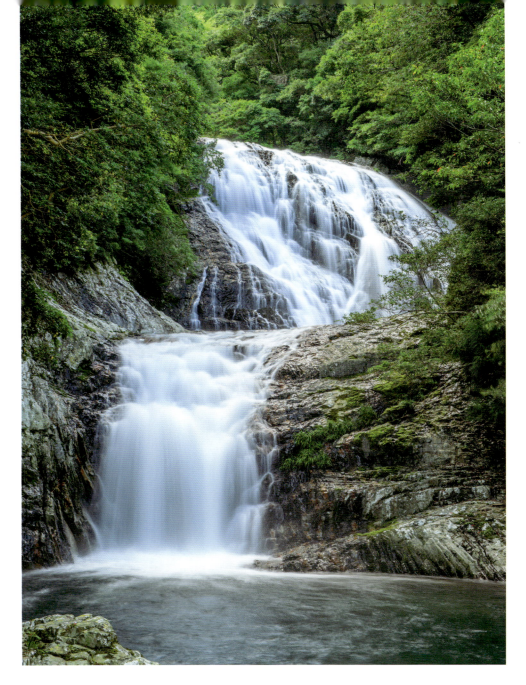

雫の滝 〈Shizuku-no-taki〉 和歌山県すさみ町／Wakayama Pref.　落差：30 m
周参見川にかかり、二段に落ちる滝。
This fall drops into the Susami River and it has two steps.

八草の滝 〈Haso-no-taki〉 和歌山県白浜町／Wakayama Pref.　落差：22 m　★
日置川中流の山腹に落ちる滝。水量が少なく、まとまった雨の後以外には流れを確認できないことも多い。
This fall drops into the mountainside near the middle stream of the Hiki River.

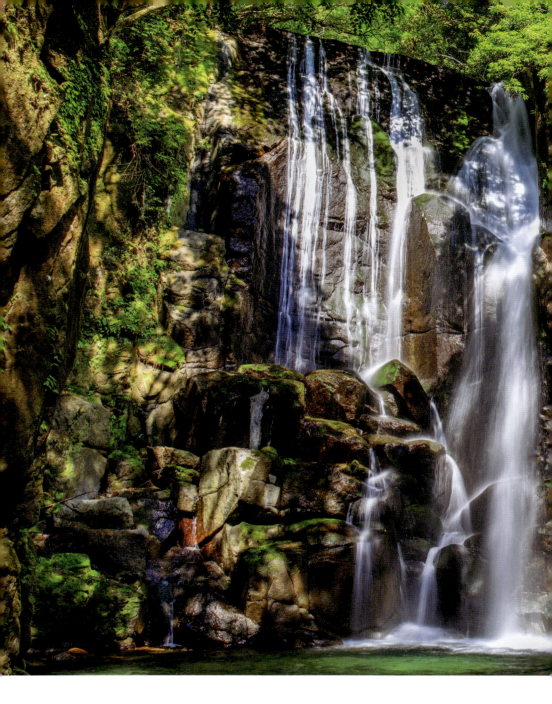

桑ノ木の滝 〈Kuwanoki-no-taki〉 和歌山県新宮市／Wakayama Pref. 落差：21 m ★

高田川の支流・桑ノ木渓谷にかかる。様々な水の流れが複雑に交差しながら流れ落ちる様が美しい。

This fall drops into the Kuwanoki Valley, a branch of the Takada River. The water descends in torrents that cross and re-cross each other, and looks beautiful.

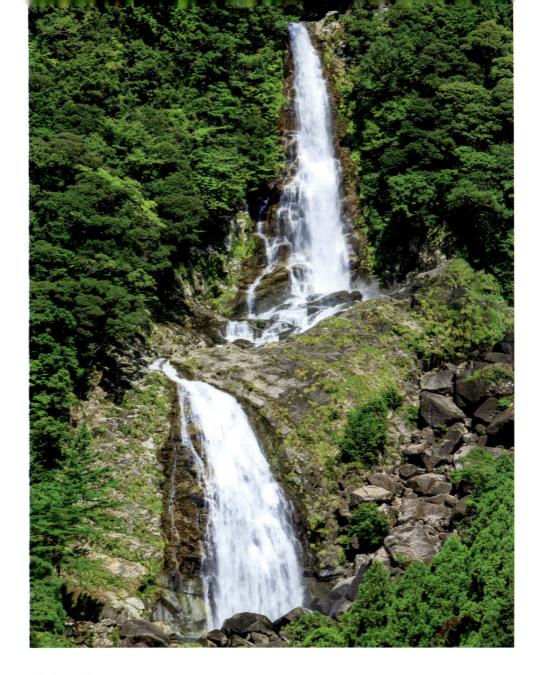

鼻白の滝 〈Hanajiro-no-taki〉 和歌山県新宮市／Wakayama Pref. 落差：83m

熊野川の支流・田長谷渓谷にかかる。38ｍ、45ｍの二段にわたって流れ落ちる。滝の名はここに昔鼻の白いウナギが住んでいたことから名づけられたという。
This fall drops into a branch of the Kumano River. It has two steps; each height is 38m and 45m. "Hanajiro" (white nose) comes from a legend that a long time ago, a white-nosed eel used to live here.

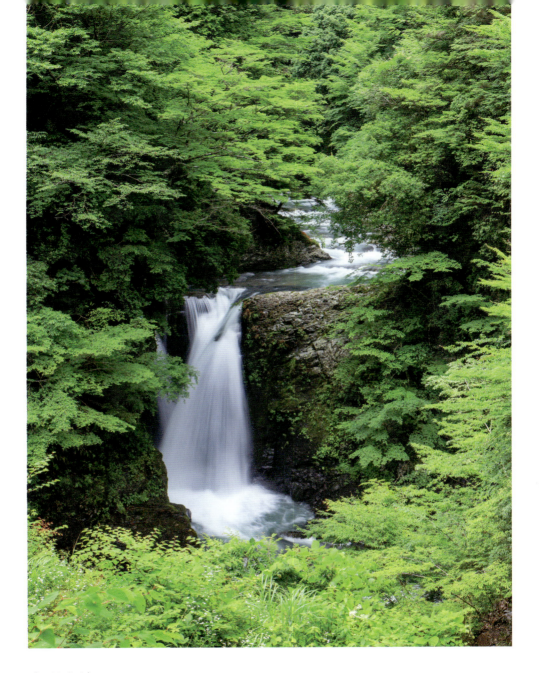

高野大滝 〈Koya-otaki〉 和歌山県高野町／Wakayama Pref. 落差：15 m

御殿川にかかる滝。紅葉の時期もまた美しい。
This fall drops into the Odo River. The scenery of autumn foliage around the fall is also splendid.

十二滝 〈Juni-taki〉 奈良県十津川村／Nara Pref. 落差：100 m

和歌山県境近く、国道168号線沿いにかかる落差の大きな滝。
This great fall is located beside Route 168, near the border between Nara Pref. and Wakayama Pref.

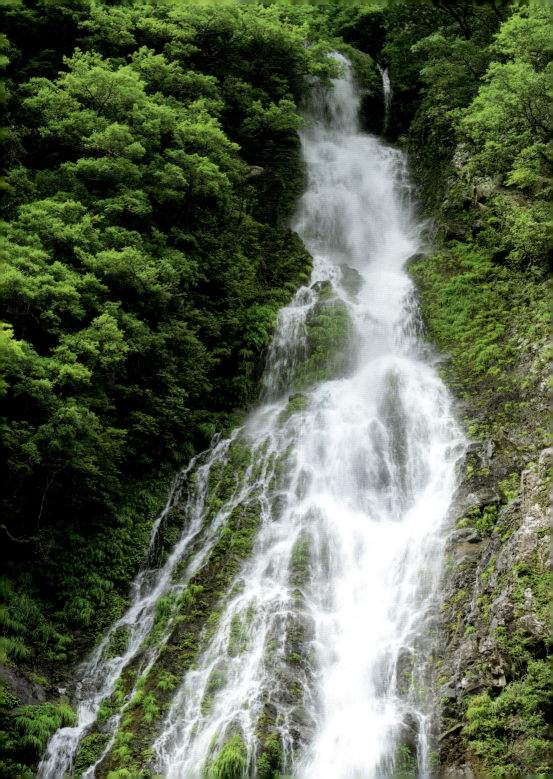

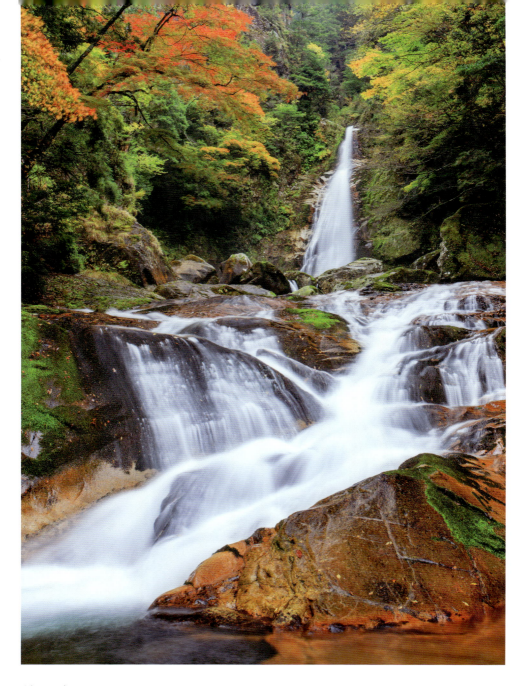

笹の滝 〈Sasa-no-taki〉 奈良県十津川村／Nara Pref.　落差：32 m　★

十津川支流の滝川上流域にかかる。白糸の様に岩肌を落ちる姿が美しい。
This fall drops into the upper stream of the Taki River, a branch of the Totsukawa River. The water descends like white strings and the view is awesome.

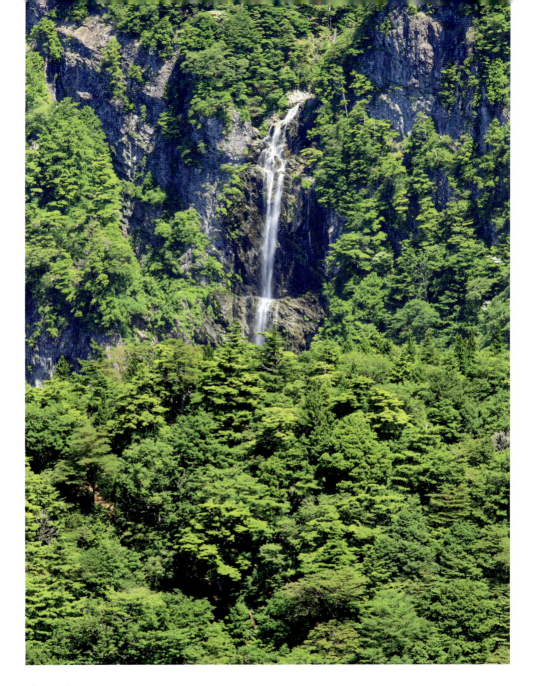

中ノ滝 〈Naka-no-taki〉 奈良県上北山村／Nara Pref. 落差：250 m ★

大台ケ原、東ノ川上流にかかる大瀑。大台ケ原を展望できる大蛇嵓や、又 劔山山頂からその姿を見ることができる。
This is a giant fall dropping into the Uno River in the Mt. Odaigahara area. You can see the fall from the Daijagura viewing deck, from where it is also possible to see Mt. Odaigahara, and the top of Mt. Matatsurugi.

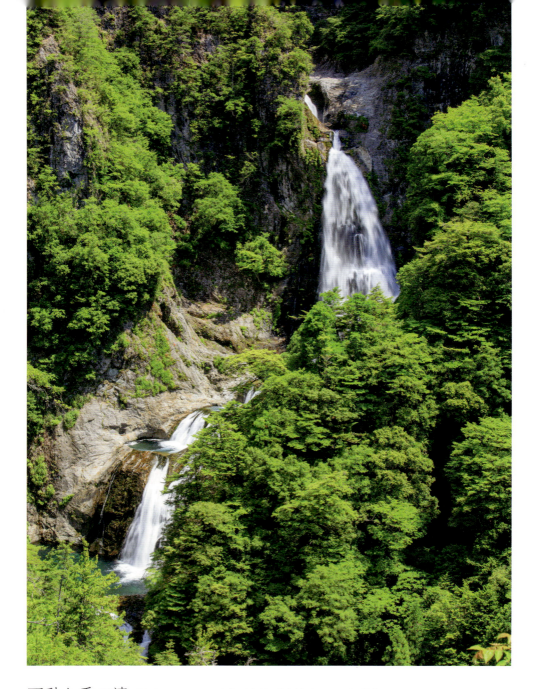

不動七重の滝 〈Fudonanae-no-taki〉 奈良県下北山村／Nara Pref.　落差：100 m　★

前鬼川にかかる。修験道の役小角に仕えた鬼の夫婦、前鬼・後鬼によって守られた聖地にふさわしい美しい滝。
This fall drops into the Zenki River and it looks beautiful. Legend has it that it was a sacred place protected by an Oni (ogre) couple, who worked for a famous monk, En-no-ozuno.

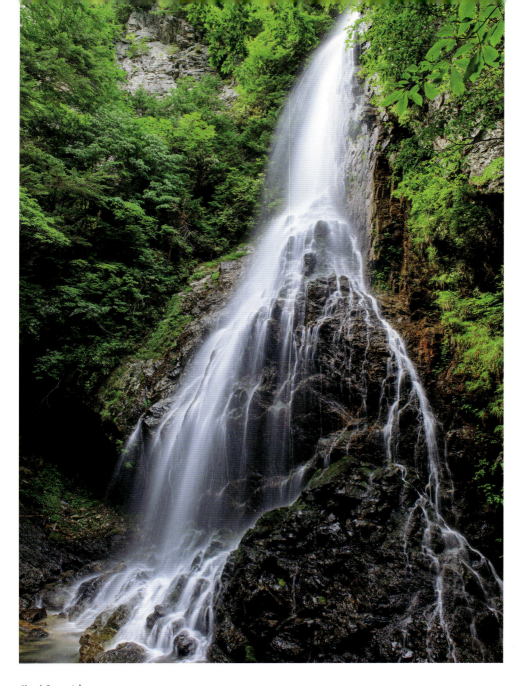

御船の滝 〈Mifune-no-taki〉 奈良県川上村／Nara Pref. 落差：50m
井光川源流域にかかる二段の滝。御船の滝は『古事記』の神武東征の説話にも登場する。
This fall drops into the headstream of the Ikari River and it has two steps. It appears in Kojiki, the oldest record of ancient matters in Japan.

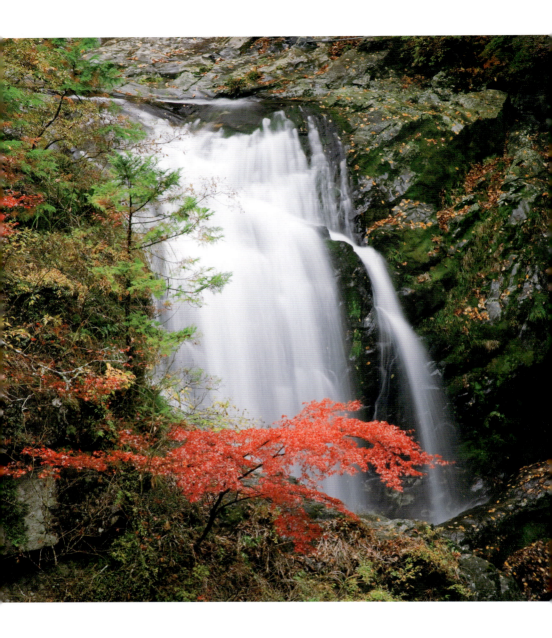

みたらいの滝 〈Mitarai-no-taki〉 奈良県天川村／Nara Pref.　落差：15 m

みたらい渓谷にかかる滝。天川川合と洞川温泉を結ぶみたらい遊歩道が整備され、滝を間近に見ることができる。
This fall drops into the Mitarai Valley. You can enjoy the fall view from the Mitarai-Yuhodo walking path, connecting Tenkawa-kawai and Dorogawa-onsen hot springs.

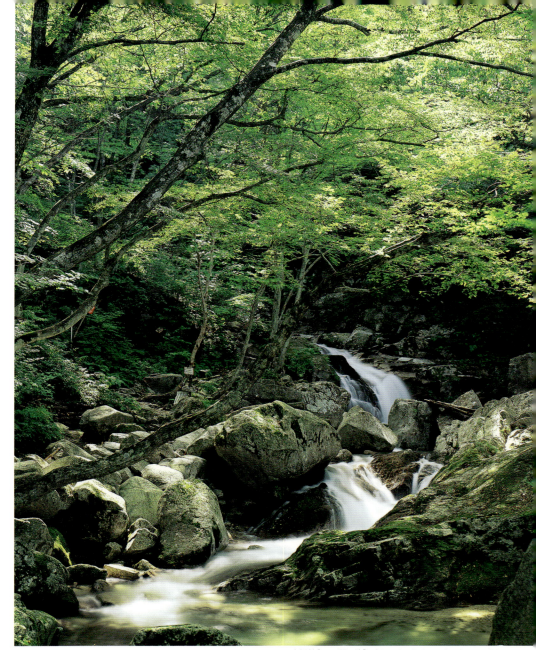

大摺鉢[八ツ淵の滝]／Osuribachi [Yatsubuchi-no-taki]

八ツ淵の滝 〈Yatsubuchi-no-taki〉 滋賀県高島市／Shiga Pref. 落差：大摺鉢 推定5m ★

鴨川源流域にかかる滝群。それぞれ滝を持つ8つの淵（七遍返し淵、貴船ヶ淵、屏風ヶ淵、小摺鉢、大摺鉢、唐戸の淵、障子ヶ淵、魚止の淵）が連なるが、崩落等で大摺鉢以外の淵は本格的な登山装備が必要。

This is a group of falls dropping into the headstream of the Kamo River. There are eight ponds and each of them has a fall. They are Shichihengaeshi-buchi, Kibunega-buchi, Byobuga-buchi, Kosuribachi, Osuribachi, etc.

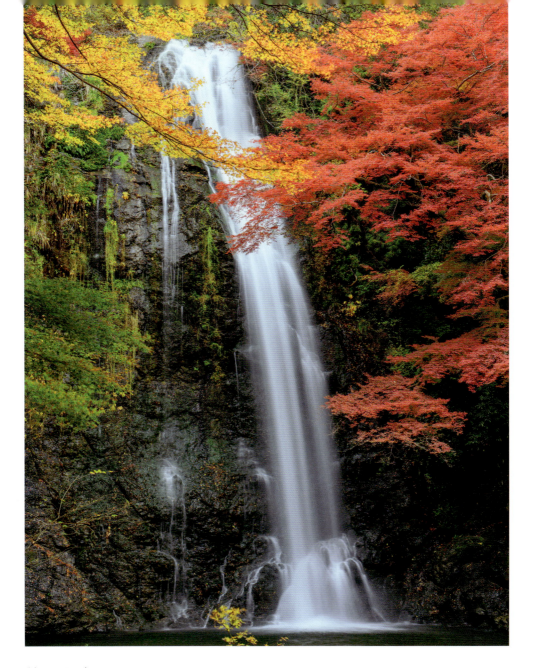

箕面大滝 〈Mino-otaki〉 大阪府箕面市／Osaka Pref. 落差：33 m ★

明治の森箕面国定公園にある。滝名は農具の「箕」に滝の姿が似ていることから名づけられたという。箕面の山は古来、山岳仏教の聖地で、この滝も役小角ゆかりの滝として知られる。

This fall is located in Meiji-no-mori Mino Quasi-national Park. The word "Mino" is used because the shape of the fall looks similar to a "Mino", a kind of old farming implement.

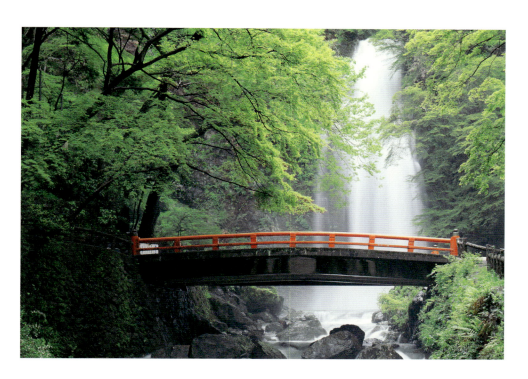

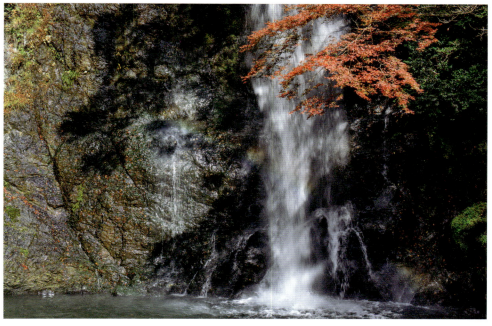

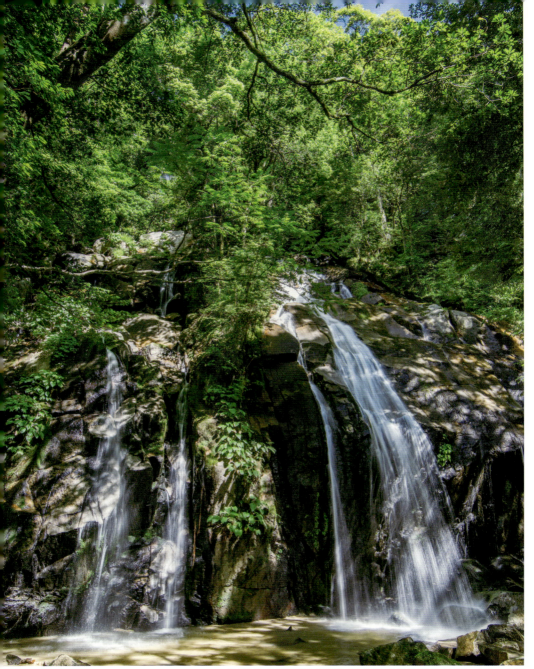

左が女滝、右が男滝［金引の滝］／ Left: Me-daki, Right: O-daki [Kanabiki-no-taki]

金引の滝 〈Kanabiki-no-taki〉 京都府宮津市／ Kyoto Pref. 落差：40 m ★

滝馬川にかかり、向かって右が男滝、左が女滝。下流の白龍の滝、臥龍の滝とともに「金引の滝」と総称される。
This fall drops into the Takiba River. The descending water splits in two. The right side is called "O-daki" and the left one is called "Me-daki". "Kanabiki-no-taki" includes "Hakuryu-no-taki" and "Garyu-no-taki", located in the lower stream of this fall.

212

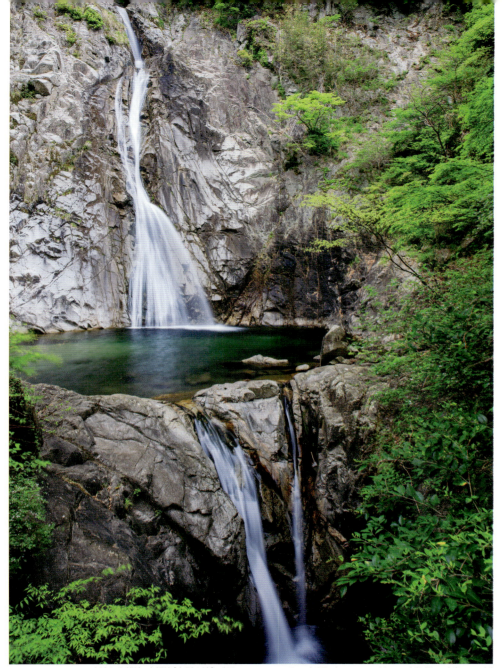

上流から雄滝、夫婦滝［布引の滝］／ The upper step: On-taki, The lower step: Meoto-daki [Nunobiki-no-taki]

布引の滝 〈Nunobiki-no-taki〉 兵庫県神戸市／Hyogo Pref. 落差：雄滝 43 m ★

新神戸駅の山手、生田川中流にかかる滝。雌滝、鼓ヶ滝、夫婦滝、雄滝の４つの滝の総称。
This fall is located on the mountainside near Shin-Kobe Station, and it drops into the middle stream of the Ikuta River. "Nunobiki-no-taki" is the general term for the four falls of Men-taki, Tsutsumi-ga-taki, Meoto-daki and On-taki.

天滝 〈Ten-daki〉 兵庫県養父市／Hyogo Pref.　落差：98 m　★

天滝川にかかる。古くから知られ『大和長谷寺縁起』や『役行者本記』などにもその記述がみられる。
This fall drops into the Tendaki River. It looks as if it is falling down from the sky and the view of it is sublime. It has been widely known to people since ancient times.

猿尾滝 〈Saruo-daki〉 兵庫県香美町／Hyogo Pref.　落差：上段 39 m　下段 21 m　★

滝の形が猿の尾に似ていることが滝名の由来。村岡藩主・山名氏は猿尾滝でそうめん流しを楽しんだと伝わる。
This fall has two steps. "Saruo" means the tail of a monkey and it is said that the fall resembles this in shape.

二段滝 〈Nidan-taki〉 兵庫県豊岡市／Hyogo Pref.　落差：9 m
稲葉川本流にかかる。落差４ｍと５ｍの二段にわたって流れる。
This fall drops into the Inaba River. It has two steps; each height is 4m and 5m.

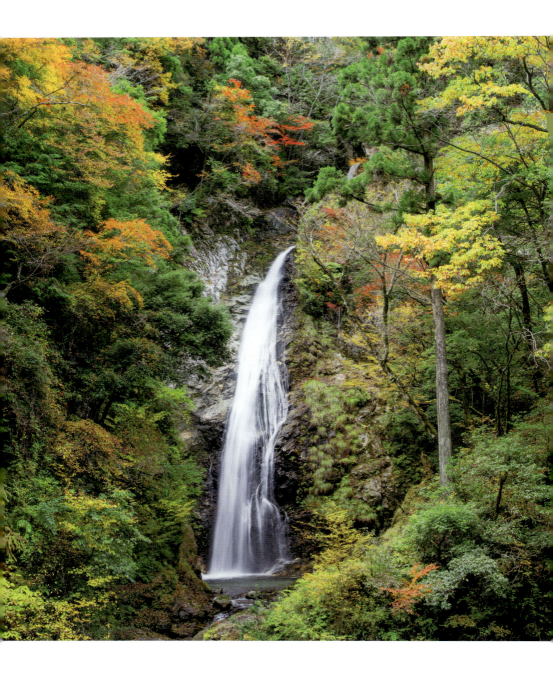

原不動滝 〈Hara-fudo-taki〉 兵庫県宍粟市／Hyogo Pref. 落差：88 m ★

八丈川上流にかかる3段の滝。遊歩道(有料)が整備され、滝を間近に見ることができる。
A three-step fall dropping into the upper stream of the Hachijo River. You can see it up close from a paid walking trail.

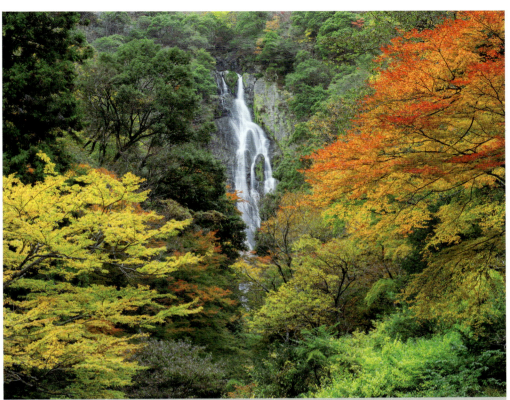

Chugoku (Western Honshu) & Shikoku

中国四国

神庭の滝 〈Kanba-no-taki〉岡山県真庭市／Okayama Pref.　落差：110m　★

神庭川にかかる名瀑。滝の中央にある岩は滝を上る鯉のようであることから、鯉岩と呼ばれている。
The famous fall drops into the Kanba River. The rock in the center of the fall is called "Koi-iwa" (Carp rock) because it looks like a carp climbing up the fall.

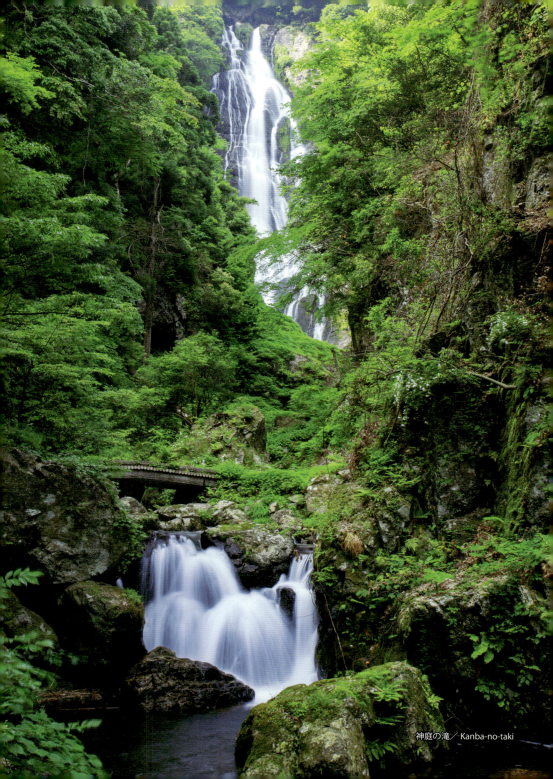
神庭の滝／Kanba-no-taki

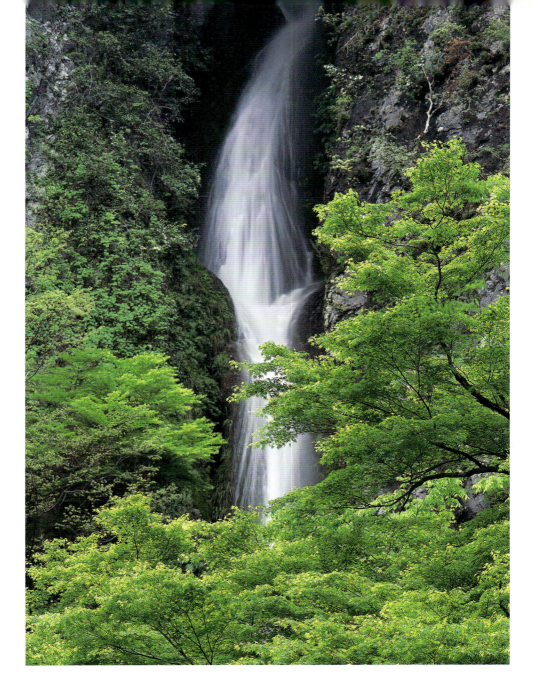

絹掛の滝 〈Kinukake-no-taki〉 岡山県新見市／Okayama Pref. 落差：60 m

高梁川と、石灰岩の岩壁が美しい井倉峡にかかり、その姿はまさしく白絹を垂らしたようである。
This fall drops into the Takahashi River and the Ikura Valley, which has beautiful limestone walls. The shape of the fall is like hanging white silk and the view is splendid.

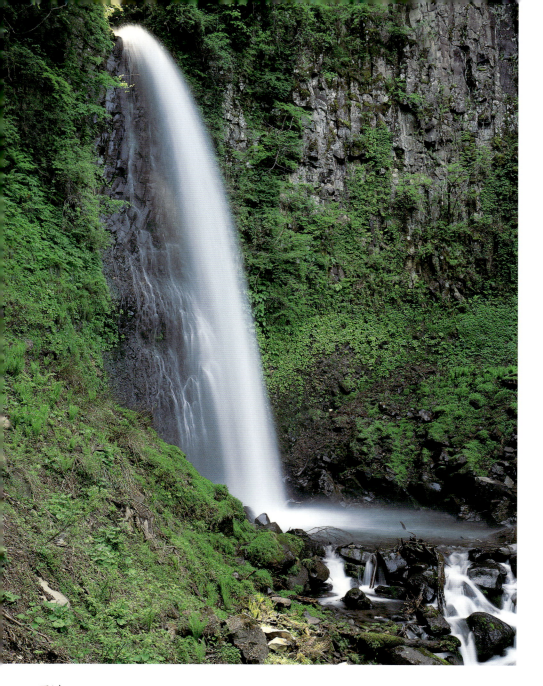

雨滝 〈Ame-daki〉 鳥取県鳥取市／Tottori Pref.　落差：40 m　★

袋川にかかる。古くから霊場として知られた滝。原生林に囲まれた滝の姿に古の人々の祈りを感じることができる。
This fall drops into the Fukuro River. It is surrounded by the primeval forests and the water descends with a heavy reverberation. It has been known as a sacred place from the old times.

三段滝 〈Sandan-daki〉 広島県安芸太田町／Hiroshima Pref.　落差：30ｍ
柴木川が刻む全長約16ｋｍの渓谷・三段峡を代表する滝。
This fall represents the natural scenery along the Sandan Valley, which stretches 16km along the Shibaki River.

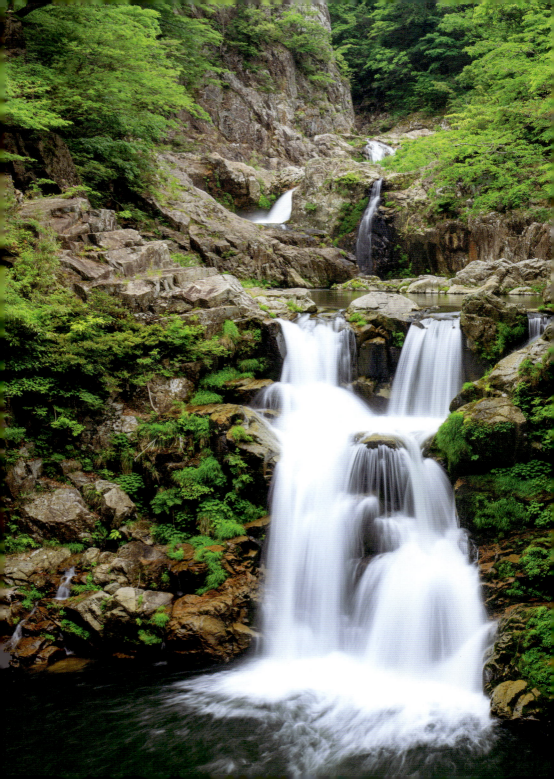

三段滝／Sandan-daki

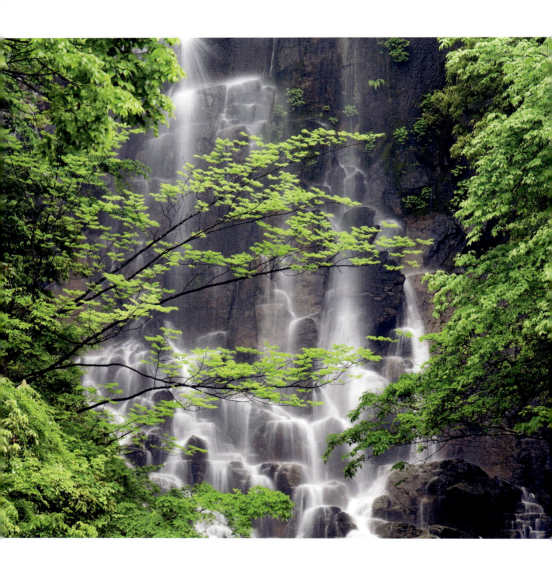

常清滝 〈Josei-daki〉 広島県三次市／Hiroshima Pref. 落差：126 m ★
江の川の支流・作木川に注ぐ。三段に流れ落ち、上段からそれぞれ「荒波」「白糸」「玉水」と名付けられている。
This fall drops into the Sakugi River, a branch of the Gono River. It has three steps from the top, which are Aranami, Shiraito, and Tamamizu.

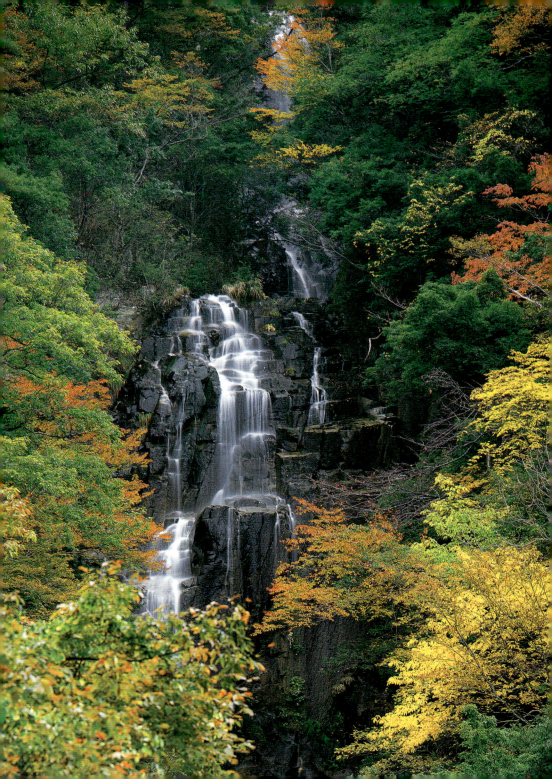

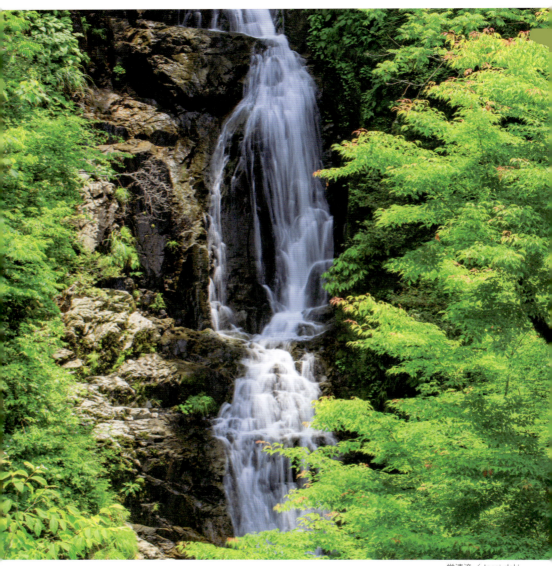

常清滝／Josei-daki

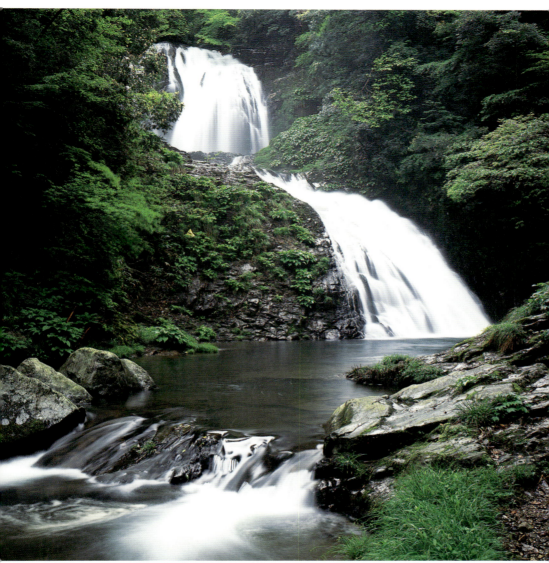

上流から八汐滝、八塩滝［八重滝］／ Yashio-daki [Yae-daki]

八重滝 〈Yae-daki〉 島根県雲南市／ Shimane Pref. 落差：40m ★
民谷川にかかる8つの滝の総称。下流から猿飛滝、滝尻滝、紅葉滝、河鹿滝、姥滝、姫滝、八塩滝、八汐滝がある。
"Yae-daki" is the general term for eight falls dropping into the Mindani River. They are Sarutobi-daki, Takijiri-daki, Momiji-daki, Kajika-daki, Uba-daki, Hime-daki, and two called Yashio-daki (written in different Kanji characters).

龍頭が滝 〈Ryuzu-ga-taki〉 島根県雲南市／Shimane Pref. 落差：雄滝 40 m ★

滝谷川にかかり、雄滝と雌滝からなる。雄滝の裏側には滝観音が祀られた岩窟があり、滝を裏から見ることができる。八重滝とあわせて龍頭八重滝と総称される。

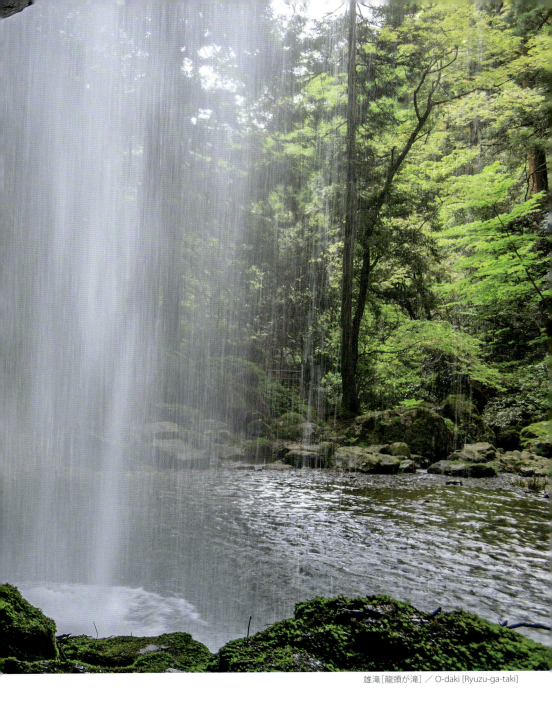

雄滝［龍頭が滝］／ O-daki [Ryuzu-ga-taki]

This fall drops into the Takidani River and it includes O-daki (the male fall) and Me-daki (the female fall). Behind O-daki, there is a cave where Taki-Kannon is enshrined, and you can have a look at the fall from there.

上：雄滝　下：雌滝　[壇鏡の滝] ／ The upper step: O-daki, The lower step: Me-daki [Dangyo-no-taki]

壇鏡の滝 〈Dangyo-no-taki〉 島根県隠岐の島町／Shimane Pref.　落差：雄滝 40 m　雌滝 40 m　★

隠岐の島にある。壇鏡神社の社殿を挟み向かって右が雄滝、左が雌滝。雄滝は裏からも見ることができる。
This fall is located in the precinct of Dangyo-jinja Shrine, Okinoshima Island. The left fall is called "Me-daki", and the right one is called "O-daki". You can see O-daki from behind the fall.

犬戻の滝 〈Inumodoshi-no-taki〉 山口県岩国市／Yamaguchi Pref.　落差：25 m
宇佐川上流域にある犬戻峡にかかる滝。犬戻峡と竜ヶ岳峡を総称して寂地峡という。
This fall drops into the Inumodoshi Valley, a branch of the Usa River. The Inumodoshi Valley together with Ryugadake Valley is called Jakuchi Valley.

鼓の滝 〈Tsuzumi-no-taki〉 山口県山口市／Yamaguchi Pref. 落差：35m
龍蔵寺境内にある。3段に落ちる滝で、滝名の由来は中段がくびれて見えることからとも、滝音が鼓の音のようだからともいわれている。

This fall is located in the precinct of Ryuzo-ji Temple. It has three steps and it is said that the name comes from the shape, which looks like a Tsuzumi, a Japanese hand drum, or the water descending sound, which is similar to Tsuzumi sound.

雌滝[雨乞の滝] / Me-daki [Amagoi-no-taki]

雨乞の滝 〈Amagoi-no-taki〉 徳島県神山町／Tokushima Pref.　落差：雌滝 45m　雄滝 27 m　★

鮎喰川の支流にかかる。雄滝、雌滝の二滝からなり、向かって右側、3段に流れるのが雌滝である。
This fall drops into a branch of the Akui River. It consists of O-daki (left) and Me-daki (right). Me-daki has three steps. There are many large and small falls near here.

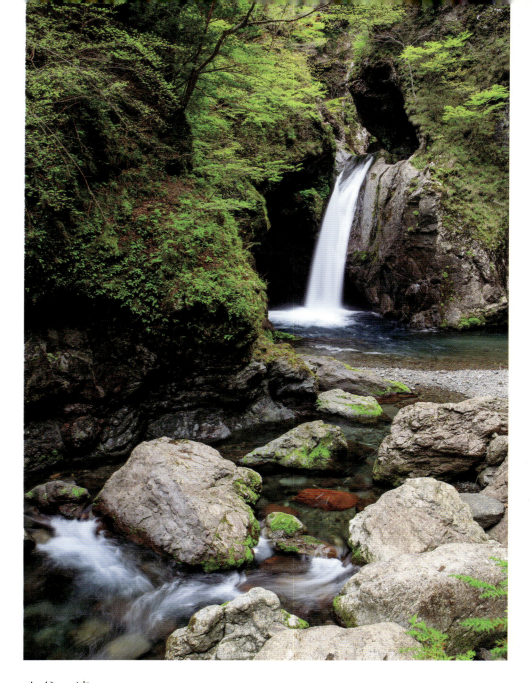

大釜の滝 〈Ogama-no-taki〉 徳島県那賀町／Tokushima Pref. 落差：20m ★

釜ヶ谷峡にかかる滝。大釜の名のとおり、釜状に見える滝壺を持ち、その底には大蛇が住むという伝説がある。
This fall drops into the Kamagatani Valley. Legend has it that a big snake lives at the bottom of the deep fall basin.

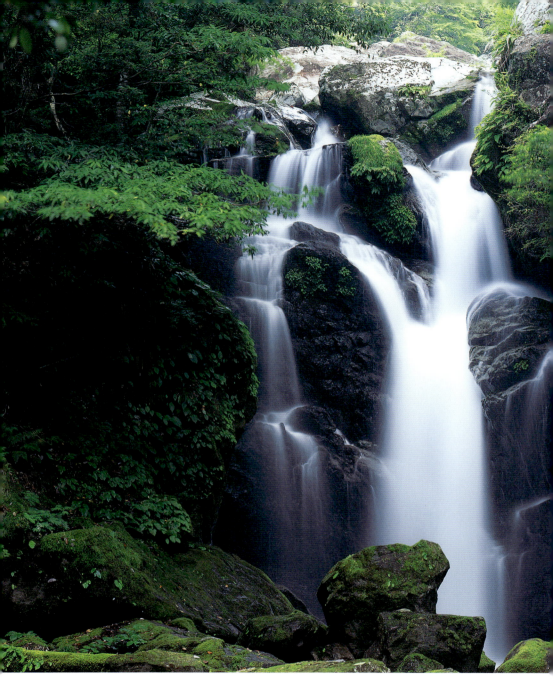

轟九十九滝 〈Todoroki-kujuku-taki〉 徳島県海陽町／Tokushima Pref.
落差：轟の滝 58 m　二重の滝 推定 7〜8 m　★

轟九十九滝とは海部川上流にかかる滝群の総称。轟の滝（本滝ともいう）の少し上流に二重の滝があり、更に上流にかけて大小さまざまな滝がかかる。

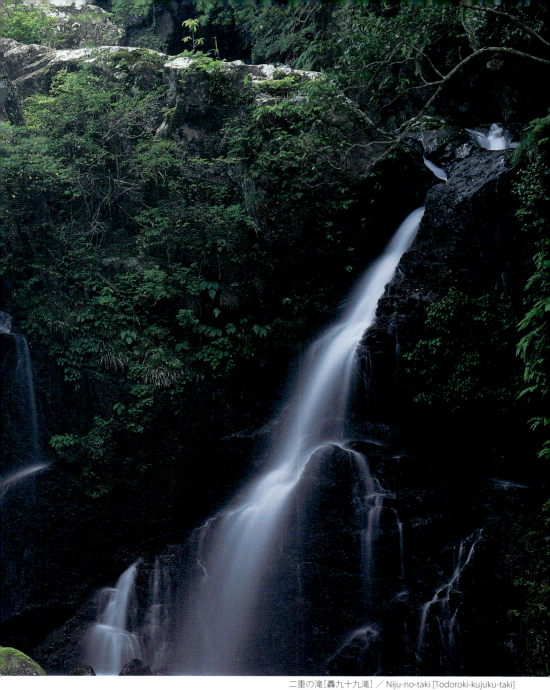

二重の滝［轟九十九滝］／ Niju-no-taki [Todoroki-kujuku-taki]

"Todoroki-kujuku-taki" is the general term for the falls dropping into the upper stream of the Kaifu River. They vary in size from small to large. The famous ones are Todoroki-no-taki and Niju-no-taki.

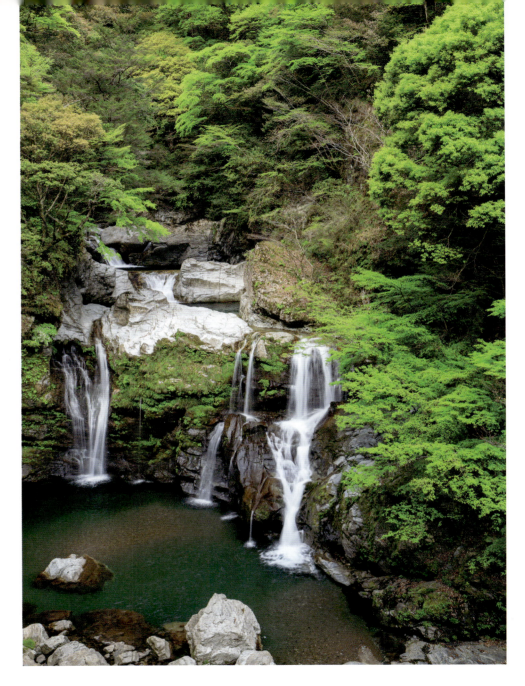

大轟の滝 〈Otodoro-no-taki〉 徳島県那賀町／Tokushima Pref.　落差：20 m

釜ヶ谷峡にかかる滝。3段に流れ落ち、大きな滝壺を持つ。
This fall drops into the Kamagatani Valley. It has three steps and a huge fall basin.

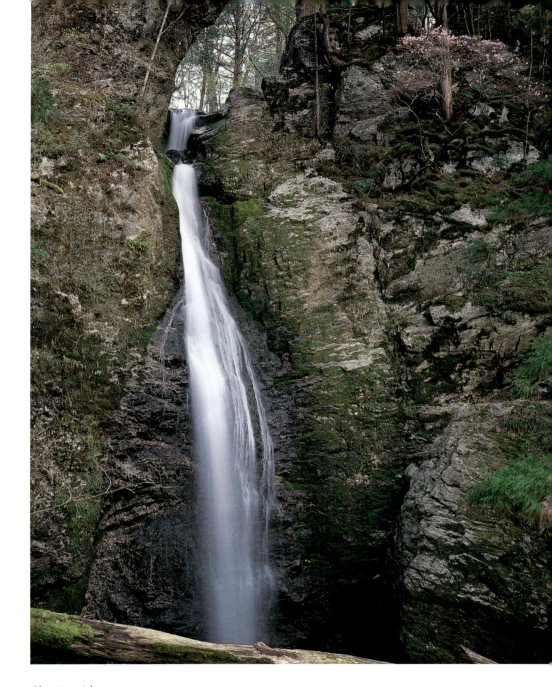

龍王の滝 〈Ryuo-no-taki〉 高知県大豊町／Kochi Pref. 落差：20 m ★

梶ヶ森県立自然公園にある。滝壺近くには龍神が祀られ、古くは若かりし空海が修行したところと伝わる。
This fall is located in Kajigamori Kochi Prefectural Nature Park. Ryujin (God of dragon) is enshrined near the fall basin. It is said that Kukai, a famous monk, used to train himself there.

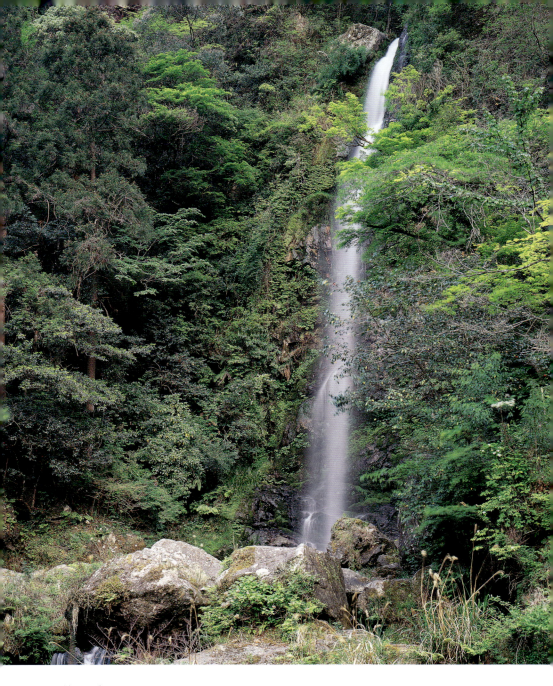

大樽の滝 〈Odaru-no-taki〉 高知県越知町／Kochi Pref. 落差：34 m ★
仁淀川の支流・大樽谷川にかかる滝。花崗岩の岩肌を落ちる直瀑。
This fall drops into a branch of the Niyodo River. It is a horsetail fall which descends over a granite cliff.

御来光の滝 〈Goraiko-no-taki〉 愛媛県久万高原町／Ehime Pref.　落差：100 m　★
面河渓の上流7kmの地点にある。石鎚スカイラインの長尾尾根展望台から遠望できる。
This fall is located 7km up the Omogo Valley. You can have a distant view of the fall from the Nagao-one viewing deck of the Ishizuchi Skyline Driveway.

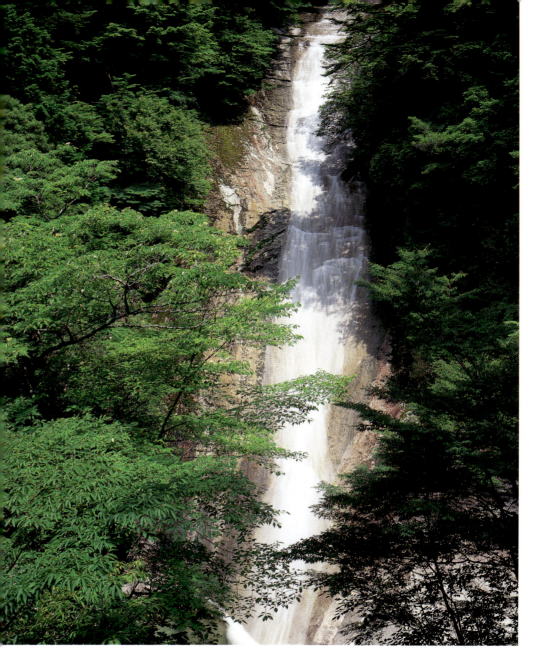

雪輪の滝 〈Yukiwa-no-taki〉 愛媛県宇和島市／Ehime Pref.　落差：80 m　★

四万十川支流・目黒川の上流に広がる滑床渓谷にかかる。緩やかな斜面を水が流れ、時に波紋が弧を描く様はこの滝名にふさわしい美しさである。
This fall drops into the Nametoko Valley of a branch of the Shimanto River. The water descends over a gentle slope and sometimes it draws splendid wave patterns.

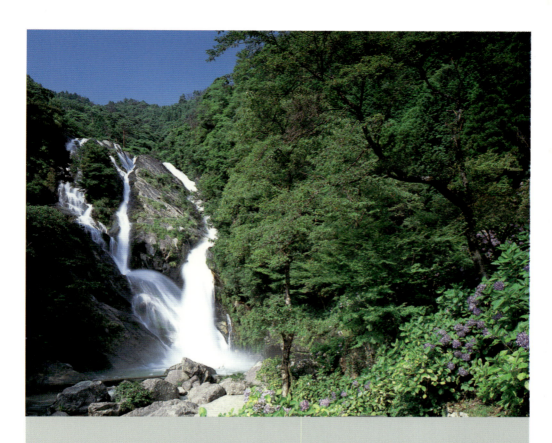

九州 沖縄

Kyushu & Okinawa

見帰りの滝〈Mikaeri-no-taki〉佐賀県唐津市／Saga Pref.　落差：100 m　★
左伊岐佐川の伊岐佐ダム下流にある。アジサイの名所としても知られる。
This fall is located at the lower stream of the Ikisa Dam. It is also famous for the hydrangeas which bloom there.

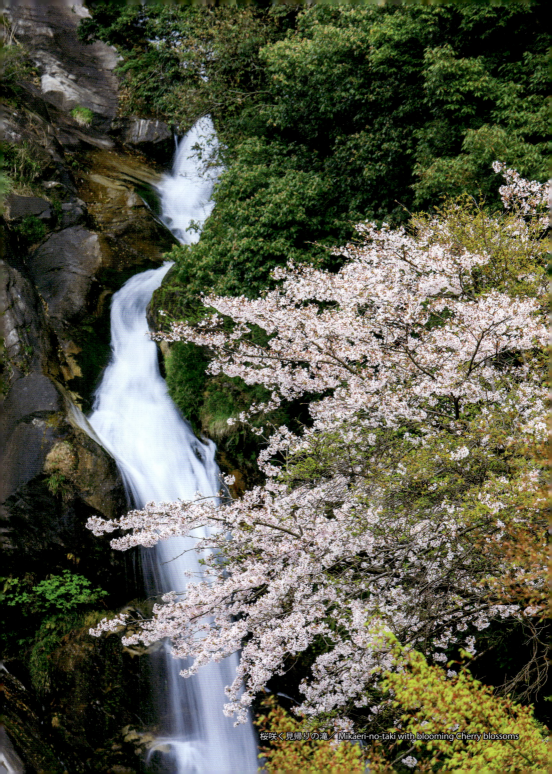

桜咲く見帰りの滝／Mikaeri-no-taki with blooming Cherry blossoms

轟の滝 〈Todoroki-no-taki〉 佐賀県嬉野市／Saga Pref.　落差：11ｍ

三段の滝。滝壺が大きく2500㎡ある。塩田川と岩屋川内川の合流付近にあり、周囲は轟の滝公園となっている。
This fall is located at the junction where the Shiota River merges into the Iwayagawachi River. It has three steps and its fall basin is 2500 square meters. Todoroki-no-taki Koen is around the fall.

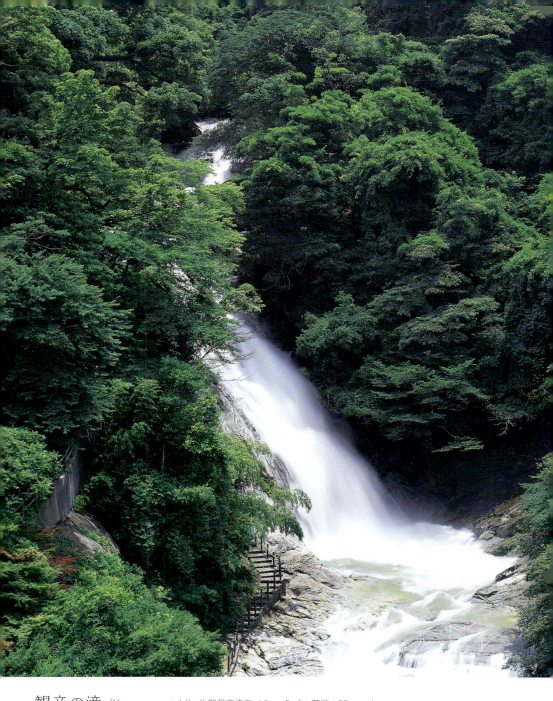

観音の滝 〈Kannon-no-taki〉 佐賀県唐津市／Saga Pref. 落差：27 m ★

玉島川の支流・滝川川にかかる。滝の傍らには生目観音が祀られ、この淵の水は眼病に効くといわれている。

This fall drops into a branch of the Tamashima River. Beside the fall, Ikime Kannon is enshrined and its water is said to be good for curing eye diseases.

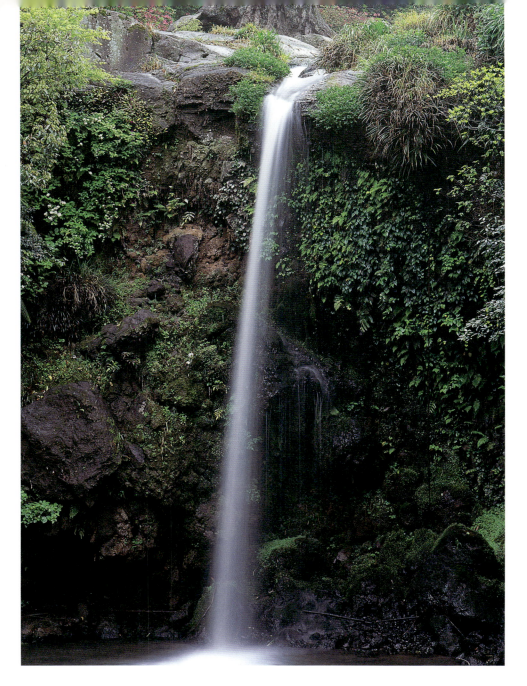

鮎帰りの滝 〈Ayugaeri-no-taki〉 長崎県南島原市／Nagasaki Pref. 落差：13.7 m

雲仙天草国立公園内。この滝を見た江戸時代の絵師・釧雲泉はあまりの美しさに描けず、筆を落としたと伝わる。
This fall is located in Unzen-Amakusa National Park. It is said that KUSHIRO Unzen, a painter of the Edo period (17th-19th century), was so surprised at the beauty of this fall that he dropped his paint brush.

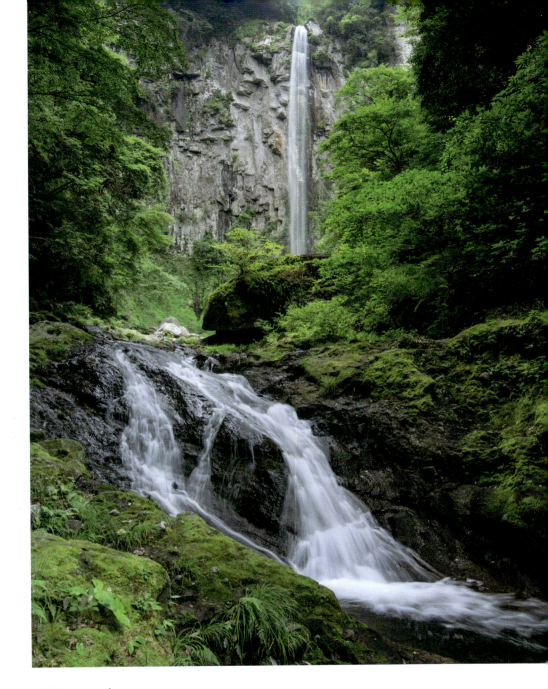

東椎屋の滝 〈Higashishiiya-no-taki〉 大分県宇佐市／Oita Pref. 落差：85 m ★

日光の華厳の滝になぞらえて、「九州華厳」とも称される名瀑。滝川にかかり、断崖をまっすぐに落ちる直瀑。
This fall is linked to Kegon-no-taki, one of the most famous falls in Japan, and called "Kyushu Kegon". It is a horsetail fall dropping into the Taki River.

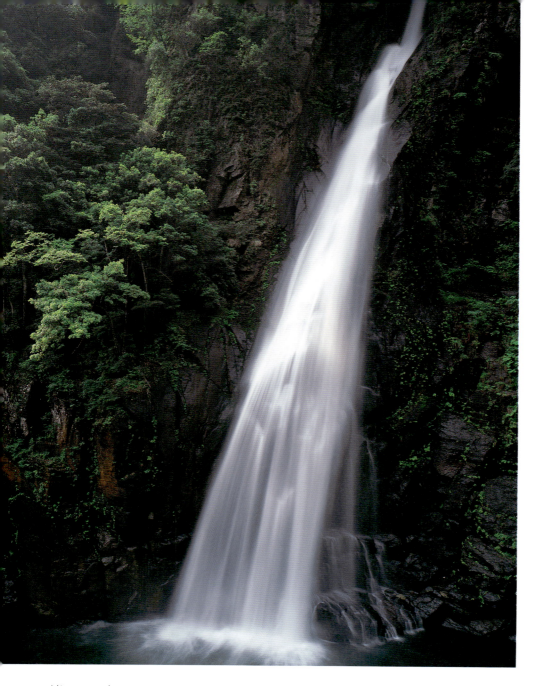

西椎屋の滝 〈Nishishiiya-no-taki〉 大分県玖珠町／Oita Pref. 落差：86 m ★

駅館川上流の渓谷にかかる。宇佐市との境にあり、東椎屋の滝、福貴野の滝とともに「宇佐の三瀑」と呼ばれる。
This fall drops into the upper stream of the Yakkan River. Together with Higashishiiya-no-taki and Fukino-no-taki, they are called the best three falls in the Usa Area.

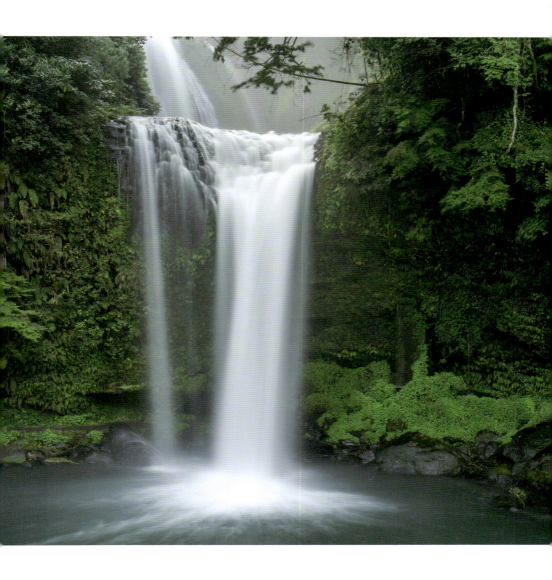

慈恩の滝 〈Jion-no-taki〉 大分県玖珠町／Oita Pref.　落差：30ｍ
日田市と玖珠町の境に位置する。上段20ｍ、下段10ｍ。滝の裏側を通ることができ「裏見の滝」とも呼ばれる。
This fall is located on the border between Hita City and Kusu Town. The upper step is 20m high and the lower step is 10m high. It is also known as "Urami-no-taki", which means that it is possible to walk and see the fall from behind.

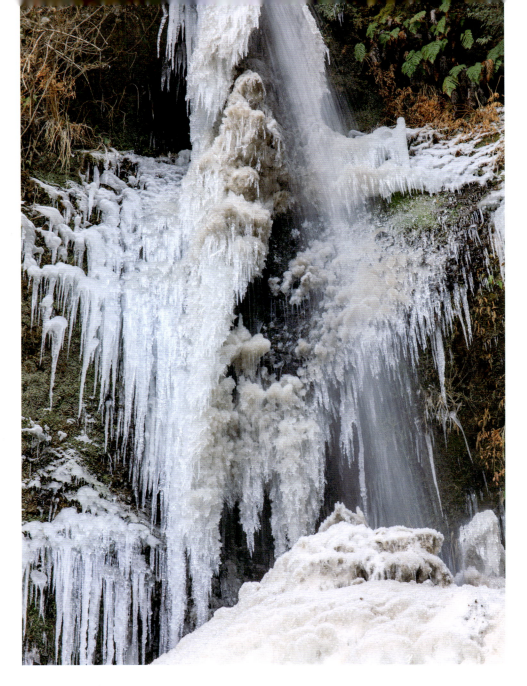

七折れの滝 〈Nanaore-no-taki〉 大分県九重町／Oita Pref. 落差：157m
九酔渓にある滝。このあたりは滝が多く、滝街道という。
This fall drops into the Kyusui Valley. There are many falls in this area, so the road along the river is called Taki-kaido (fall road).

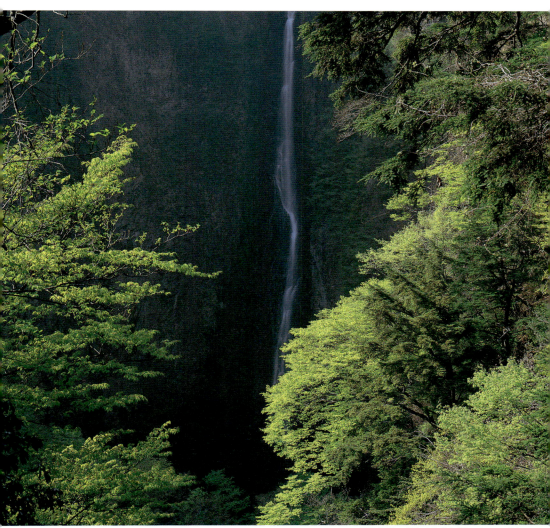

雄滝[震動の滝]／O-daki [Shindo-no-taki]

震動の滝 〈Shindo-no-taki〉 大分県九重町／Oita Pref. 落差：雄滝 83 m ★

九酔渓にかかる。九重"夢"大吊橋からその姿を見ることができる。名にふさわしく轟音とともに流れる雄大な滝。
This fall drops into the Kyusui Valley. You can see it from the Kokonoe-Yume-Otsuribashi suspension-bridge. The water descends with a loud boom and it looks powerful.

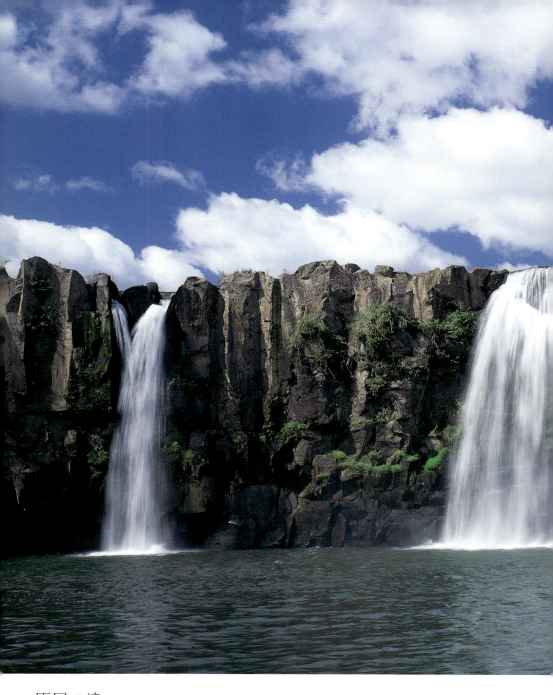

原尻の滝 〈Harajiri-no-taki〉 大分県豊後大野市／Oita Pref.　落差：20m　★

9万年前の阿蘇山噴火によって生じた火砕流が固まり、それを緒方川の流れが長い年月をかけて削り、滝となった。幅120m。

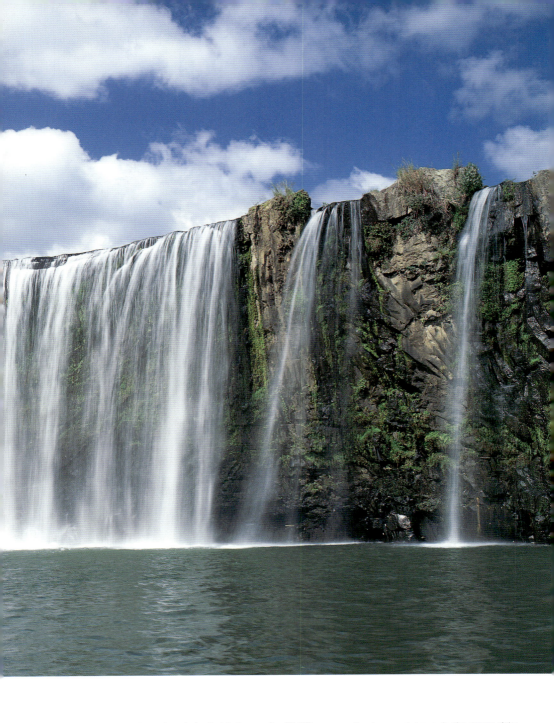

A pyroclastic flow rock, which was brought by the Mt. Aso eruption 90,000 years ago, has been eroded away by the stream of the Ogata River to create this fall. It is 120m wide.

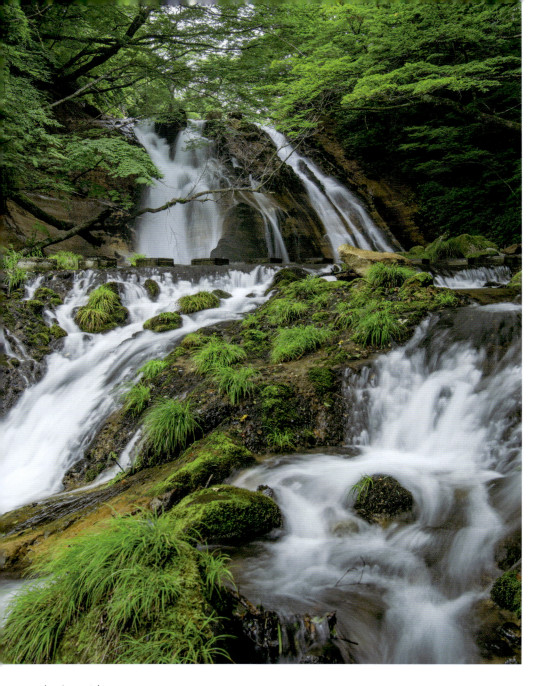

名水の滝 〈Meisui-no-taki〉 大分県由布市／Oita Pref.　落差：20 m

黒岳の麓から湧き出る湧水「男池」の下流にある。
This fall drops into the lower stream of the O-ike Pond, which is a spring water pond at the foot of Mt. Kurodake.

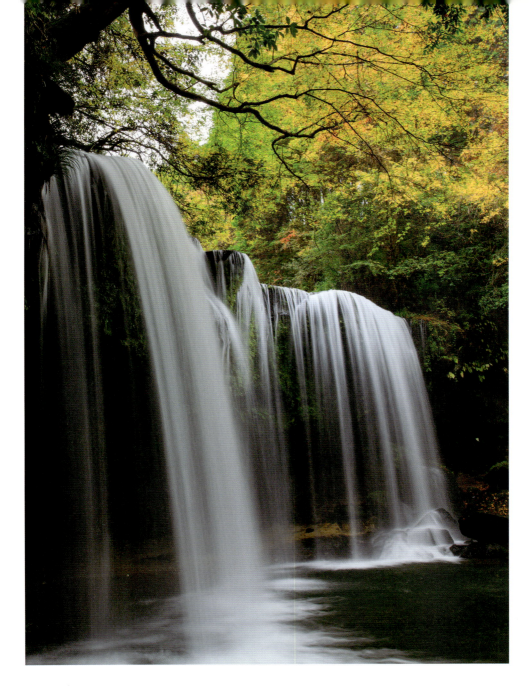

鍋ヶ滝 〈Nabe-ga-taki〉 熊本県小国町／Kumamoto Pref.　落差：10 m

9万年前の阿蘇山噴火と川の浸食により形成された。幅20m、水のカーテンといわれ、滝裏からも見ることができる。
This fall was formed by an eruption of Mt. Aso, 90,000 years ago, and by erosion by rivers. It is 20m wide and called "The curtain of water". You can see it from behind the fall.

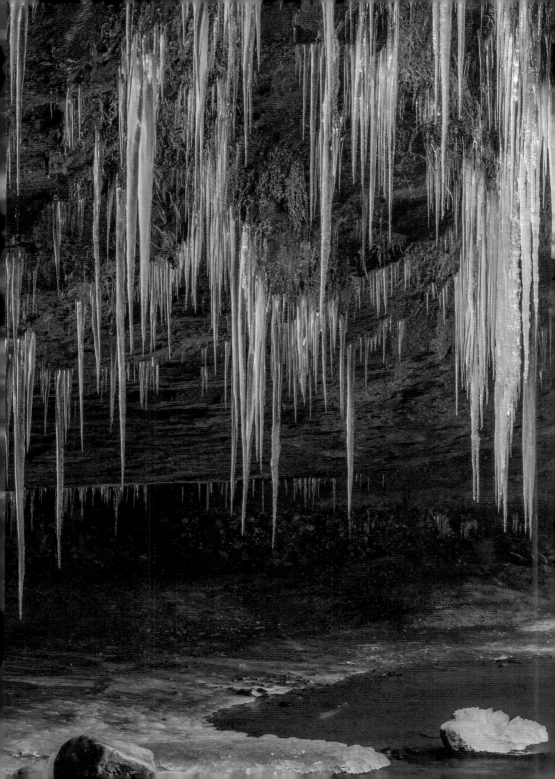

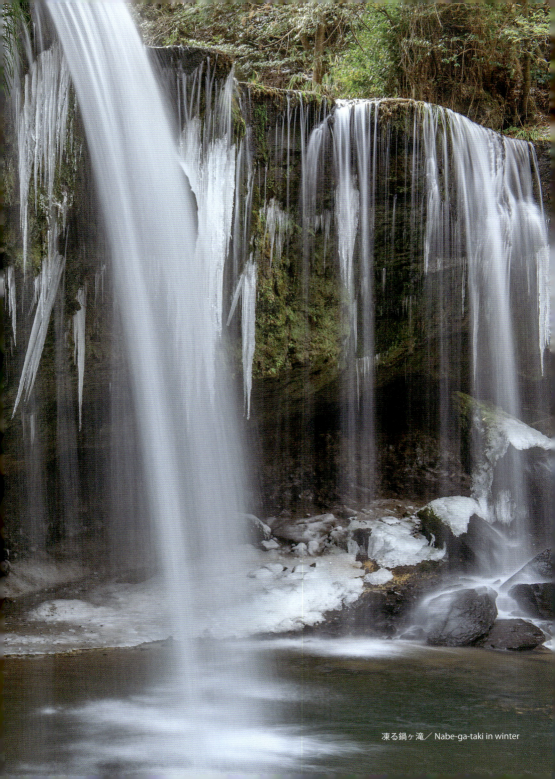

凍る鍋ヶ滝／Nabe-ga-taki in winter

夫婦滝 〈Meoto-daki〉 熊本県南小国町／Kumamoto Pref. 落差：男滝 15 m 女滝 12 m
田の原川と小田川がここで合流する。向かって左が田の原川の男滝、右が小田川の女滝。

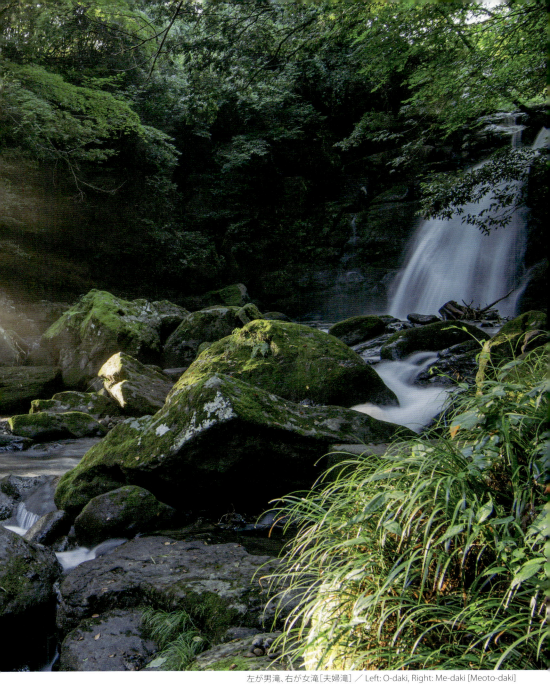

左が男滝、右が女滝［夫婦滝］／Left: O-daki, Right: Me-daki [Meoto-daki]

"Meoto" means a married couple and it has two falls. The left fall is O-daki dropping from the Tanoharu River, and the right fall is Me-daki dropping from the Oda River.

263

四十三万滝 〈Yonjusanman-taki〉 熊本県菊池市／Kumamoto Pref. 落差：不明 ★

菊池渓谷を代表する滝。滝名の由来は昭和9年、新聞社の景勝地募集で43万票を獲得し1位になったからとも、1日の平均流水量が43万石（約7.8万ｔ）あったからともいわれる。
This is the symbol of the Kikuchi Valley. Yonjusanman means the number of 430,000. Some say it comes from the quantity of descending water, and others say it is based on the vote count in a contest for favorite scenic spots of a newspaper company.

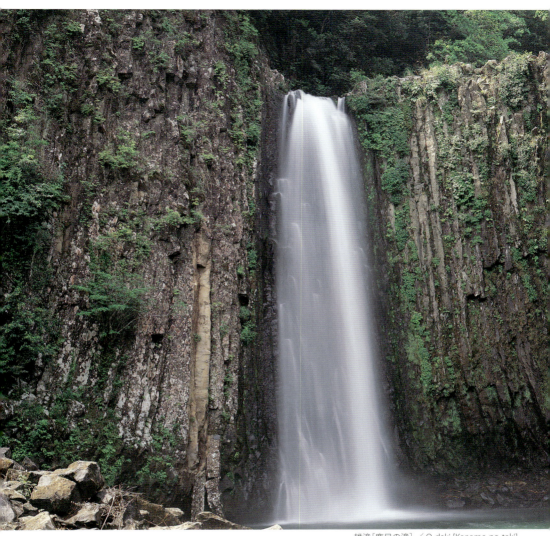

雄滝［鹿目の滝］／ O-daki [Kaname-no-taki]

鹿目の滝 〈Kaname-no-taki〉 熊本県人吉市／ Kumamoto Pref.　落差：雄滝 36 m　★

鹿目川にかかる。雄滝とその南にある雌滝、上流の平滝の三滝の総称。柱状節理の岩盤が圧巻である。
This fall drops into the Kaname River. "Kaname-no-taki" is the general term for this and two other falls. The bedrock showing the columnar joints is superb.

265

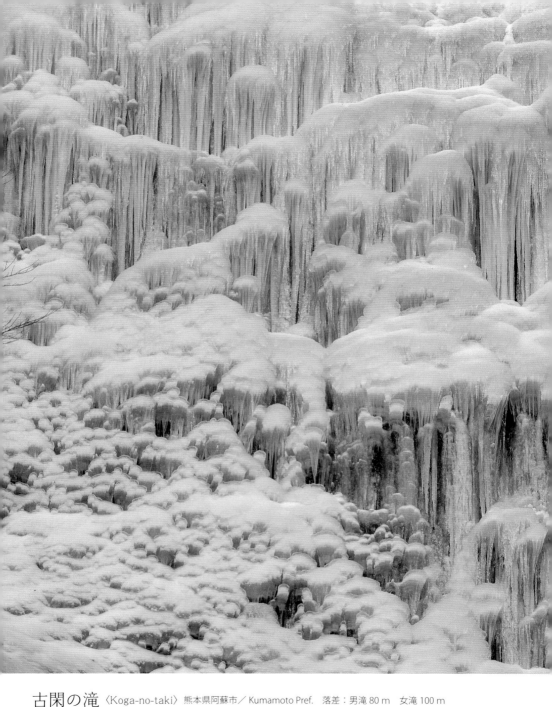

古閑の滝 〈Koga-no-taki〉 熊本県阿蘇市／Kumamoto Pref. 落差：男滝 80 m　女滝 100 m

阿蘇山の外輪山の一部を形成する坂梨流紋岩にかかる。左が男滝、右が女滝。冬には見事な氷瀑となる。この氷が融ける音は春を告げる音といわれている。

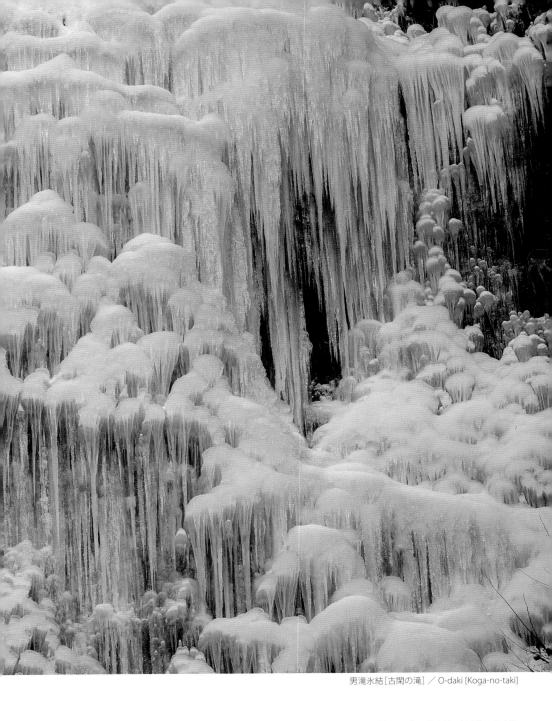

男滝氷結[古閑の滝] ／ O-daki [Koga-no-taki]

This fall is located on the outer rim of Mt. Aso. The left fall is called O-daki (male fall), and the right one is called Me-daki (female fall). In winter it ices up and people say that the sound of melting ice water brings spring.

267

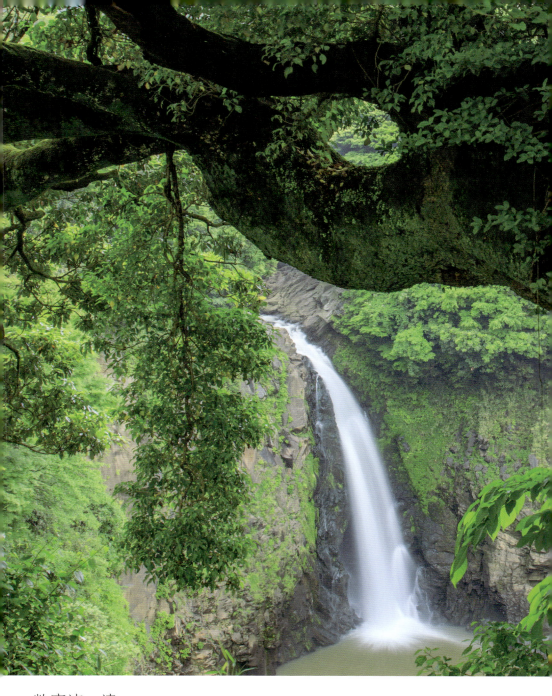

数鹿流ヶ滝 〈Sugaru-ga-taki〉 熊本県南阿蘇村／Kumamoto Pref.　落差：60m　★

黒川にかかる。一説には、建久2年(1191)の巻狩(狩猟)の際、逃げ場を失った鹿が数頭落ちたことが滝名の由来という。

This fall drops into the Kuro River. Sugaruga means deer flowing and it comes from a legend that when Makigari hunting session was help in 1191, a few deer fell down this fall.

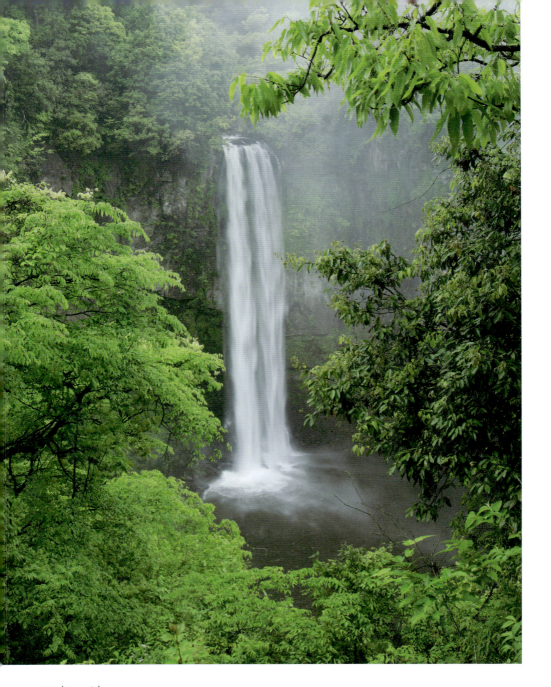

五老ヶ滝 〈Goro-ga-taki〉 熊本県山都町／ Kumamoto Pref.　落差：50 m

五老ヶ滝川、「通潤橋」近くにかかる。天文13年(1544)勅使がこの滝を見物した記録も残る、古くからの名勝。
This fall is located near Tsujun-kyo Bridge on the Goro-ga-taki River. It has been widely known to people as a viewpoint from the old times.

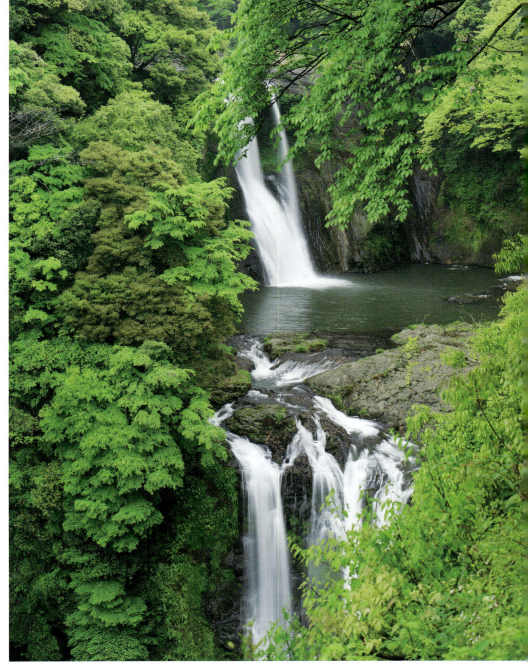

上段が鷹滝、下段が鵜の子滝［鵜の子滝］／ The upper step: Taka-daki, The lower step: Unoko-daki[Unoko-daki]

鵜の子滝 〈Unoko-daki〉 熊本県山都町／Kumamoto Pref. 落差：上段 20 m　下段 40 m

二段の滝。下段を鵜の子滝、上段を鷹滝と呼ぶこともある。緑川の支流・笹原川にかかる。
This fall drops into the Sasahara River, a branch of the Midori River. It has two steps and the upper one is sometimes called "Taka-daki".

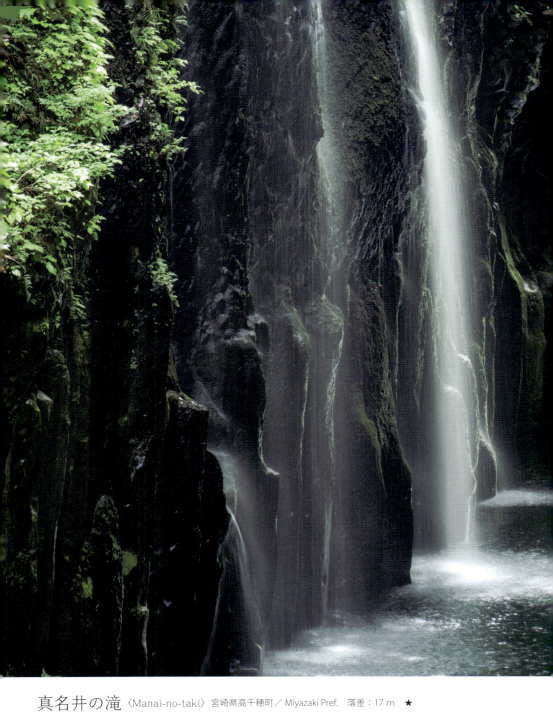

真名井の滝 〈Manai-no-taki〉 宮崎県高千穂町／Miyazaki Pref.　落差：17m　★

高千穂峡のシンボル。岩盤からの湧水が断崖を流れ落ちる滝。天孫降臨の際、この地に水がなかったため、天村雲命が水種を移した。その「天真名井」の水が滝となって流れ落ちるという。

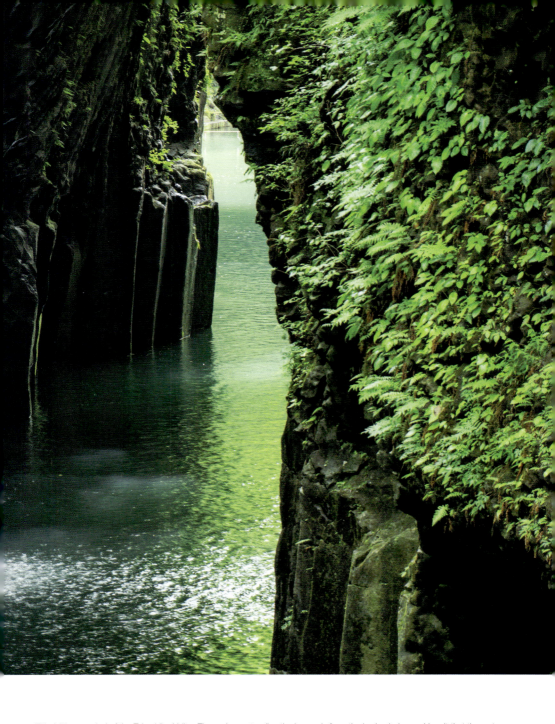

This fall is a symbol of the Takachiho Valley. The spring water directly descends from the bedrock. Legend has it that the water was brought when God first came down to this world from the sky.

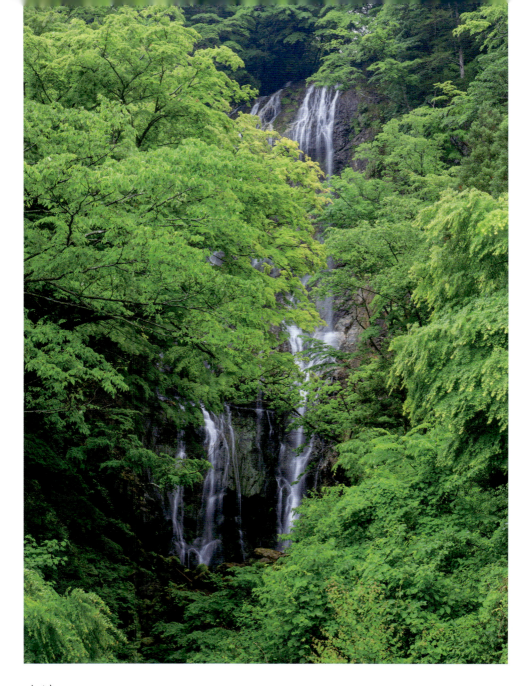

白滝 〈Shira-taki〉 宮崎県五ヶ瀬町／Miyazaki Pref. 落差：60m
五ヶ瀬川源流域にかかる滝。標高900m地点にあり、冬には氷結する。
This fall drops into the Gokase River basin and is located at a height of 900m above sea level. In winter the fall turns to ice.

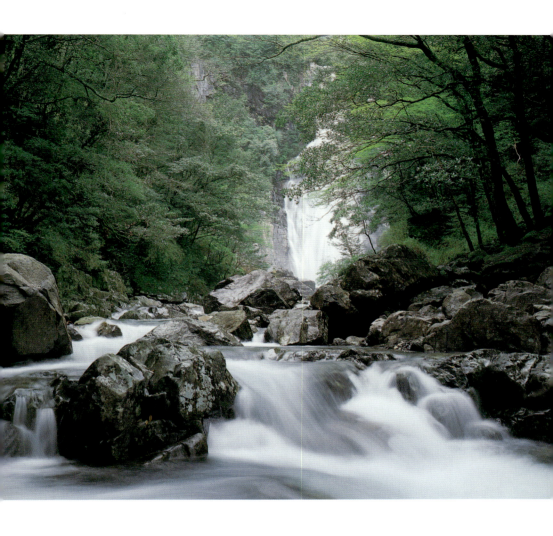

矢研の滝 〈Yatogi-no-taki〉 宮崎県都農町／Miyazaki Pref.　落差：73 m　★

名貫川源流部・矢研谷にかかる。滝名は神武天皇東征の折、この滝で矢を研いだという言い伝えから。
This fall drops into the headstream of the Nanuki River. Yatogi means to sharpen an arrow. Legend has it that during an expedition of the Emperor Jinmu, he sharpened his arrow at this fall.

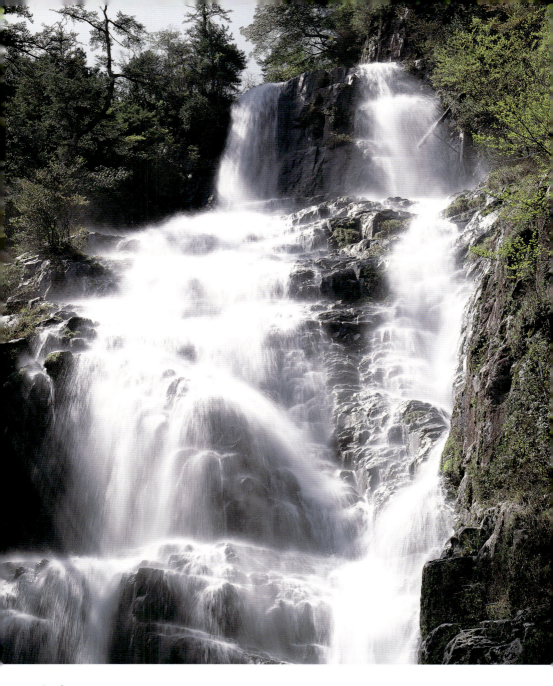

白滝 〈Shira-taki〉 宮崎県都農町／Miyazaki Pref.　落差：75m

欅谷最深部にかかる。名貫川の源流部・甘茶谷、欅谷、矢研谷などにかかる滝群を総称して尾鈴山瀑布群という。
This is the one of the Osuzuyama-bakufu-gun (the group of falls of Mt. Osuzu), dropping into the headstreams of the Nanuki River. Shira-taki is a large scale fall situated in the deepest part of the Keyaki Valley.

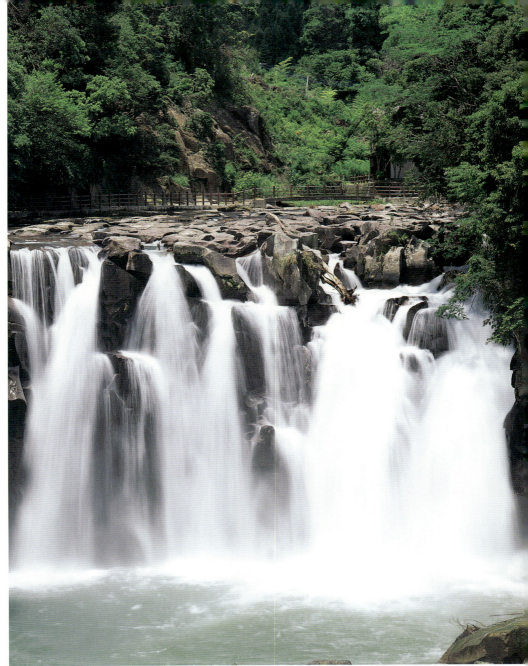

大滝［関之尾滝］／ O-taki[Sekinoo-no-taki]

関之尾滝 〈Sekinoo-no-taki〉 宮崎県都城市／ Miyazaki Pref. 落差：大滝18ｍ ★

庄内川にかかる。落差18m幅40mの大滝の他、男滝、女滝をあわせた三滝の総称。滝上流には大規模な甌穴群がある。
"Sekinoo-no-taki" is the general term for the three falls dropping into the Shonai River. O-taki (pictured) is 18m high and 40m wide. There are a large number of potholes in the upper stream of the falls.

277

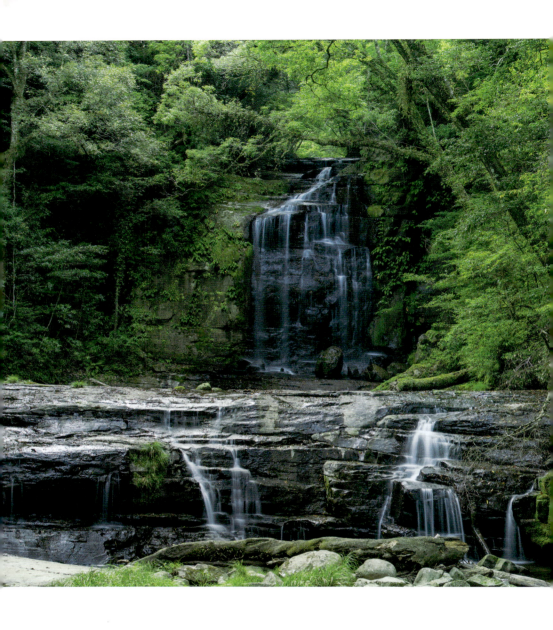

五重の滝 〈Goju-no-taki〉 宮崎県日南市／Miyazaki Pref.　落差：25 m

猪八重川が刻む猪八重渓谷には、大小の滝が数多くかかる。五段に流れる五重の滝はその中でも中心的存在。
There are many large and small falls in the Inohae Valley. "Goju-no-taki", which has five steps, is the center piece of these.

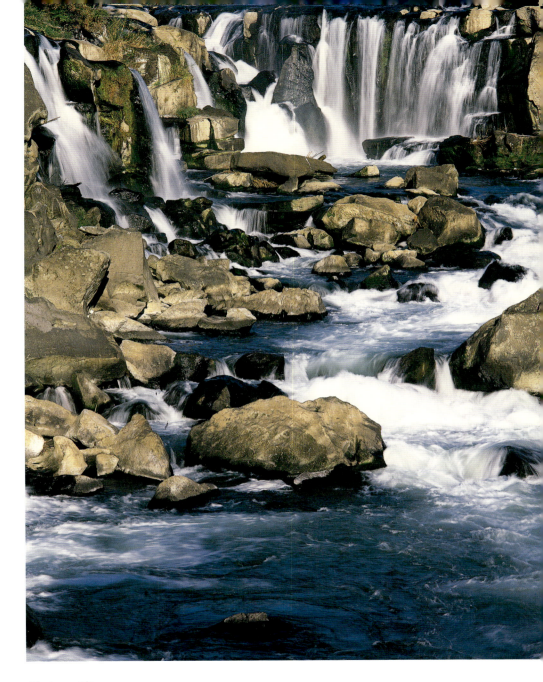

曽木の滝 〈Sogi-no-taki〉 鹿児島県伊佐市／Kagoshima Pref.　落差：12 m

川内川にかかる。幅210mにわたって流れ落ちる豪快な滝。一帯は曽木の滝公園として整備されている。
This fall drops into the Sendai River. It is 210m wide and very dynamic. The area around the fall is maintained as Sogi-no-taki Park.

湯之尾滝 〈Yunoo-daki〉 鹿児島県伊佐市／Kagoshima Pref.　落差：5 m
江戸時代、利水のための井堰「湯之尾井堰」として作られた人工滝。

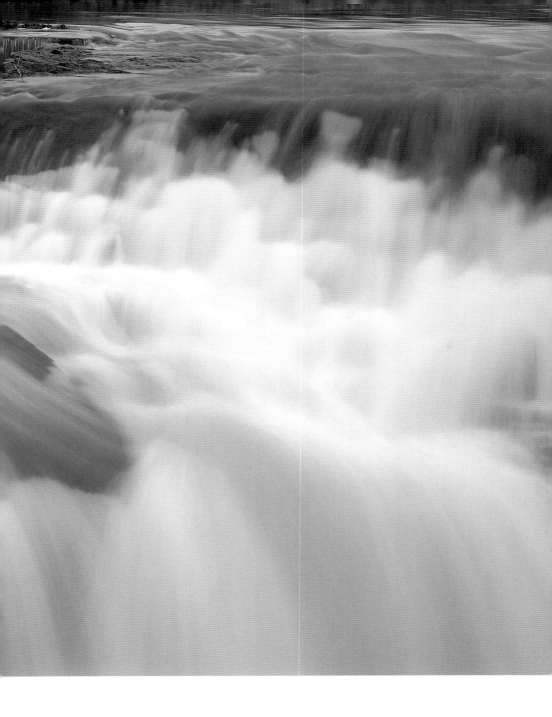

This is an artificial fall, which was constructed in the Edo Period (17th-19th century) for flood-control.

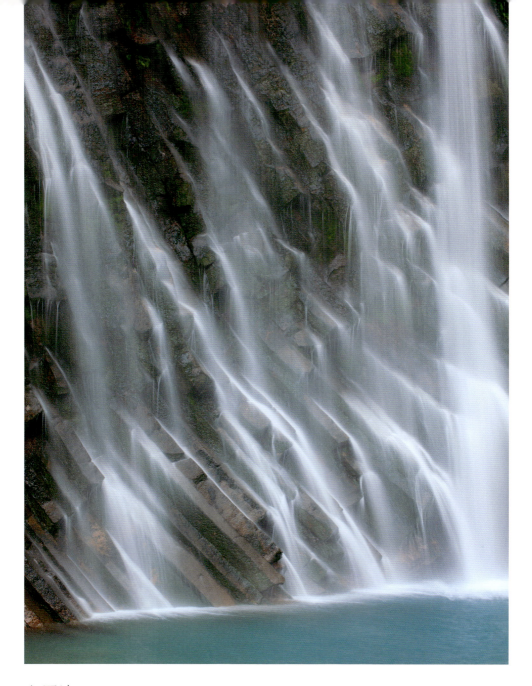

丸尾滝 〈Maruo-no-taki〉 鹿児島県霧島市／Kagoshima Pref. 落差：23 m

中津川にかかる。周囲の温泉水を集めて流れ落ちる湯の滝。温泉成分のため、青白く濁った水が美しい。
This fall drops into the Nakatsu River. The water comes from the nearby hot spring; therefore, it is colored bluish white and very beautiful.

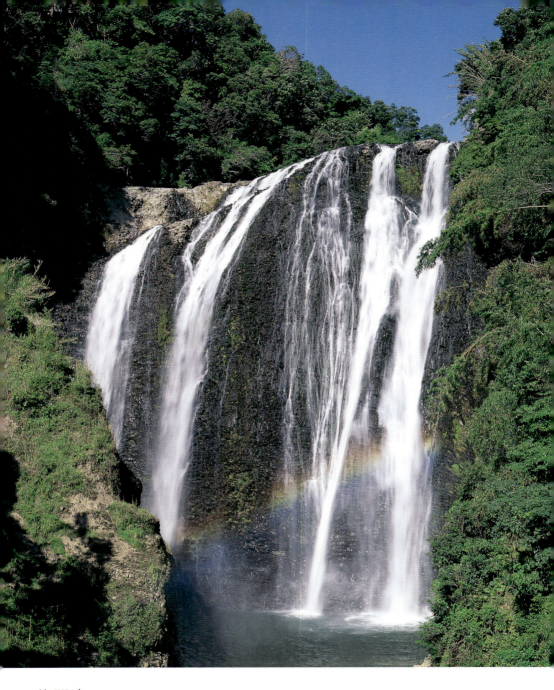

龍門滝 〈Ryumon-daki〉 鹿児島県姶良市／Kagoshima Pref.　落差：46 m　★

網掛川にかかる。昔この滝を見た唐人が黄河上流の龍門瀑のようだと賞したことからこの滝名がついたといわれる。
This fall drops into the Amikake River. The name "Ryumon-daki" comes from "Ryumon-baku fall", which drops into the Huang He River in China.

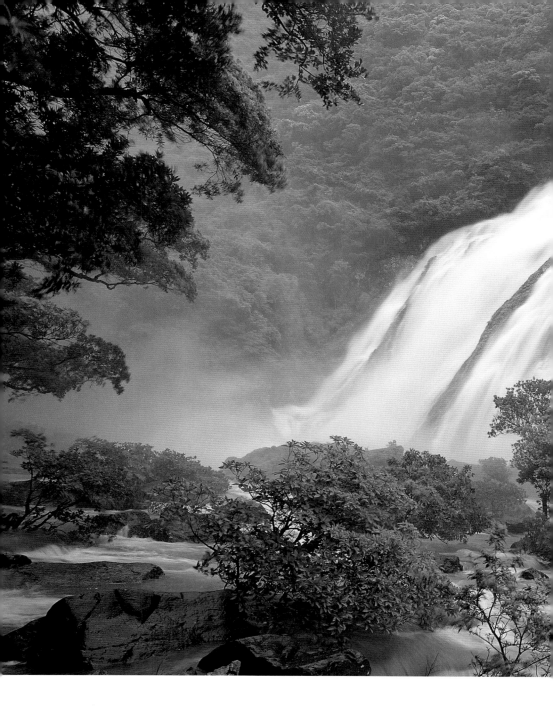

大川の滝 〈Oko-no-taki〉 鹿児島県屋久島町／Kagoshima Pref.　落差：88 m　★

屋久島一の規模を持つ滝。雨の多い屋久島だが、大雨の後などは急激に増水する。

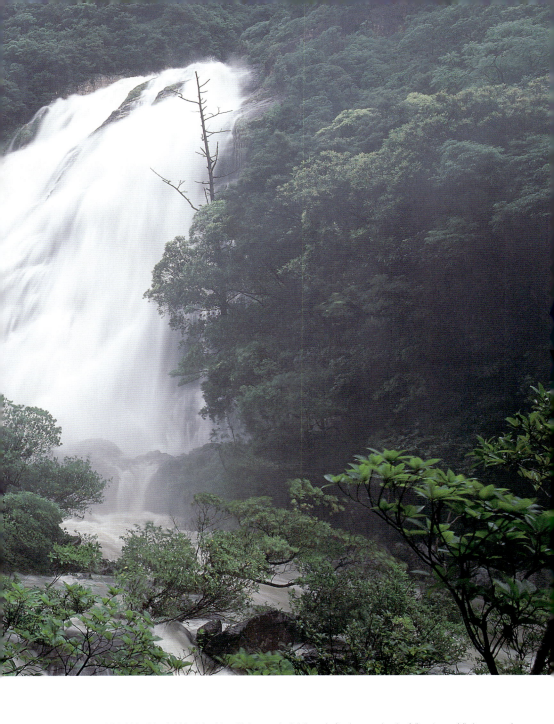

This is the largest fall in Yaku Island. Yaku Island has high annual rainfall, and after heavy rain, the fall water rapidly increases in volume.

千尋の滝 〈Senpiro-no-taki〉　鹿児島県屋久島町／Kagoshima Pref.　落差：60 m
鯛ノ川が花崗岩の岩盤を滑り降りる滝。滝に向かって左側の岩盤の巨大さを、千人が手を結んだぐらいの大きさにたとえたことから「千尋」の名がついた。

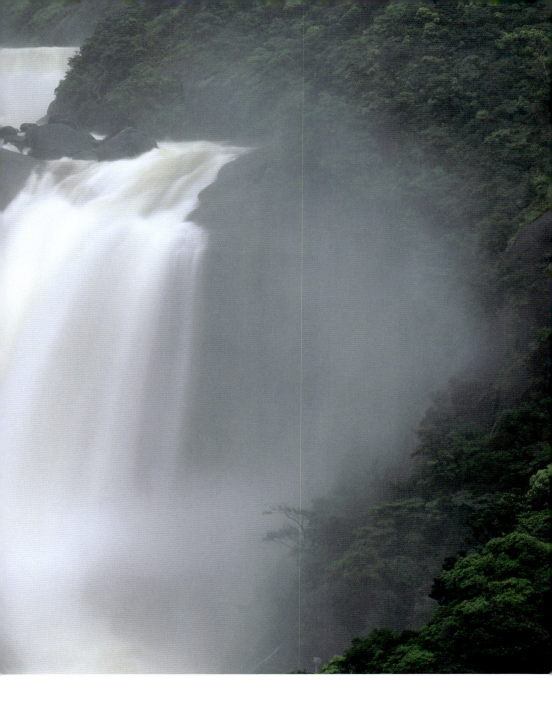

The Tainoko River descends over granitic bedrock. It is said that the giant rock on the left side of the fall looks as big as one thousand people holding their hands.

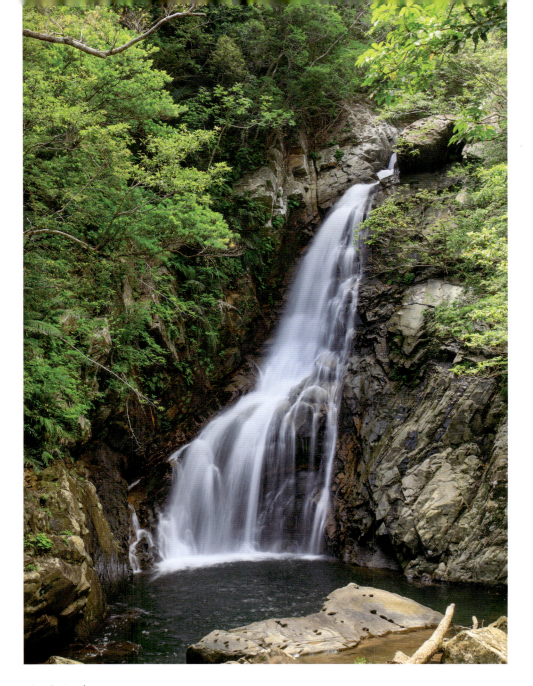

比地大滝 〈Hiji-otaki〉 沖縄県国頭村／Okinawa Pref.　落差：25.7 m

やんばるの豊かな自然の中、比地川が大きく流れ下る。比地大滝キャンプ場から遊歩道が整備されている。
The Hiji River flows through the rich countryside of Okinawa. You can walk to the fall along the hiking path from Hiji-otaki Campsite.

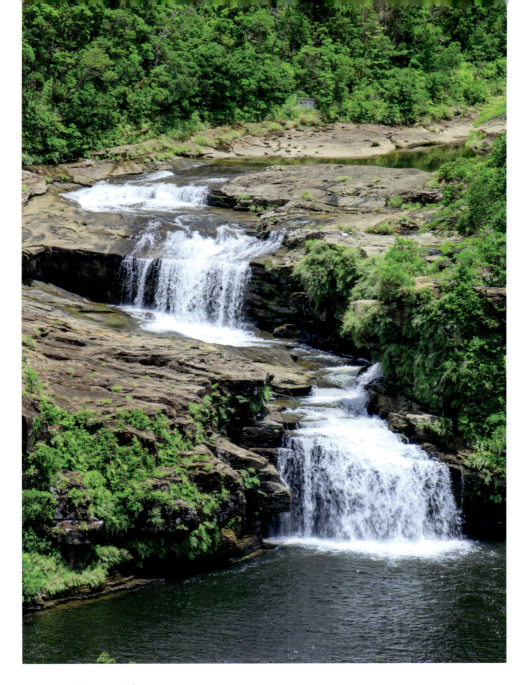

マリユドゥの滝 〈Mariyudu-no-taki〉 沖縄県竹富町／Okinawa Pref.　落差：15ｍ　★
西表島の浦内川にかかる。マリユドゥは「円い淀み」という意味で、円弧を描きながら二段に水が流れるからとも、円い滝壺を持つからともいわれる。
This fall drops into the Urauchi River, Iriomote Island. Mariyudu means round backwater.

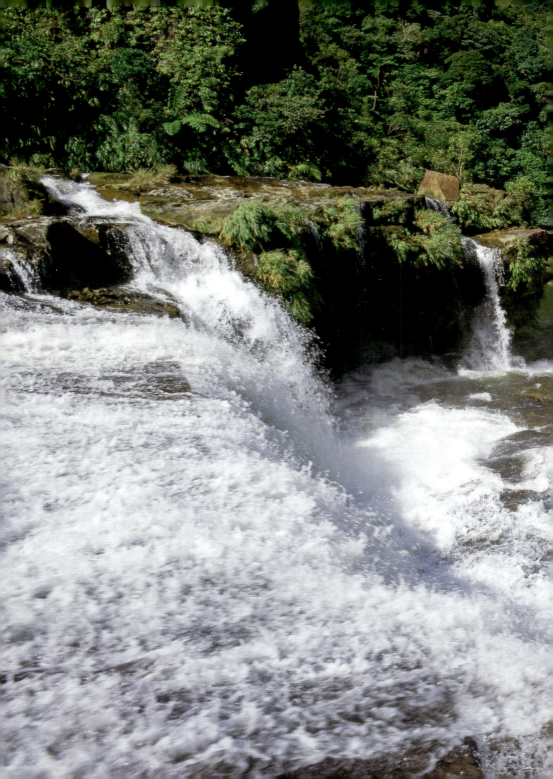

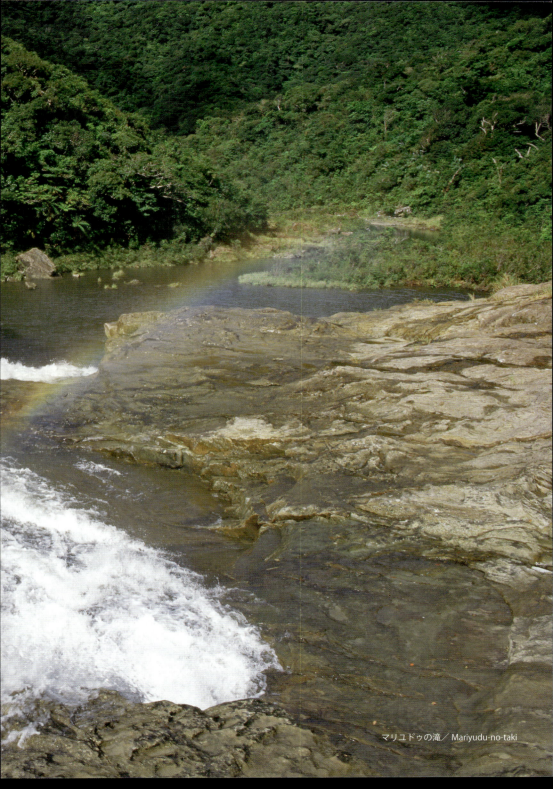
マリユドゥの滝／Mariyudu-no-taki

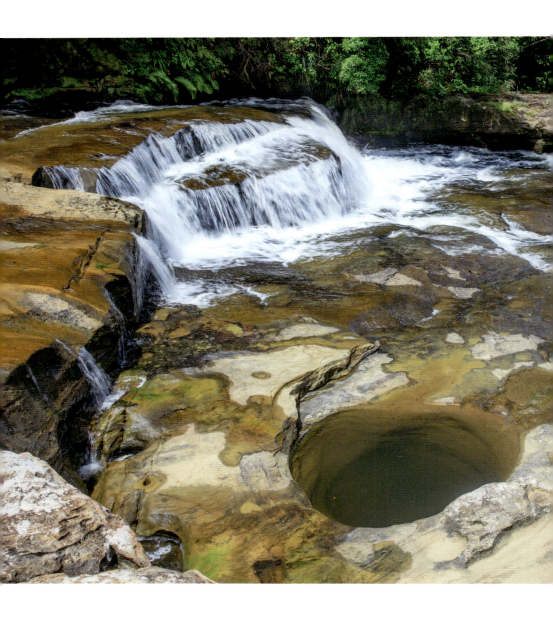

カンピレーの滝 〈Kanpire-no-taki〉 沖縄県竹富町／Okinawa Pref. 落差：不明

西表島、マリユドゥの滝の上流に位置し、約200mにわたって幾段にも落ちる。カンピレーとは「神の座」の意。
This fall is located in the upper stream of "Mariyudu-no-taki", Iriomote Island. It has many steps and descends over 200m. Kanpire means the seat of God.

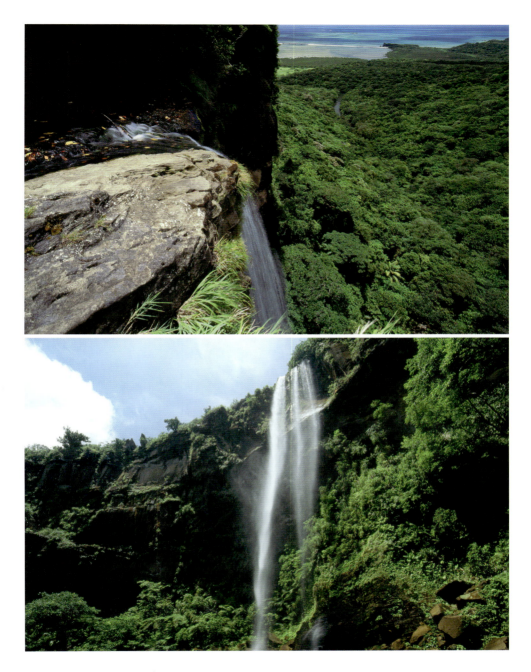

ピナイサーラの滝 〈Pinaisara-no-taki〉 沖縄県竹富町／Okinawa Pref. 落差：55m

西表島の北部、ヒナイ川にかかる。ピナイとは髭、サーラとは下がったものの意。滝の姿を老人の白い髭に見立てている。
This fall drops into the Hinai River in the north of Iriomote Island. Pinai means mustache and sara means hanging. The fall is said to resemble the white mustache of an old man.

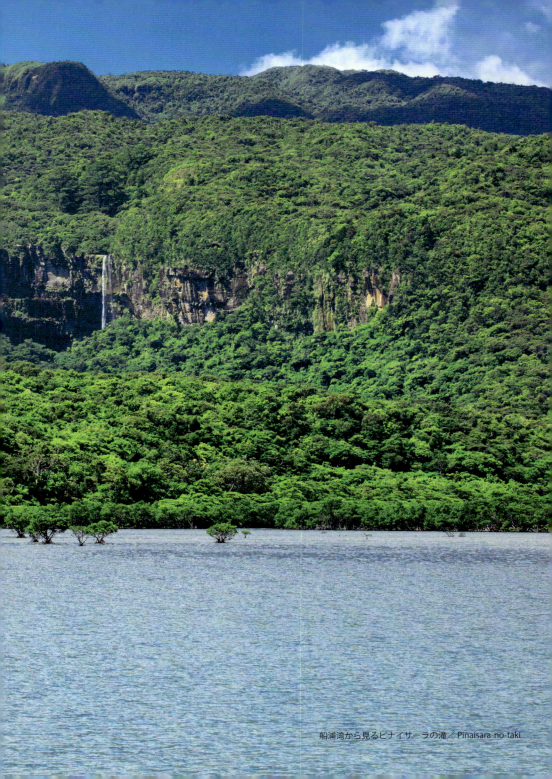

船浦湾から見るピナイサーラの滝／Pinaisara-no-taki

滝の形態

【分岐瀑】

傾斜した岩肌に沿って流れ、岩の凹凸によって途中でいくつかの流れに枝分かれして落ちる滝。直瀑に比べると女性的な優しい印象のものが多いとされる。

七ッ滝（山形県鶴岡市）

【渓流瀑】

ゆるやかに傾斜した川床を滑らかに流れ下る滝。その規模を、落差の代わりに全長で表す場合がある。また、高低差が大きいものだけ滝とする場合などがある。

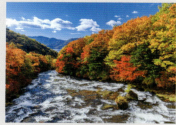

竜頭の滝（栃木県日光市）

【潜流瀑】

河川の流れによるものではなく、地層の中の地下水が湧き出して落下することにより形成される滝。流身が幅広のものもある。数が少なく、珍しい形態とされる。

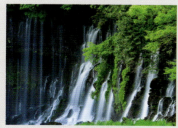

白糸の滝（静岡県富士宮市）

【直瀑】

滝口からほぼ垂直に落下する滝。落差が大きいと滝音も大きくなり、豪快な滝となる。エネルギッシュで名瀑が多いが、落差や幅によって印象は異なる。

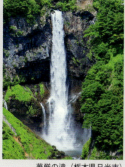

華厳の滝（栃木県日光市）

【段瀑】

二段、三段と階段状に落ちる滝。段数は様々で、見る角度によってその表情を変える変化に富んだ滝とされる。最下段以外の段に滝壺が生じるものもある。

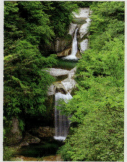

神蛇滝（山梨県北杜市）

滝の種類は外形で大別すると以上の5種が一般的であるが、いくつかの種類を兼ね備えた複合型も存在し、必ずしも1種類に分類できるわけではない。また、これら5種以外の分類法もある。

日本の滝信仰

古来、日本人にとっての滝は、山岳宗教の修行場として常に信仰との結びつきを持って存在してきた。それゆえ、「不動の滝」「観音滝」「称名滝」など、信仰心から命名されたであろう滝が全国に多数存在している。信仰と結びついたものでは、熊野那智大社の「那智の滝」が最も有名であろう。また、宗教的な意味合いがなくとも、その地方に語り継がれる伝承を持った滝がいくつかある。美しい水が織りなす自然の姿に、日本人の心が惹きつけられるのは昔も今も変わらない。

あ ● と ● が ● き

　日本列島は海岸から山まで急峻な地形が多く、川や谷、沢を遡ると大小の滝に出会える。そして、それらを彩る周囲の色は季節ごとに変化する。新緑や季節の花々、紅葉や雪景色など、四季の移ろいが滝の表情を幾重にも変えてゆき、見る者を魅了する。

　春、立山連峰を源流とする「称名滝」に雪解け水が多く流れ込む。滝の右側には「ハンノキ滝」が現れ、二つの滝がV字を描いて同じ滝壷へ注ぎ、滝見台の私を濡らした。まだ残雪を残した滝壷には虹が発生して、神々しい自然との出会いに心揺さぶられたのを覚えている。

　季節は夏へと向かい、滝の断崖絶壁の自然林が芽吹き、萌黄や新緑にツツジやフジの花も彩を添える。滝の豪快さとコラボレーションし、爽やかで清々しい風景を生み出す。豪雨後の屋久島では「大川の滝」の水量が増し、滝口から落下する水勢により強風が発生、水飛沫と共に襲ってきた。轟音の大瀑布と地響きの大迫力に恐怖を覚える中、雨合羽を着て長靴を履き、カメラにも防水対策をして膝下まで濁流に浸かりシャッターを切る。撮影の度に傘でカメラを保護し、レンズについた水滴を取り除いては撮影を続けたが、全身に降り注ぐ自然のエネルギーに威圧された。

　潜流瀑は崖の途中から溶岩断層を通って無数の伏流水が滴り落ちる滝を言うが、滝に苔の緑が美しく映えた姿は清涼感に溢れる。緑の自然林に囲まれた軽井沢の「白糸の滝」では、透明度の高い滝壺の水にカメラを沈め、半水面写真をマイナスイオンとミストを浴びながらの撮影となった。幅広に落ちる幾筋もの水流と、澄んだ水中に広がる世界。それらを取り囲む新緑と相俟って、神秘的な光景が広がっていた。

　錦繍の頃、周辺の樹々の赤や黄色に彩られ華やかで艶やかな滝風景を、滝音やせせらぎの音に包まれながらレンズにおさめてゆく。全山埋め尽くす程の紅葉の中に落ちる一筋の滝は、まるで一幅の絵のようだ。

　厳冬期には、足元は滑り止めのアイゼンを履き、凍てつくような寒さの中、滝壺を目指す。飛瀑が氷結して氷柱を成長させ、氷瀑となった巨大な氷のシャンデリアを前に、自然の造形美の力に圧倒され、夢中で撮影した。

　滝との出会いを求めて苦しい山道を何度も歩いてきた。その度に、轟音が次第に大きくなり始めると期待に胸が膨らんだ。そして辿り着いた先に待つ滝との対峙が、いつだって私を楽しませてくれた。訪れる度に四季折々の違う表情を見せ、見たままの美しい瞬間を収めようとして気が付けば私は夢中でシャッターを切っている。多彩さ、それこそが日本の滝の魅力であろう。

2018年5月

森田敏隆

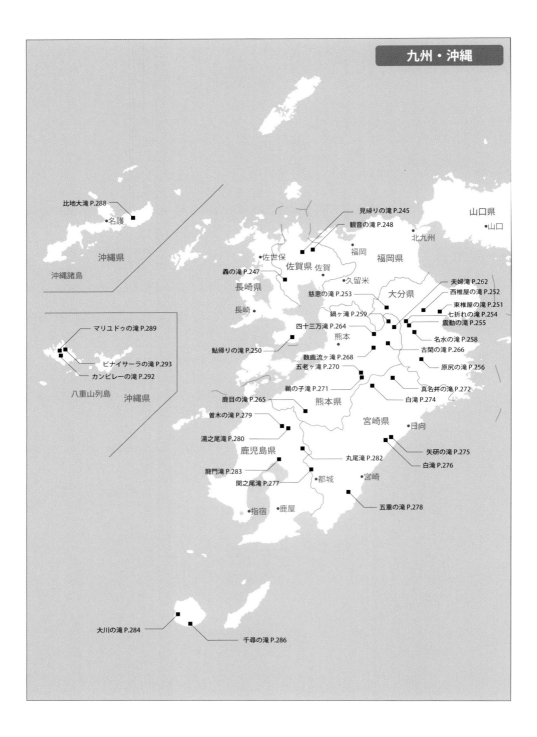

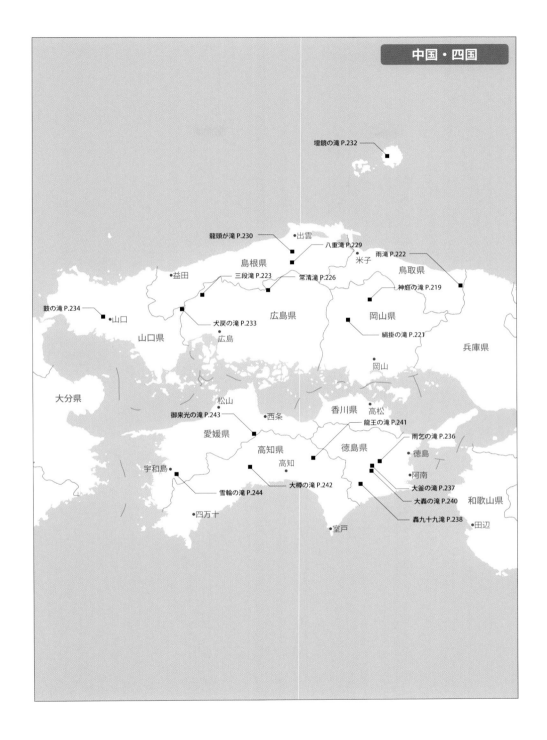

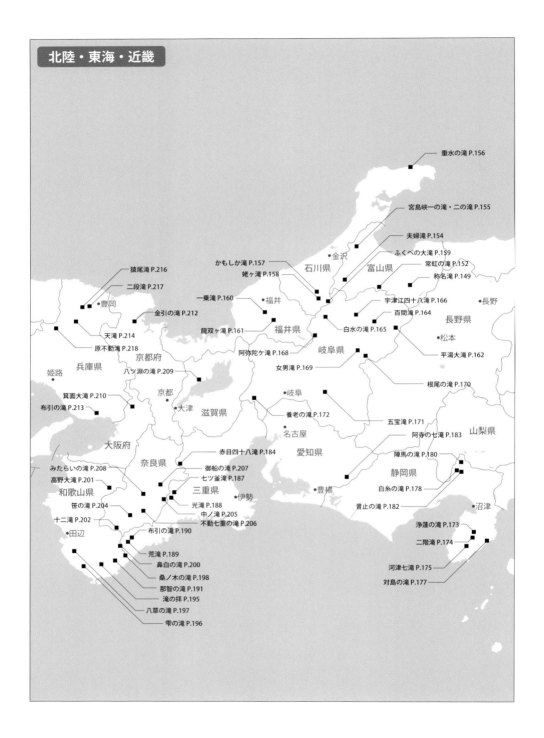

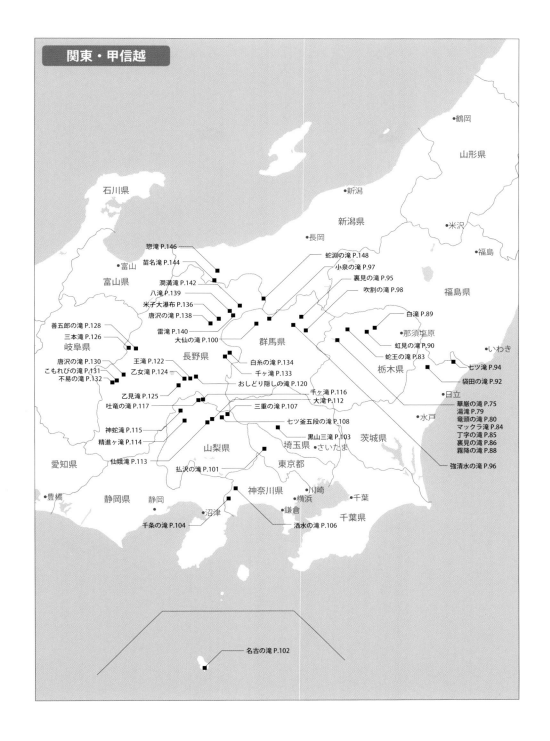

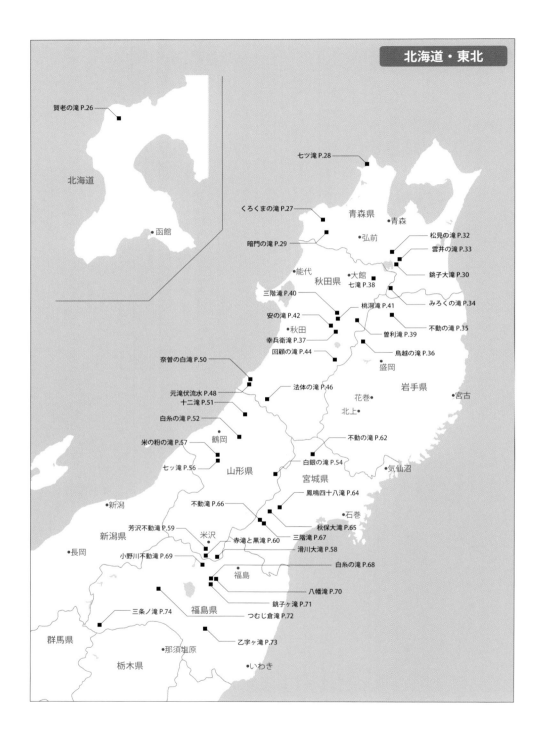

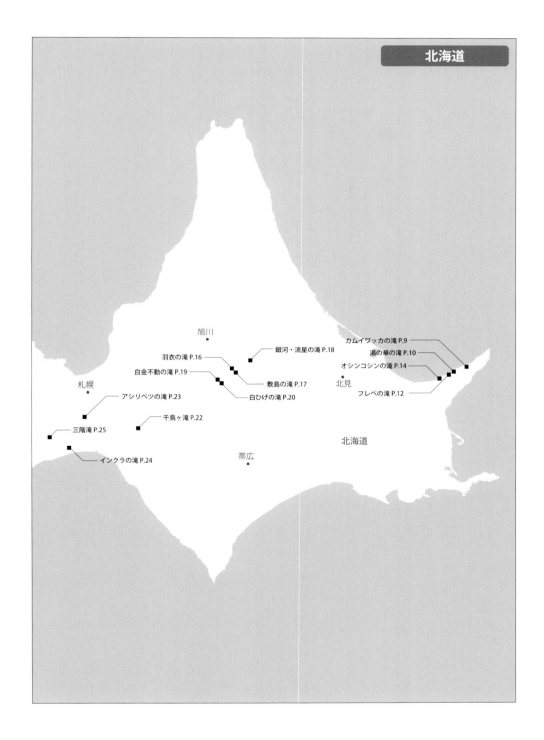

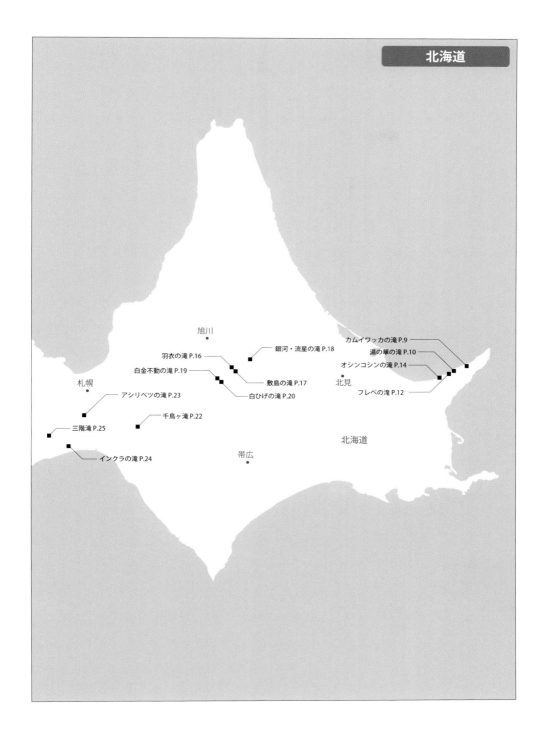

303

●参考文献

『日本の名瀑』グリーンルネッサンス（1990 年）
『日本の滝 100 選』編／グリーンルネッサンス事務局
講談社（1991 年）
『日本の滝①』著／北中康文　山と渓谷社（2004 年）
『日本の滝②』著／北中康文　山と渓谷社（2006 年）

カバー表紙：称名滝とハンノキ滝（富山県）
カバー裏表紙：白糸の滝（静岡県）
カバー折り返し：曽利滝（秋田県）

森田敏隆（もりた　としたか）

1946 年	大阪府八尾市志紀に生まれる。
1964 年	和歌山県立神島高等学校（旧田辺商業高等学校）卒業。 株式会社和楽路屋写真部入社。
1975 年	フリー写真家になり、エムオーフォトスを開設。
1990 年	株式会社エムオーフォトス代表取締役就任。
所属団体	日本写真家協会会員
写真集	『日本国立公園』（全 4 巻）、『瀬戸内』、『日本列島花百景』、 『日本の大自然』（全 28 巻）……毎日新聞社刊 『桜百景』、『日本の国立公園・国定公園』（上下巻） 　　　　　　　　　……クレオ刊 『SAKURA』、『熊野古道を行く』……世界文化社刊 『KYOTO&NARA』……チャールズ・イー・タトル出版刊 『たんぼ』、『あさのいろ』……ピエ・ブックス刊 『きせつのいろ』、『雲のある風景』、『さくらいろ』、 『はないろの季節』、『あきいろ』、『里のいろ』、『夕のいろ』、 『夜のいろ』、『日本の原風景 城』 『日本の原風景 町並 - 重要伝統的建造物群存地区 -』、 『一度は見たい桜』、『絶景！ふるさとの富士』、 『心も染まる紅葉』、『見わたすかぎりの花』、 日本の名景シリーズ『岬』、『水』、『夜』、『富士』、『湖』、 『庭』、『塔』、『城郭』、『町並』、『棚田』、『古道』 　　　　　　　　　……光村推古書院刊 『一本桜』、『一本桜百めぐり』、『棚田百選』、 『歴史の道百選』……講談社刊 『日本の国立公園』（上下巻）……山と渓谷社刊 『NATIONAL PARKS of JAPAN』……環境省 『歩きたい歴史の町並』……JTB パブリッシング
現 住 所	〒558-0004　大阪市住吉区長居東 1-25-11 株式会社エムオーフォトス
ホームページ	http://www.morita-mo.jp

宮本孝廣（みやもと　たかひろ）

1963 年	和歌山県南部川村（現みなべ町）に生まれる。
1981 年	和歌山県立南部高等学校卒業とともに森田敏隆に師事。 現在、株式会社エムオーフォトスに所属。
写真集	日本の名景シリーズ『紅葉』……光村推古書院刊

スタッフ

レイアウト：稲本雅俊（スタジオ Dd）
印刷設計：戸田茂生（日本写真印刷コミュニケーションズ）
印刷進行：川上宏次（日本写真印刷コミュニケーションズ）
英　訳：辻見郁子
編　集：大西律子・高橋梓（光村推古書院）

日本の原風景 滝

平成 30 年 7 月 24 日初版一刷発行

写　真	森田敏隆 宮本孝廣
発 行 者	合田有作
発 行 所	光村推古書院株式会社 〒 604-8257 京都市中京区堀川通三条下ル橋浦町 217-2 PHONE 075（251）2888 FAX 　 075（251）2881 http://www.mitsumura-suiko.co.jp
印　刷	日本写真印刷コミュニケーションズ株式会社

© 2018 MORITA Toshitaka, MO Photos
Printed in Japan
ISBN978-4-8381-0577-9 C0026

本書に掲載した写真・文章の無断転載・複写を禁じます。
本書のコピー、スキャン、デジタル化等の無断複製は著作権
法上での例外を除き禁じられています。本書を代行業者等の
第三者に依頼してスキャンやデジタル化することはたとえ個
人や家庭内での利用であっても一切認められておりません。

乱丁・落丁本はお取替えいたします。